The Panasonic Lumix DMC-GH2

Dr. Brian Matsumoto is a retired scientist who has worked for 30 years recording his experiments with a wide range of film and digital cameras, both in research and as Director of the Integrated Microscopy Facility for the Molecular, Cellular, and Developmental Biology Department at the University of California, Santa Barbara. Now he spends his time photographing with a variety of equipment ranging from microscopes to telescopes. He carries a camera on all his hikes and enjoys photographing nature.

In addition to the three books he has written for Rocky Nook, Dr. Matsumoto has published several articles and has had his photographs published in a number of periodicals. He is experienced in the technical aspects of photography and has taught courses on recording scientific experiments with digital cameras.

Carol Roullard has been an avid photographer since high school, where she first experimented with black and white artistic composition. She has continued photographing (mainly nature and architecture) throughout the years. Carol has used a variety of cameras covering a wide range of makes and models, from simple point-and-shoot to complex professional cameras. She has been using the latest Panasonic G series models for the past several years.

Carol is a retired Project Management Quality and Compliance engineer, a role in which she developed procedural and quality control methodology for IT projects. In addition, she developed and conducted training sessions covering best practices for procedural and quality control, breaking down complex subjects into easy-to-use approaches to learning.

Visit Brian and Carol's website at: http://www.VistaFocus.net

The Panasonic Lumix DMC-GH2

The Unofficial Quintessential Guide

Brian Matsumoto
Carol F. Roullard

rockynook

Brian Matsumoto, Carol F. Roullard, www.VistaFocus.net

Editor: Gerhard Rossbach
Copyeditor: Jeanne Hansen
Layout and Type: Petra Strauch
Cover design: Almute Kraus, www.exclam.de
Printed in China

ISBN 978-1-933952-89-5

1st Edition
© 2012 by Brian Matsumoto, Carol F. Roullard
Rocky Nook Inc.
802 East Cota St., 3rd Floor
Santa Barbara, CA 93103

www.rockynook.com

Library of Congress Cataloging-in-Publication Data

Matsumoto, Brian.
 The Panasonic Lumix GH2 : the unofficial quintessential guide / by Brian Matsumoto and Carol
F. Roullard. -- 1st ed.
 p. cm.
 ISBN 978-1-933952-89-5 (pbk.)
 1. Lumix digital camera--Handbooks, manuals, etc. 2. Photography--Digital techniques--Hand-
books, manuals, etc. I. Roullard, Carol F. II. Title.
 TR263.L86M38 2012
 771.3'1--dc23
 2011033244

Distributed by O'Reilly Media
1005 Gravenstein Highway North
Sebastopol, CA 95472

*This book is dedicated to the memory of
Eric Alfred Tieg who passed September 5, 2011.
His spirit and good humor will live on in our memories.
He is sorely missed.*

Getting Started

The Panasonic Lumix DMC-GH2: New Features

The Panasonic Lumix DMC-GH2 is the top model in this company's lineup of mirrorless interchangeable-lens cameras. It is an updated version of the GH1 (now discontinued) and is more advanced than the G3. This is probably the best camera around for taking videos and still photographs.

Its most important improvement is the sensor. First, it is 16 megapixels. The only other Panasonic camera that records at this level is the Panasonic G3. But the GH2's sensor is unique: it is oversized so that when you choose different aspect ratios, the number of pixels can be expanded along its width. When using a 16:9 or 3:2 aspect ratio, it provides more pixels than any other Panasonic camera.

The data output rate has been increased, so a subject's movement within the electronic viewfinder appears smoother and more natural. Also, this faster data stream improves the quality of video recordings.

This new sensor is more sensitive and less noisy, so its base ISO is now 160, instead of 100 as in the older cameras. Previously, when working with the GH1 and the G2, we worked at a maximum ISO of 800; now, with the more advanced sensor, we can work easily at a maximum ISO of 1600. Panasonic allows you set the ISO of this camera up to 12800, in contrast to the GH1's maximum of 3200 and both the G2's and G3's maximum of 6400.

If you want one camera that can do an excellent job for still and video work, this is the camera for you.

Using This Book

The Panasonic GH2 camera works effectively in a beginner's hands as well as those of an experienced camera user. The camera has a diverse range of functionality and controls, enabling people at all levels of photographic experience to obtain great quality photographs. This book contains chapters geared toward various experience levels and your specific needs. Beginners will find helpful information in chapter 4, "Automatic Settings," intermediate photographers can turn to chapter 6, "Taking Control of the Camera," and more advanced photographers will be interested in chapter 7, "Manual Operation of the Camera." Regardless of your skills or level of interest, this camera has it all—or just about all. That is what makes it an exciting camera. But the abundance of commands and controls can also make it potentially confusing. It does not help that many of the settings a user will set for ISO, automatic focusing, and shutter speed can be overridden by the automatic modes.

Each chapter of this book, starting with fully automatic functions, and progressing to semiautomatic and manual features, will describe the camera's capabilities in simple, descriptive terms to help you learn what the camera can do. We will cover video features, managing your still pictures and videos outside of the camera, and

quick tips to help reduce possible errors and improve your use of the camera. In addition, we will try to put it all together for you with some real-life scenarios. This will be especially helpful for novice and intermediate users.

For beginners and those who wish to use the camera immediately, the Panasonic GH2 has an Intelligent Auto (iA) Mode for both still pictures and videos.

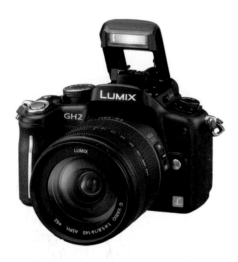

This mode determines the camera settings needed to get quality results. For those coming from the point-and-shoot crowd, this is a great way to start. If you already have the battery and memory card installed, turn on the camera and switch on the Intelligent Auto Mode by moving the mode dial to the bright red iA setting (top of the camera on the right). The iA icon will display in the lower left corner of the display screen. All you need to do is find your subject and press the shutter-release button. It really is that simple.

A helpful progression for learning to use this camera is to take advantage of its most automatic modes, and as you develop your skills, gradually start to adjust the camera yourself. For example, the power of Intelligent Auto Mode is its ability to identify the type of scene you are viewing and provide the best camera settings to capture the image. Unfortunately, scene identification is imperfect, so if the camera's intelligent software fails to correctly identify the type of scene, it uses a generic setting that should still capture a technically good image—just not necessarily the best.

You can help your camera by identifying the subject from a set of predefined scene modes. This requires rotating the mode dial away from iA and matching an icon to the subject you're photographing. This prevents the camera from misidentifying the subject and providing less than optimal camera settings. The predefined scene modes have icons for daytime and evening portraits, as well as scenic, sports events, baby, pet, and close-up photographs. These modes automatically fine-tune the focusing, exposure, and light sensitivity for obtaining the picture.

The Intelligent Auto Mode and predefined scene modes control the camera settings for you and therefore need the least amount of input from you. You will find these modes valuable, and will create better pictures than you would using the Intelligent Auto Mode.

Ultimately, you can take even greater control of the camera by using semi-automatic settings, where the camera adjusts only some of the settings automatically and you select the rest. For the most experienced users, the camera controls can be set manually. This gives users the opportunity to fully exercise their artistic creativity to capture unique images. Using the camera in manual mode enables you to break the rules for creating a unique image. Also, you can be confident when you set the white balance, shutter speed, or aperture that the camera will not override your settings.

To control all these options, the Panasonic GH2 camera has many different menu commands and buttons, which you need to understand and manage. While in the manual mode, you will have to rely on your experience and creativity to get the pictures and videos you want. In this case, all of the camera menu and button controls are at your disposal.

Appendix B of this book covers the Intelligent Auto Mode menu commands. In addition, there is a downloadable GH2 Command List available on the Rocky Nook website that includes all of the camera's menu commands and their submenu commands and available options, along with some useful pointers. This list can be found at http://rockynook.com/panasonicgh2.

There are so many available commands, many of them covering small details about the camera, that it would require a very large book to explain them all in detail, which, quite frankly, would bore many of you. The downloadable GH2 Command List is a great resource for reviewing all of the commands if you want to look for something that might pertain to a specific setting you want to try out.

Setting Up Your New Panasonic GH2 Camera

When you take your camera out of the box, you will have the following components:

- Camera: 16.05 effective megapixel Lumix DMC-GH2
- One of the following two lenses (if you purchased a kit):
 - Lumix G Vario HD 14–140 mm, f/4.0–5.8, with MEGA OIS (optical image stabilization); part of the GH2H camera kit
 - Lumix G Vario 14–42 mm, f/3.5–5.6, with MEGA OIS (optical image stabilization); part of the GH2HK camera kit
- Supplied with purchased lens:
 - Lens caps (front and rear)
 - Lens hood
 - Lens storage bag
- Battery: DMW-BLC12E lithium ion
- Battery charger/AC adapter
- Shoulder/neck strap

- Stylus pen
- Battery case
- USB cable
- Body cap
- AV cable
- CD-ROM featuring PHOTOfunSTUDIO 6.0 BD Edition and SILKYPIX Developer Studio
- Camera manual in the language of the marketing location from which your camera was purchased

Take an inventory to ensure you have a complete kit before starting to assemble your new camera. Your camera is very easy to set up: charge your battery fully, attach the lens, and insert a memory card to store your pictures and videos. When you are done, you're ready to start.

Battery

The supplied lithium ion battery is delivered partially charged and should be charged to full capacity before using. You should never let the camera's battery drain completely since this may damage the battery. Use Panasonic-certified batteries only. Noncertified batteries can ruin your camera and void its warranty. If you are unsure if your battery is certified, check with the Panasonic website or contact Panasonic technical support.

Why Not Use a Non-Panasonic-Authorized Battery?

Counterfeit batteries are not made under the same guidelines and regulations as Panasonic-certified batteries. In fact, Panasonic programmed the camera's software to detect unauthorized batteries and, if detected, refuse to start the camera. Using a counterfeit battery can cause degradation or, worse, damage to your electronic devices. Using unauthorized equipment will nullify your camera's warranty.

The battery charger is supplied with your camera. Unfold the prongs from the charger and plug it into an electrical socket. Insert the battery with the printed side out, pointing away from the plug. The charge indicator light will glow when charging and will extinguish when the battery is fully charged. If the charger's light starts flashing, there was a problem, such as a defective battery. Panasonic estimates it will take 155 minutes to fully charge a depleted battery. Future charges will take less time, depending on how much residual charge remains in the battery when the recharge process is started.

Memory Card

Usually, whether you order the camera online or buy it in a store, you will be reminded that the camera needs a memory card, making it a perfect time to buy one. This is good advice since the camera will not operate without one!

You may already have a compatible memory card from a previous camera. You can use an older camera's memory card for your new Panasonic GH2 camera if it is an SD, SDHC, or SDXC card. If not, you will have to purchase one. But what should you buy?

The camera uses a Secure Digital (SD) memory card. These postage stamp sized cards come in many varieties, with different memory capacities and different data transfer speeds. Your camera can read SD, SDHC, or SDXC cards. These designations refer to the card's maximum memory capacity. Don't be too concerned about these designations. It is more important to know the memory capacity of the card (see the Memory Card box). At the time this book was written, Panasonic sold an SDXC Class 6 card that holds 64 gigabytes (GB) of data for about $450. But you can opt for a 16 GB card (about $80) or an 8 GB card (about $40) instead.

If you wish to record videos, you need to check the card's speed rating. Cards are categorized according to classes. The higher the Class rating, the faster it can receive and send data. The Panasonic cards rated as Class 6 or higher can be used with any of the camera's recording modes. You can use a Panasonic Class 4 16 GB card (about $50) if you use the highly compressed Advanced Video Coding High Definition (AVCHD) movie mode. You will need a faster card, Class 6, when using the less compressed Motion JPEG movie format.

What size memory card you buy depends on how you will use the camera and maintain the stored pictures and videos. If you plan to take a lot of videos, you will need a large amount of memory, at least 8 GB. If you are going to take mainly still photos, 4 GB should suffice. The amount of memory you need also depends on how often you download the stored pictures and videos to your computer, thereby freeing up the memory to record more.

If you tend to leave your pictures and videos on the memory card, you will need a larger card. We recommend you get in the habit of transferring your images from your camera to your computer at the end of each shooting day. This will allow you to start fresh the next day with a blank memory card. It will also allow you to consider a smaller memory card, thus saving money. Many people keep an additional memory card for those occasions when they will be doing a lot of recording and will not be able to download the contents to a computer.

> ## Memory Card
>
> The camera's user manual tells you how many pictures or videos can be stored on the memory card. But these values are approximations since several criteria go into determining how much space a file will occupy. The space used depends on the number of pictures and the length of each video, and their file type (JPEG and/or RAW), aspect ratio, and compression.
>
> Memory card criteria:
> * SD memory card (8 MB to 2 GB)
> * SDHC memory card (4 GB to 32 GB)
> * SDXC memory card (48 GB to 64 GB)
>
> Additional information:
> * An SDHC memory card can be used with equipment that's compatible with SDHC or SDXC memory cards.
> * An SDXC memory card can be used only with equipment that's compatible with SDXC memory cards.
> * Check the Panasonic website to see if your computer and other equipment are compatible when using the SDXC memory cards:
> http://panasonic.net/avc/sdcard/information/SDXC.html

After you have everything, you are ready to insert the battery and memory card. Invert the camera body, and on the right side of the bottom of the camera you will see a switch with LOCK and OPEN. Slide the switch toward OPEN and the door will pop open. The battery has a printed arrow indicating the side that slides into the compartment. You will hear a solid click when you insert the battery. The battery fits only one way—if you do not hear a click, then its contacts have not connected to the camera. Turn the battery around and reinsert it. To remove the battery, push the small lever at the base of the chamber opening. The battery will pop up for easy removal.

The memory card compartment is on the side of the camera above where the battery is stored. Slide the compartment door toward the back of the camera to cause the compartment door to spring open. The memory card slides in with the end that has the metallic reading bars going in first. You can remove the memory card using a simple push and release mechanism. Push the memory card in a bit and it will pop out for easy removal. If the memory card is not properly inserted in the camera, a NO MEMORY CARD error message is displayed on the LCD screen. If this occurs, remove the memory card and reinsert it. The message should go away. If it doesn't, the card may be defective and it will have to be replaced. Check appendix A, "Common Error Messages and Resolutions," for more information. To

close the memory compartment door, reverse the process and slide the card door back into place.

Next, attach the lens to the camera body. Remove both the rear lens cap and the camera body cap by turning the caps counter clockwise. Store both caps in a safe place for future use. There is a red bump at the base of the lens and a red dot on the camera body where the lens should be attached. Insert the lens into the camera body so the two red marks match up. Turn the lens clockwise to seat it properly. Make sure you do not have the lens at an angle because it will not seat properly. There will be a distinctive click when the lens is properly mounted.

If the lens is not seated properly, an error message will display on the LCD screen when you turn the camera on informing you that there is a problem detecting the lens. Usually this means the lens had not been rotated fully clockwise. If the problem persists, check out appendix A.

Last but not least, attach the camera shoulder/neck strap. The strap should always be secured to the camera and placed either around your neck or over your shoulder when you're carrying or using the camera.

Protecting the Lens

There are several precautions you can take to protect your camera's lens against damage. The first and most obvious is to keep the lens cap on when not using your camera. This has two benefits: first, the camera lens is protected from being scratched in your camera bag while being jostled in a car or carried on your back; second, you will always know where the cap is. We keep the cap on in situations where we can run into objects, such as rocky outcroppings and branches, and even on the beach.

In addition, put the lens hood on. This will help keep errant branches and rocky outcroppings from easily hitting the lens. Keep in mind that this will also help to increase contrast by blocking light coming from the side of the lens and entering the camera.

The third way to protect your camera's lens is to use an ultraviolet (UV) filter. These filters are sized and threaded and can be screwed onto the lens, serving as a clear optical lens cap. Panasonic sells these filters, but if you know the thread diameter of the lens, you can buy them from other retailers.

Using a UV filter as a lens protector is controversial. There are some who claim it is a good idea. There are others who claim that the protection is minimal and the filter degrades the image. We found that inexpensive, nonbrand-name UV filters are more likely to cause image degradation. Be sure to buy a quality filter made by a reputable manufacturer. Tiffen, Hoya, or B+W UV filters are good and will not degrade the lens performance.

Viewing Menu Commands

You are ready to turn on your camera. The ON/OFF switch is on the top right side of the camera (figure 1-1). Switch the lever to ON. Next to the word "ON," a small green light will glow. This light goes off when the camera is turned off or if it goes to sleep to conserve battery power. If this happens, a light press on the shutter-release button (big silver button) will wake up the camera.

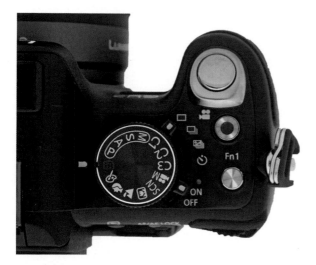

Figure 1-1: The mode dial on top of the camera

The first time you turn on your new camera, you will be asked if you want to set the camera's internal clock. This information is recorded with each picture and video. But before we cover setting the camera's clock information, let's first examine how to navigate through and set values for the camera's extensive menu commands.

The Panasonic GH2 camera has two methods to view the menu options. You can use either the LCD screen (Panasonic refers to this as an LCD monitor) in the center of the camera back or the electronic viewfinder (Panasonic refers to this as Viewfinder and sometimes Live View) at the top of the camera back. Although you can use the viewfinder to navigate through the menu structure, most people find using the LCD screen to be more convenient, and therefore we will describe menu navigation from the LCD screen perspective.

Menu Commands

You view and set menu commands by pressing the MENU/SET button that is surrounded by four directional arrow buttons (on the right side on the camera back; figure 1-2). Which main menu options display is dependent on the mode the camera is in. There is a core set of main menu options. Although the displayed

menu screen structure and associated commands vary depending on your selected mode, how you navigate through the menu structure is the same.

Press the MENU/SET button. You will see a screen with the main menu options displayed as icons in a vertical bar on the left side of the screen. To the right of the vertical bar of icons, you'll see the first page of the selected main menu option's available commands. The top row of the screen shows the name of the icon selected and a series of numbers that should be viewed as page numbers within the icon's list of commands. Considering that there can be up to seven pages, and each page can list up to five options, you can spend considerable time navigating through the menus.

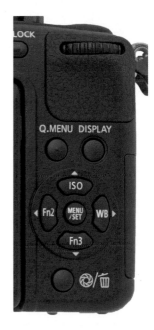

Figure 1-3a shows the main menu with the core set of options. Starting at the top they are REC, MOTION PICTURE, CUSTOM, SETUP, MY MENU, and PLAYBACK. Note that the selected option in the left column is displayed in color.

The main menu options for the Intelligent Auto Mode and the predefined scene camera modes (covered in detail in chapter 4) are variations of the core options. When the camera is in Intelligent Auto Mode, the REC main menu option is replaced with

Figure 1-2: The MENU/SET button surrounded by four directional arrow buttons

an iA icon and INTELLIGENT AUTO in the menu title (figure 1-3b). In addition, the MY MENU option is not available. The predefined scene modes have an additional main menu option displayed at the top of the main menu list (figure 1-3c). This additional option allows the user to select a scene option with predefined camera setting values.

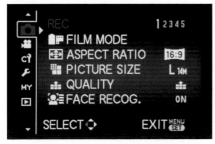

Figure 1-3a: The core main menu options displayed in the vertical left-hand bar

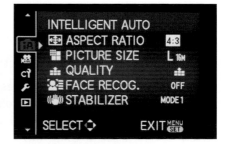

Figure 1-3b: Main menu options in Intelligent Auto Mode

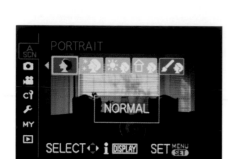

Figure 1-3c: Main menu options of the Portrait predefined scene mode

Each main menu option has a set of command options, which are displayed to the right of the left-hand vertical bar. These commands can have values or submenu commands of their own, each with values to choose from.

Up to five commands can be listed on the screen at one time. Except when in Intelligent Auto Mode, each main menu option requires multiple pages to view all of its available commands. As mentioned earlier, the menu option page numbers are displayed in the top right corner of the screen as a series of numbers. As you scroll through the menu command options, moving from page to page, the current page number becomes enlarged and highlighted.

We will refer to different Panasonic GH2 camera commands throughout this book. To help you quickly locate them within the menu structure, we will refer to the commands using the following notation:

MENU/SET>main menu name>(*pg* submenu page #) submenu command name>[value1], [value2]

The ">" symbol separates menus and submenus, and "*pg*" refers to the page on which the submenu is found. No page number will be included for the commands displayed on page 1. If the submenus have subordinate commands, we will list them separated by > until we have reached the command we are discussing. We will include command values in brackets when they pertain to the subject being covered. We will list the page number so you can rapidly move through the menu commands to the page that you need.

For example, we will identify the AUTO BRACKET command location as follows:

MENU/SET>REC>(*pg* 4) AUTO BRACKET

Figure 1-4(a-c) shows the following series of screen shots (from left to right): main menu with AUTO BRACKET command highlighted (figure 1-4a); the AUTO BRACKET command's SEQUENCE option selected (figure 1-4b); the SEQUENCE command's option [0/–/+] selected. Using this book's defined menu nomenclature, the SEQUENCE command and its available options is displayed as:

MENU/SET>REC>(*pg* 4) AUTO BRACKET>SEQUENCE>[0/–/+], [–/0/+]

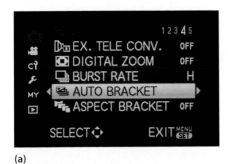

(a)

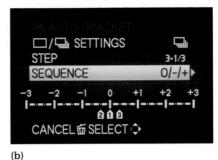

(b)

(c)

Figure 1-4(a-c): Main menu flow to the AUTO BRACKET command

When the MENU/SET button is pressed, based on the mode dial setting, the menu will display where it was last saved, with the selected command highlighted in a yellow square. If the menu was last positioned on the main menu list, the selected main menu vertical bar will have three yellow arrows: one at the top, one at the bottom, and one to the right of the selected option. If the menu was last positioned on a specific command, there will be two yellow arrows: one at either end of the command. These yellow arrows indicate which directional arrow buttons are available to move through the menu structure from the given point (figure 1-4a). Moving to the right will take you deeper into the menu command structure to view the command's additional submenus (figure 1-4b) or available settings (figure 1-4c).

Some menu commands have values that are represented by icons rather than words. In these cases, we will write the values in italics. For example, the LVF DISP. STYLE command has two values represented by icons. The menu path will be presented as follows:

MENU/SET>CUSTOM>*(pg 4)* LVF DISP.STYLE>*[Viewfinder Style]*, *[LCD Monitor Style]*

In a couple of places we include nonspecific menu options in the menu paths. These will also be represented in italics.

Menu Navigation Tip

Wherever you are within the menu structure, the top line contains the name of the menu command you came from when entering the currently displayed submenu or specific command. Using the AUTO BRACKET example, the first displayed menu screen will have REC on the top line. When you get to page 4 of REC and select AUTO BRACKET, AUTO BRACKET is displayed on the top line (figure 1-4b).

Menu Navigation

The camera gives you many ways to navigate through available menus and select command values. You can use either the directional arrow buttons or the rear dial, and monitor the navigation on either the LCD screen or the electronic viewfinder. Play with these options so you are comfortable maneuvering through the list of menu commands and their values.

Using the Directional Arrows

Navigating through the camera's extensive set of menu commands is easy using the up, down, right, and left directional arrow buttons on the back of the camera. The center MENU/SET button functions as an enter key so you can select the yellow highlighted command or value.

When you have highlighted a menu command, pressing the right or left directional arrow button will move the cursor in or out of the selected menu or command and its respective list of commands or values. Using the up or down directional arrow button will move the cursor to scroll up or down through menu commands or a specific command's list of available values. The item highlighted in yellow marks the cursor's position. Use the MENU/SET button to choose the value for the selected menu option.

Using the Rear Dial

In addition to using the directional arrow buttons, you can use the rear dial to navigate through the menu commands and their associated values. The rear dial works by rotating left or right, which moves the selection cursor vertically up or down through the list of menu commands. The commands are highlighted in yellow, just as they are when you use the directional arrow buttons.

When you want to move from the list of main menu options into its list of available commands, press the rear dial to select the menu option, and the cursor position will move to the first command displayed in the submenu list. Again, rotate the rear dial right or left to move through the list of submenu commands.

When you want to view the available values of the highlighted menu command, press the rear dial again, and the submenu values will appear. Rotate the rear dial to move through the available values. Press the rear dial to select the value you want. The selected value will be displayed next to the submenu command, and the list of available values will disappear.

We use the rear dial when moving through a long list of commands that spans several pages; it is more convenient than pressing the directional arrow buttons. The only disadvantage is that it does not allow you to move out of the list of commands and back to the list of main menu options. For that you would need to use the left directional arrow button.

Recommendation for Menu Navigation

Spend some time exploring the available main menu options for each of the mode dial options so you can see the differences and similarities. Use both the directional arrow buttons and the rear dial to navigate through the menus, the commands, and their available values. Experiment moving in and out of commands and scrolling from page to page. Doing so early in learning how to use your camera will enable you to find a navigation style best suited to you.

Touch Screen

The Panasonic GH2 camera continues the Panasonic tradition of using a touch screen. You might think using the touch screen capability is not much of an advantage, but most likely you will come to the same conclusion as we did—this feature is a major advantage when focusing your camera when it's on a tripod, taking a picture, activating a video, zooming in and out of an image, and reviewing saved pictures and videos.

Other Touch Screen Operations

There are several other camera functions where you may find the LCD touch screen capabilities advantageous. Use the LCD touch screen to identify the subject you wish to track when the auto focus mode dial is set to AF Tracking. You can reposition the histogram and the crosshair guide lines using the touch screen. You can also display the Quick Menu (chapter 5) using the touch screen option.

One of the most frequently used operations is to play back your pictures by sweeping your finger across the screen or tapping to zoom in to better view the picture's detail. We will address using the LCD touch screen in more detail when we cover these camera functions later in the book. As with many things, experiment with the LCD touch screen. We are sure you'll find that many functions are easier to use this way.

Information and Error Messages

The Panasonic GH2 camera helps you with a large number of descriptive information and error messages to guide you through setting up and using the camera. See appendix A for a compiled list of common error messages and resolutions in alphabetical order.

Important RESET Command

Nothing is perfect. With that said, Panasonic has thought of just about everything, including a command to reset the camera's command settings back to its defaults. As you use the camera, you will be setting, changing, and resetting the camera command options frequently, and at times the camera may get confused. Panasonic has added a RESET command in the SETUP menu so you can restore the default menu options and, in essence, start over:

MENU/SET>SETUP>(*pg* 5) RESET

This command has two options:
- Reset only the REC menu and FACE RECOG. command settings.
- Reset the SETUP and CUSTOM menu command settings.

There are drawbacks to doing a reset. Resetting the REC menu and FACE RECOG. commands deletes the saved registered face recognition data. If you have registered specific people's names and birth dates with their faces, this information will be deleted. Executing the SETUP and CUSTOM menu commands reset will erase saved World Time and Travel Date information, along with Baby1, Baby2, and Pet names, as well as their associated birthday and age information. However, if your camera commands stop working as described in the manual, you might need to execute the RESET command.

Cleaning the Sensor

Each time you turn on the camera, it automatically cleans the sensor. There may be times when you feel an extra cleaning is needed without turning the camera off and back on. You can use the following command to clean the sensor:

MENU/SET>CUSTOM>(*pg* 7) SENSOR CLEANING

The camera will walk you through the execution of the command. After the sensor is cleaned, two messages will display: first SENSOR CLEAN and then PROCESS FINISHED.

Note: Although the Panasonic GH2 manual states the camera's sensor is cleaned by "blow[ing] off the debris and dust," most likely this is actually done by vibrating the sensor at 50,000 times per second. Regardless of how it actually occurs, use the SENSOR CLEANING command if you think an additional cleaning is required.

Setting the Clock Date and Time

When you turn your camera on the first time, the PLEASE SET THE CLOCK message is displayed. The date and time stamp is a great way to keep track of when a picture or video was taken, plus there are several camera functions that use this date and time stamp to your advantage. You can always set it later, but it is easiest to do when the message is displayed.

Setting the date and time is easy. Use the right and left directional arrow buttons or turn the rear dial to move through the options. The up and down yellow arrows surrounding the highlighted option represent the active directional arrow buttons. To make your selection, use the directional arrow buttons to move through the available values.

If you decide to set the date and time later, you can do so from the SETUP menu. Select the MENU/SET>SETUP>CLOCK SET option and push the right directional arrow button to advance into the menu's values. Enter the current date and time, and press the MENU/SET button to accept (figure 1-5).

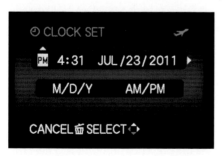

Figure 1-5: CLOCK SET display screen with the clock's date and time set

In addition to the clock date and time, you should set the Home settings in the WORLD TIME command:

MENU/SET>SETUP>WORLD TIME>[HOME], [DESTINATION]

The [HOME] option allows you to identify your time zone and whether daylight saving time applies. The same information can be set for travel destinations using the [DESTINATION] value. When you travel to another time zone, you can set the

destination settings within World Time and the travel start and end dates within the Travel Date option:

MENU/SET>SETUP>TRAVEL DATE

This way, the camera's clock date and time will be set to your destination during the specified travel dates.

Daylight Saving Time

Many areas within the United States observe daylight saving time. In the spring and fall, the time is set forward or backward one hour, respectively. Every year a big effort ensues to remind people of the time change and which way to set their clocks. The camera's World Time option allows you to specify if you reside in or will be traveling to a location that observes daylight saving time. If so, the camera will take this into account when calculating the current time. This way, you won't have to remember to change the camera's clock. It will be done automatically for you.

The Dual Viewing System of the Panasonic

The Panasonic GH2 cameras are unique in that they have two electronic displays: an electronic viewfinder that has an eyepiece and the LCD screen on the back of the camera. Most digital camera users are familiar with the latter. Unlike early versions of electronic viewfinders that appeared in Minolta, Sony, and Olympus digital cameras, Panasonic's electronic viewfinder is very sharp and has a good refresh rate. It enables you to use the camera at eye level, and it functions as a replacement to the optical viewfinder familiar to users of digital single-lens reflex (DSLR) cameras. Unlike DSLRs, you can use this viewfinder to frame and compose your video while the camera is recording.

Both the viewfinder and the LCD screen will work, but only one at a time. The viewfinder is enabled when the camera senses the presence of something near the viewfinder window. When something is detected, the camera assumes it is your eye and activates the viewfinder while deactivating the LCD screen. When you move your head away, the LCD screen will turn back on and the viewfinder turns off. This thoughtful feature preserves battery life.

As with everything in life, there are both drawbacks and advantages to each of the viewing displays. The Panasonic GH2 camera has some different settings for controlling what you see in the viewfinder or on the LCD screen. As you use the camera and become familiar with its settings and buttons, over time you will

develop personal choices as to which method works best for you. We will cover details about the LCD screen and the viewfinder and how to display information on them in chapter 3.

Diopter Adjustment Dial

There is one more thing you need to know about the viewfinder. It has a magnifier that should be adjusted to the user's eye. There is a small wheel to the left of the eyepiece called the diopter adjustment dial (figure 1-6). Rotate the wheel back and forth until the objects in the viewfinder are maximally sharp. Of course, if you share your camera with others, your setting may not be perfect

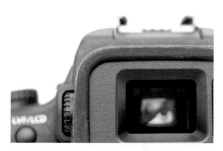

Figure 1-6: The diopter adjustment dial to the left of the viewfinder

for them. If your family and friends need to change the setting, you will have to readjust it for yourself when you take the camera back.

Recommendations

We recommend you use only Panasonic-certified batteries and appropriate memory cards to ensure quality and equipment functionality. We also recommend you have a spare battery and memory card at your disposal to prevent situations when you want to take a picture but are unable to because of a drained battery or full memory card.

It is best to set the camera's clock when you first turn on the camera. This way your future recordings will contain the date and time stamp.

As you might have already noticed, the Panasonic GH2 camera is very complex. There are well over 100 different commands and subcommands, and multiple buttons, levers, and dials. Many of the components will function differently depending on other settings. Basically there is a lot to learn. As you progress through this book, we recommend you take time to explore each of the discussed camera components before you start to seriously use them when taking pictures and videos. Many of the functions have multiple ways to execute them. Through your exploration, you will develop your own personal style of using the camera— one that will help you capture the results you want with ease and panache.

Basic Photographic Ideas and External Buttons

2

Introduction

The Panasonic GH2 camera comes with a 200-plus page manual that lists scores of menu commands and options. This can intimidate the most experienced user, let alone a person attempting to move beyond a simple point-and-shoot camera. But do not be discouraged; these commands provide an extensive mix of automation versus manual control. Some of the automatic features will, in fact, override your manual settings. The most important of these commands boil down to providing enough light to the sensor for proper exposure, focusing on the correct region of the scene for a sharp image, and controlling the shutter speed so the image is not blurred. All of the commands provide an ability to selectively apply manual control. Some of the automatic modes, especially the iA setting, will override the values you select for manual operation. But, significantly, even in the most automated mode, you can use the rear dial to override the automatic exposure setting and provide either more or less light to the sensor.

This chapter will describe the photographic basics of exposure, depth of field, shutter speed, and sensor sensitivity, as well as the camera controls that affect these four items. In essence, our goal is to provide an intuitive rather than a scientific grasp of how changing the camera's controls can help improve your pictures and videos.

A photograph is a two-dimensional rendering of a three-dimensional subject. The camera's light detector, called a sensor, is flat, and a lens projects light from the subject onto the sensor. If the distance from the lens to the sensor is not adjusted precisely, the subject will be blurred, causing a loss of definition. Further, only a scene in a specific plane that is parallel to the sensor is rendered at maximum sharpness—in other words, the subject is in focus only if it occupies this plane. Objects in front of or behind this plane are less sharp, a progression that increases until the most distant planes appear as a complete blur. This is unlike our vision, where the eye and brain interpret the entire view as being well defined. In contrast, the camera and the photographer must decide how to record the single maximum plane of sharpness so the photograph most closely mimics the automatic control of the human eye.

The sensor can record only a defined amount of light—too little and you record a dark frame with no details in the image, too much and your image is brilliant white and the details are washed out. If you provide the correct amount of light, the sensor records an image rich in details.

2

What Are Sensors and Images?

Digital cameras use a solid-state device composed of millions of individual photo sites for converting light into an electrical signal. The individual photo site is the physical basis of a pixel, the smallest unit for sensing light. In the GH2, there are more than 16 million pixels in a 4608 × 3456 rectangular array. Signals from these sensors are transmitted to the camera's viewing screen. Altogether, they will make up a mosaic of intensities and colors that will become an image. The viewed image is a numerical expression, which can be manipulated mathematically so that the camera's computer can alter its appearance. Recording the picture requires that these values be stored on a memory card from which they will eventually be downloaded to a computer.

Three things control exposure. The first is the lens aperture. This regulates how much light enters the camera body. The second is the shutter speed. This regulates how long the sensor is receptive to light. A short shutter speed of 1/1000 second will provide less light to the sensor than a long shutter speed of 1 second. The final control is ISO, which is essentially an electrical adjustment to increase the sensor's signal. Think of it as a sensitivity control—the higher the ISO, the more sensitive the sensor is to light.

To properly record a subject requires two things: its image must be focused onto a sensor and the intensity of light collected must lie within a prescribed range. Scientifically, one can define and describe how to set the camera. Photographically, this is not so easy because many of the controls allow us to record the image at settings that are not optimal for sharpness or exposure but which will, nonetheless, render an artistically satisfactory image. For example, although focus is maximally sharp at only one distance from the camera, by closing down the lens aperture you can create an acceptably sharp image in front of and behind this distance. This is depth of field, and it is invaluable for rendering close and distant subjects acceptably sharp. However, closing down the aperture can introduce optical artifacts that reduce definition.

Artistically, there are scenes where increasing the depth of field outweighs the loss of ultimate sharpness. Of course, increasing the depth of field by closing down the lens aperture will significantly reduce the amount of light that reaches the sensor. To compensate for this, an experienced photographer either increases the amount of light illuminating the subject or uses a slower shutter speed to provide more light to the sensor. When using an automatic exposure, the camera will adjust to a slower shutter speed in response closing down the aperture.

File Formats

When you push the shutter-release button to take a picture or initiate the recording of a video, the digital camera will capture the image or video and store it on the memory card. You will eventually need to transfer these saved files to your computer. The file format (type) of the saved image or video will help determine what you can do with it after you transfer the file to another medium.

There are two different file types you can choose for your pictures: JPEG and RAW. Which one you select depends on what you are going to do with your pictures after they have been saved.

JPEG and RAW Definitions

A **JPEG** image file has been compressed using a method developed by the Joint Photographic Experts Group. There is some loss of information from the image file that cannot be restored. The file name has the extension .jpg (commonly used on Windows computers) or .jpeg (commonly used on Macintosh computers).

A **RAW** file comes from a digital camera and is minimally processed so it has all the data captured by the imaging sensor. A Panasonic GH2 RAW file has the file name extension .rw2.

When you start using your Panasonic camera, you will find that JPEG is the default file type. The JPEG file format has the advantage of being readable and usable by almost any computing device. For example, you can view these files on your cell phone and send them as e-mail attachments, and viewing them on your personal computer is usually a simple matter of pointing your mouse cursor on the file name and clicking.

In contrast, the RAW format is more cumbersome and requires more storage space on the recording medium. It is a proprietary format specific to the camera manufacturer and usually requires special software to open. But this is the file that the majority of users process when working with programs such as Photoshop.

These inconveniences are accepted because the RAW format minimally processes the data from the camera (hence the name RAW) and gives knowledgeable users greater flexibility in processing their images on their computers. There are many software packages available that will allow you to enhance, clean up, change, and sharpen your saved images. These programs work better when the image has been saved in RAW format because there is much more data available to work with than in JPEG format.

So what to use? Well, the simplest answer is to use both. The Panasonic GH2 allows you to save your image in both RAW and JPEG format (table 2-1). This gives you the best of both worlds: the convenience of using an accessible, small JPEG file

2

and the capability of full image processing potential by using the RAW file format. To set the camera to store an image in both JPEG and RAW, press the MENU/SET button and then proceed as follows:

If you are in Intelligent Auto Mode:

MENU/SET>INTELLIGENT AUTO>QUALITY>*select one of the menu command options*

If you are not in Intelligent Auto Mode:

MENU/SET>REC>QUALITY>*select one of the menu command options*

QUALITY Option	QUALITY Description
⬛⬛⬛	JPEG Fine: Image is stored in JPEG format only. A high level of detail is captured.
⬛⬛⬛	JPEG Standard: Image is stored in JPEG format. A lower level of detail is captured because of increased file compression.
RAW⬛⬛⬛	RAW + JPEG Fine: Two images are stored, one in RAW and one in JPEG Fine with a high level of detail captured.
RAW⬛⬛⬛	RAW + JPEG Standard: Two images are stored, one in RAW and one in JPEG Standard where JPEG Standard has a lower level of detail captured because of increased file compression
RAW	RAW Only: Image is stored in RAW format.
3D Interchangeable Lens Attached	
3D ⬛⬛⬛	MPO + JPEG Fine: Two images are stored, one in MPO and one in JPEG Fine.
3D ⬛⬛⬛	MPO + JPEG Standard: Two images are stored, one in MPO and one in JPEG Standard.

Table 2-1: Available QUALITY command options

Storing your images as both JPEG and RAW files will be done at the expense of memory card space; for a given amount of memory, you will store about 25 percent fewer images than if you stored only RAW images. If you store just JPEG images, the difference is striking. By avoiding the RAW file format, you can take almost 10 times more pictures. However, this is a minor disadvantage considering the low cost of memory. So you must balance this with the impracticality of handling this many pictures in a shooting session. If you make a practice of downloading your pictures at the end of the day, around 400 pictures will most likely be adequate. If you don't download at the end of each day, you can always carry more than one memory card and replace the card as the need arises.

REC MODE Option	REC MODE Description	REC QUALITY Option	REC QUALITY Description (Used in all video modes except 24P and Variable Movie)
AVCHD(1080i)	Best REC MODE for playing video on a TV in full HD	FSH	High quality. High megabits per second recorded. 1920 × 1080 pixels (approx. 17 Mbps).
		FH	Medium quality. Medium megabits per second recorded. 1920 × 1080 pixels (approx. 13 Mbps).
AVCHD(720p)	Best REC MODE for playing video on a TV in HD. Compatible with Lumix AVCHD Lite.	SH	High quality. High megabits per second recorded. 1280 × 720 pixels (approx. 17 Mbps).
		H	Medium quality. Medium megabits per second recorded. 1280 × 720 pixels (approx. 13 Mbps).
MOTION JPEG	Best REC MODE for sending videos via email and playing videos on a PC	HD	High Definition format. 1280 × 720 pixels (30 frames/second).
		WVGA	WBGA format. 848 × 480 pixels (30 frames/second).
		VGA	VGA format. 640 × 480 pixels (30 frames/second).
		QVGA	QVGA format. 320 × 240 pixels (30 frames/second).
Creative Motion Picture Mode on the Mode Dial			
Creative Movie Option	Creative Movie Description	REC QUALITY Option	REC QUALITY Description
24P Cinema in Motion Picture Mode	Record videos with afterimages like a cinema	24H	1920 × 1080 pixels (24p frames/second, approx. 24 Mbps)
		24L	1920 × 1080 pixels (24p frames/second, approx. 17 Mbps)
Variable Movie Mode in Motion Picture Mode	Record videos in slow or fast motion	24H	1920 × 1080 pixels (24p frames/second, approx. 24 Mbps)
		24L	1920 × 1080 pixels (24p frames/second, approx. 17 Mbps)

Table 2-2: The relationships among MOTION PICTURE, REC MODE, and REC QUALITY commands

There are two different methods for initiating a video: using the red Motion Picture button and using the Creative Motion Picture Mode on the mode dial. Each method results in different file format options (table 2-2). Basically, you will have variations

2

of AVCHD and Motion JPEG file formats to choose from. The recording quality level within the file type further defines your choice. This involves a combination of the following commands:

MENU/SET>MOTION PICTURE>REC MODE
MENU/SET>MOTION PICTURE>REC QUALITY

Keep in mind that video files can be massive. One of the distinctions of these files is the extent to which they have been compressed and the ease with which they can be edited on your computer. The AVCHD formats are used if you intend to play back your video on your high-definition TV. Motion JPEG creates a larger file, but one advantage is that it can easily be edited on a home computer. You can use Quick-Time, for example, to download and play back your video. As a file, it is easier to manipulate on the computer and does not require a CPU as powerful as is needed for an AVCHD file.

Shutter-Release Button

The shutter-release button is found on the camera's top right panel. This is the control you will use most frequently. When you press the shutter-release button halfway down, you will feel an increase in resistance. Even though the camera has not fired, you can stop there and hold this position; this resistance is a control point. It initiates many of the camera's settings. For example, fully implementing focus may take a brief moment, especially in very low light conditions. Pressing the shutter-release button halfway will allow the camera to determine if it can obtain focus. If so, the camera displays a green circle on the display screen. When the camera is focused, the lens is locked, and as long as you maintain pressure on the shutter-release button you can shift the camera to another scene while maintaining the original focus setting. To take the picture, continue pressing the shutter-release button down fully.

If you jam the button down, the camera will not fire. The default setting for this camera is to lock up until focus is established. Slowly pressing the shutter-release button is essential in using this camera properly. Not only can you hold it steadier when this is done, but it enables you to make sure all the settings are appropriate for taking the picture.

Focusing

Lenses for the Panasonic GH2 can be focused manually or automatically. For manual focusing, the photographer turns the lens-focusing ring while looking through the viewfinder or at the LCD screen until the image is sharp. In automatic focusing, you

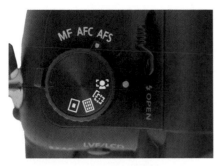

Figure 2-1: Auto focus mode dial

have to tell the camera what to focus on. For the Panasonic GH2 there are four different settings for automatic focus: 1-area-focusing, 23-area-focusing, AF Tracking, and Face Detection. These automatic focusing options reside on the auto focus mode dial on the top-left side of the camera (figure 2-1, table 2-3).

Auto Focus Mode	Auto Focus Mode Dial Icon	Display Screen Icon
Face Detection		
AF Tracking		
23-area-focusing		
1-area-focusing		

Table 2-3: Auto Focus (AF) Mode icons

Focus Mode: Identifying the Region to Focus On

The Panasonic GH2 camera uses contrast detection to find focus. Basically, it measures the range of intensities as the camera lens is moved in and out of focus. When the range of intensities is at a maximum, focus is obtained. So the first thing the photographer does when using the camera is identify what they want to record as being sharp.

For example, your friends are standing in front of a range of majestic mountains— do you focus on your friends and render the mountains a blur, or do you focus on the mountains and render your friends as a blur? For most of us, the decision is easy—we focus on our friends. Unfortunately, our camera has no friends, and it will not be able to distinguish between people and mountains. A solution to this dilemma is to have the photographer tell the camera what is important. Typically, the camera provides a targeting sight within its display, and you aim it at the subject of interest. Press the shutter-release button halfway, and the object within the target becomes sharply focused. For an automatic camera, this is reliable and provides the user with maximum control. Another strategy is to use the Panasonic GH2's automatic features. The camera can be set to identify and focus on faces (Face Detection), thereby rendering people sharply. However, this feature is not foolproof and can fail to identify countenances.

If the camera cannot focus, the photographer can remedy it in several ways. First, failure to focus can be due to a lack of intensity information. If the targeting sight is aimed at your friend's white shirt, it cannot find the point of maximum intensity variation. So you aim at another structure that has a lot of tonality, such as the person's eyes, and use them as the focus point. To use this targeting trick, set the camera's auto focus mode dial to the 1-area-focusing icon.

Auto Focus Mode Dial

When you look down on the top of the camera you will find the auto focus mode dial, which has four icons: 1-area-focusing, 23-area-focusing, Face Detection, and AF Tracking. Use this dial to set the areas to be focused on. The white dot on the camera body, to the right of the dial, is the selection indicator. However, your selection can be overridden when you use the camera in one of its automated modes. In addition, when using the A, P, S, and M Modes, the only setting that will not be overridden is 1-area-focusing. For example, suppose you set the camera to Face Detection, and even though there are people in the scene, the camera does not find a face to focus on. It will automatically switch the focusing mode to 23-area-focusing and try to focus on something in the scene. If that fails to work, the camera goes to 1-area-focusing.

1-Area-Focusing

Rotate the auto focus mode dial to 1-area-focusing by matching up its icon against the white dot on the camera body. The 1-area-focusing icon consists of a small rectangle within a rectangular border. When it is selected, a rectangle of white brackets is superimposed on the displayed image. This is the targeting sight, and it identifies the object that will be used for focusing.

Normally it will be in the center of the screen, but it can be positioned anywhere on the screen. Moreover, the size of the targeting sight can be changed. These points will be covered later in chapter 6.

For now it is important to realize that the targeting sight establishes a single point for focusing. A particularly convenient method of positioning the sight is to use the touch screen. By simply touching the rear LCD screen, you will position the sight under your finger.

To be guaranteed of getting 1-area-focusing mode, you will have to use the camera in a semiautomatic or fully manual mode. If you use iA or an advanced scene mode that uses facial detection, the camera will override the setting on the auto focus mode dial.

23-Area-Focusing

The 1-area-focusing setting is the most accurate way to implement automatic focusing, but it can slow your picture taking because you have to aim the targeting sight onto the subject. When you're feeling rushed, it may be desirable to use a shotgun approach and have the camera guess what parts of the framed image it should use for good focus.

This is accomplished by using what Panasonic defines as 23-area-focusing, where up to 23 regions may serve as focus points, freeing you from having to select and then aim your targeting sight. When focus is achieved, the camera may show what areas were chosen for focusing by displaying multiple rectangles on the targeted regions. This is not guaranteed when the camera is firing in bursts, like a machine gun. To select 23-area-focusing mode, rotate the auto focus mode dial to the icon that has nine small rectangles within a larger rectangle opposite the white dot.

Pressing the shutter-release button halfway activates focusing, and there may be a series of multiple green rectangles displayed, indicating where focus is being locked in. In chapter 6, we will discuss how you can limit the number of areas so that only portions of the screen are used for focusing. For now, we will take advantage of having all these focus points.

AF Tracking

It is possible to tell the camera to lock onto an object and track it. The camera alters the focus and exposure to ensure the object is accurately recorded as it moves within the display screen. This mode is called AF Tracking, and it is selected by choosing the auto focus mode dial icon that has a border surrounding a crosshair. The target can be selected by using either the shutter-release button or the LCD touch screen.

When you're using the viewfinder, there is a white targeting sight. If you position the sight on your subject and press the shutter-release button halfway, the camera will attempt to lock onto the subject. If it fails, the white targeting sight turns red. If it succeeds, the sight turns yellow, and the sight will follow the subject as it moves across the screen. When you use the Pet predefined scene mode, AF Tracking is activated. Pressing the shutter-release button fully captures the image. To cancel this mode, press the MENU/SET button or turn the auto focus mode dial to another mode.

Another, possibly easier, way to use AF Tracking is to take advantage of the LCD touch screen function. After selecting AF Tracking on the auto focus mode dial, touch the subject you wish to lock on and track when its displayed on the LCD screen. If the targeting sight turns yellow, the camera is locked on the subject and will track it as it moves through the frame. To take the picture, press the shutter-release button halfway to focus the lens. When focus is achieved, the tracking square

2

turns green. Press the shutter-release button fully to take the picture. To cancel tracking, press the MENU/SET button or change the auto focus mode dial setting.

Surprisingly, if the object moves outside of the display screen, AF Tracking will attempt to reacquire it if the subject returns within the screen. However, its success is unreliable.

Face Detection

When you're photographing friends and relatives, their faces should be recorded sharply. The Panasonic GH2 camera uses facial detection software to achieve this goal. Setting the auto focus mode dial to Face Detection enables this command. In addition, when you're using the camera in Intelligent Auto and several of the predefined scene modes such as Portrait, Baby1, Baby2, and Night Portrait, the camera will use Face Detection to establish focus. If the camera fails to find a face, it goes to 23-area-focusing.

Face Detection can be used with either the viewfinder or the LCD screen. When a face is detected, a yellow border appears surrounding it. The size of this border and its position varies depending on the size and position of the face. When several faces are in the scene, the camera identifies the multiple faces by surrounding each of them with square frames—one square will have yellow lines and the remainder have white lines. The yellow-framed face is the focus point, and it turns green when you press the shutter-release button halfway. The green square indicates that focus has been achieved.

Face detection is imperfect. It will not work on profiles and sometimes fails if the face is viewed at an angle. When this occurs, the camera goes to 23-area-focusing to make a best guess on what should be recorded.

Face Detection versus Face Recognition

These terms can be a source of confusion. Be aware that Face Detection is an automatic focusing mode and simply identifies a generic face to focus on. Face Recognition refers to identifying a specific person's face so you can review, or pull up, all the pictures with that person's face. To do this, the face is registered in the camera—essentially you are giving that face a name. This recognition software is fallible. There are situations in which it fails to identify a registered subject correctly. Using Face Recognition will be discussed in chapter 4.

Recommendations for Choosing an Auto Focus Mode

Normally, we set the camera on 1-area-focusing and leave the auto focus mode dial there. This is the most reliable method to use, and when the other auto focus modes fail, this is the one the camera will select. For action scenes, such as sports,

when we cannot aim the target properly onto a subject, we use 23-area-focusing. This ensures the camera will focus on whatever is within the field.

The key for reliable automatic focusing is having a subject that has details and is well illuminated. If this is not possible, then you will need to use manual focusing.

We rarely use facial detection—when a face is tilted or under unusual lighting conditions, this software may fail to detect it. At this point, the camera shifts itself to 23-area-focusing mode to find a point of focus. We prefer to use 1-area-focusing to focus on a person's eyes. This is a trick portrait photographers use—they know that viewers are drawn to the subject's eyes, and a flattering portrait requires sharply rendered eyes.

Focus Mode Lever: Locking or Releasing Focus

Underneath the auto focus mode dial is a small handle called the focus mode lever (figure 2-1). Moving this lever changes the camera settings from Automatic Focus Single (AFS), to Automatic Focus Continuous (AFC), to Manual Focus (MF). The first two commands determine whether automatic focus is a one step or a continuous operation. The AFS locks the focus on one point and then enables the camera to be fired. The AFC is a mobile command where focus is first established and then is allowed to change if the subject moves forward or backward. In other words, focus varies continuously. The last command, MF, requires the user to focus the camera by turning the lens-focusing ring; the user must judge from the display whether the right area is in focus. The camera will fire when the shutter-release button is pressed. The first two settings rely on automatic focusing; the latter requires the user to manually focus the camera.

Basically, after you select a focus mode setting, you aim the camera at the subject, press the shutter-release button halfway, and wait for the focus to lock in; this is evidenced by the appearance of a green circle on the screen. Then press the shutter-release button all the way down.

When AFS is selected, the camera remembers the focus point, and it will fire only at that point. To use it, move the focus mode lever until the pointer is aimed at the letters AFS. A white target sight is displayed on the framed image. Move the camera to center the sighting target on the object you wish to focus on. At this point, pressing the shutter-release button halfway focuses the lens. You know the process is successful when the target sight turns from white to green, a green dot appears in the upper-right corner of the screen, and, if the BEEP command is turned on, two beeps sound. Now focus is locked and the camera is ready to fire. Depressing the shutter-release button fully takes that picture.

If you wish, you can move the camera and fire it, even if the original subject you focused on is not in the target sight. This method is used in complex scenes where the focusing target is in the center of the screen but the subject is not. Rather than reposition the focusing target, it is faster to aim the target onto the subject

2

of interest and lock the focus by pressing the shutter-release button halfway. Now the camera is in focus. While continuing to hold the shutter-release button halfway, reframe the picture with the subject back where you originally wanted it, and press the shutter-release button fully to take the picture.

If the camera fails to find focus, the target sight turns red and there is no beep, no green circle, and the camera will not fire when the shutter-release button is fully depressed. AFS is used the most because it provides the photographer with precision when focusing. However, it is also the mode where potential photographic opportunities can be lost since the camera cannot be fired when focus cannot be obtained. Similarly, as long as you maintain pressure on the shutter-release button, the focus setting is retained. If the subject moves forward or backward and is now out of focus, you can fire the camera and have a blurred image.

To guarantee getting a sharp image of a moving object, turn the focus mode lever to AFC. In this setting, the focusing motor is continually on to keep a moving subject in focus. This setting is often used when taking photographs of rapidly moving subjects and firing the camera in Burst Mode, where the camera fires continuously while the shutter-release button is fully depressed. During the intervals between shots, the autofocus motor keeps focusing the lens. When AFC is selected, you can frame the subject in the display screen and press the shutter-release button halfway. The camera starts to focus. It signals that it found focus by displaying a green circle in the upper-right corner of the screen. When firing the camera at 3 frames per second in Burst Mode, the camera will focus and fire continuously when the shutter-release button is fully pressed. Later we will discuss how to enable the Burst Mode.

The final setting is Manual Focus (MF). As the name implies, the user focuses by physically turning the lens-focusing ring until the image is sharp in the display screen. When you use this setting, turning the lens-focusing ring turns on the autofocus motor, which moves the lens assembly. This fly-by-wire approach robs you of tactile feedback. Unlike older lenses with mechanical gearing, the lens-focusing ring will not stop when you reach minimum focus or when you reach infinity focus.

For a modern camera, it may seem that manual focus is an archaic feature; however, its availability is a recognition of the superiority of the human eye and brain for defining focus. Automatic systems can be fooled. This is often seen in nature photography when an animal is being photographed from cover. Automatic focus may focus on branches and reeds in front of or behind the animal of interest. MF ensures that you will focus on the correct object. Another benefit of this mode is the increased speed with which you can trigger a second shot. When using automatic focusing, there is a slight delay before the camera fires because it waits to confirm focus. Even when using AFC there is a delay. These holdups can be avoided by using MF. The increased speed in operation may seem trivial, but it can be critically important when photographing a skittish subject.

Exposure (Shutter Speed, Aperture, ISO)

Light intensity is controlled in one of two ways: by regulating the amount of light falling on the sensor or by regulating the duration of time light falls on the sensor. The first method requires an adjustable opening whose periphery stops the entry of light into the camera body. Usually this is an iris diaphragm whose aperture can be varied continuously. In older cameras, a ring changes the opening, and to ensure reproducible settings the ring has indentations with tactile clicks to signal when a defined position is reached. These positions are marked with numbers—such as 1, 1.4, 2, 2.8, 4, 5.6, 8, 11, 16, 22, or 32—called f-stops.

To put it simply, the f-stop number quantifies the amount of light passing through the lens, with each number signifying a doubling or halving, depending on if it decreases or increases the amount of transmitted light. In other words, the amount of light increases as the numeric value falls, and vice versa. So a setting of f/16 doubles the volume of light coming through the lens, as compared to the f/22 setting.

The second method of controlling light is to regulate the duration the light is allows to fall on the sensor. A shutter controls the time the sensor is exposed to light by first blocking the light and then unblocking it for a brief period of time. The duration the sensor receives light is the shutter speed. An exposure of 1/30 second allows twice as much light to fall on the sensor as a shutter speed of only 1/60 second. In the Panasonic GH2, shutter speeds range from 120 seconds to 1/4000 second.

What Are f Numbers?

An f number is the ratio of a lens's opening to that lens's focal length. It provides a measure of consistency when using lenses of different focal lengths or magnifications. A telephoto lens with a focal length of 400 mm and a wide-angle lens with a focal length of 14 mm will both pass the same intensity of light when they are set to f/16.

Having two means for controlling light has advantages. For one, you can control a much broader range of intensities. Closing the aperture and shortening the shutter speed are additive and will reduce the light's effect more than doing just one or the other. The light intensities you work with will range from the longest shutter speed and the most open aperture to the shortest shutter speed and the narrowest aperture.

Second, multiple combinations of aperture and shutter speed settings can result in an equivalent exposure. For example, setting the lens aperture to f/2 and the shutter speed to 1/60 second is, in terms of exposure, the same as setting the

aperture to *f*/16 and the shutter speed to 1 second. Equivalent exposures can be obtained by the judicious selection of aperture and shutter speed.

It can be seen, then, that the dual control of shutter speed and aperture provides the photographer with multiple settings for controlling exposure. For a given condition, you can use a shutter speed of 1/15 second at *f*/16, or 1/30 second at *f*/11, or 1/60 second at *f*/8, and so on. By altering the aperture, you can use a faster or slower shutter speed for a given scene, providing artistic opportunities in rendering an image. For example, when you use a fast shutter speed, flying birds can be rendered as tack-sharp objects suspended in space, and when you use a slower shutter speed their flapping wings can be blurred to give the impression of movement. To obtain an equivalent exposure with these two shutter speeds, the faster speed will require the lens aperture to be opened to admit more light, and the slower speed will require the aperture to be narrowed.

Another advantage of mixing and matching f-stops and shutter speeds is increasing or decreasing the depth of field. Narrowing the aperture increases the depth of field, and opening the aperture decreases the depth of field. In a scenic shot, such as a broad landscape, it is frequently desirable to render much of the scene in sharp focus. Such a photograph requires a longer shutter speed to compensate for the small aperture.

Portrait photographers use this feature to direct the viewer's attention to their subject. While ensuring that the face is in focus, you can blur the background and foreground by opening the aperture to decrease the depth of field. To compensate for the increased amount of light falling on the sensor, you will have to use a shorter shutter speed. Again, the dual control of shutter speed and aperture comes into play.

The final adjustment for exposure is the numeric standard set by the International Organization for Standardization (ISO). In film photography, this is the measure of the film emulsion's sensitivity to light. For digital cameras, it is an adjustment that enables the photographer to capture subjects in dim lighting. Raising the ISO increases the output from the sensor, but the brightened image suffers some degradation. Usually the range of light that the sensor can record is reduced and the image becomes somewhat granular. With high ISO values, areas that should be rendered as smooth tones will become speckled with blotches of color.

To get a feel for ISO, many film photographers use a rule for judging exposure. For a subject in open sunlight, the shutter speed is set to the reciprocal of ISO (1/ISO) and the lens aperture is set to *f*/16.

The Panasonic GH2 camera's intrinsic sensitivity is ISO 160, so under these conditions its shutter speed is set to 1/160 second and its lens aperture is set to *f*/16. For many photographers, multiplying the camera's ISO by eight will still generate an image of acceptable quality—so if the ISO is raised from 160 to 1280, the shutter speed will be reduced to 1/1280 while retaining a lens aperture of *f*/16.

What Is ISO?

ISO stands for the International Organization for Standardization. Historically, it referred to the sensitivity of film to light. Today it is associated with digital cameras and provides a measure of how much gain can be employed to generate a brighter image. The sensor's sensitivity to light does not actually vary—it generates a signal that is proportional to the intensity of light falling on it. However, it has an amplifier whereby a weak signal can be increased. This gain is adjusted by setting the camera's ISO number. A photographer therefore has the option of capturing an image in dim lighting by raising the ISO. For the highest image quality, the lowest ISO number is used, and in the case of the Panasonic GH2 camera, this ISO value is 160. For the Panasonic GH2, many photographers use an ISO of 400 and claim that there is little degradation in the image. However, most agree that noise becomes apparent at ISO 800 and is greater at ISO 1600. We prefer not using an ISO greater than 1600 and capture most of our images at ISO 160.

An experienced photographer will set the ISO manually; however, the Panasonic GH2 camera can be configured to set its ISO automatically, depending on the subject matter. If there is plenty of light and the subject is stationary, the camera favors a lower ISO for maximum image quality.

However, for photographing at night, the camera will raise its ISO setting to ensure that the photographer can capture the shot. When using Intelligent Auto Mode, the camera will automatically set its aperture, shutter speed, and sensor sensitivity for capturing the optimum image.

This introduction to exposure and description of the roles of aperture, shutter speed, and sensor sensitivity provides a framework for understanding the rationale of some of the camera's automated settings and the need to have multiple commands to handle a variety of settings. We will discuss these controls in detail in subsequent chapters on semiautomatic and manual settings for photography.

However, for the sake of completeness, we should mention that the ability to override automatic exposure is always available. This is accomplished with the camera's rear dial. Pressing this dial activates Exposure Compensation, and rotating the dial will make the view through the display brighter or darker as you vary the exposure from greater to lesser values.

One of the virtues of the electronic display is that when you're changing the camera settings, the effect is reflected in the changing appearance of the image. If the image appears overly dark, you can compensate by increasing the camera exposure using the rear dial. We will discuss how to evaluate and apply these changes in more detail in chapter 3, but for now it is sufficient to know that it can be changed.

2

Exposure Value (EV)

Even though the Panasonic GH2 has an accurate exposure system, you may wish to take over and either add to or subtract from the recommended exposure. This capability is always available to you using the Exposure Compensation function. In this context, Exposure Value (EV) has a value of one stop and is used to describe the difference between the indicated and the set exposure. The camera's exposure scale starts at 0, so at this setting there is no compensation being applied. But by rotating the rear dial, it is possible to apply up to five f-stops of overexposure (+5 EV) or five f-stops of underexposure (−5 EV). Since there are two bars between each increment, you can set the exposure values by one-third of an f-stop. The effects of applying this compensation can be seen on the display, which gets progressively brighter when increasing EV and darker when subtracting EV.

The ISO button allows you to set the camera sensitivity. However, it is deactivated in Intelligent Auto Mode and many of the predefined scene modes. For most cases, to use this control you will need to set the camera to a semiautomatic or manual operating mode. This will be discussed in chapters 6 and 7.

White Balance and the Appearance of Color

We live in a world of color, with our eyes and brain working together so we can identify hues correctly, no matter the lighting conditions. Our vision works so well it is inconceivable that an object's appearance should vary if it is sitting in direct sunlight, if it is in the shade, or if it is indoors and illuminated by a desk lamp.

But to a digital camera, its appearance does vary. The camera will record the changing appearance of the object under these lighting scenarios. If nothing is done to the image, the object will be recorded with varying color shades depending on the ambient lighting condition. To match our visual impression of what the object should look like, digital cameras have an automatic white balance—a program that adjusts the balance of colors so the hues of an object appear the same no matter the lighting condition.

For the most part, the Panasonic GH2 camera does an excellent job of rendering the color of objects. Unfortunately, it is not foolproof, so the camera has a button on the back that is labeled WB (White Balance). Pressing this button displays a series of icons representing many common light sources. Selecting one calibrates your camera to shoot in the indicated conditions, such as open daylight, cloudy skies, or indoor incandescent lighting.

When the Panasonic GH2 camera is used in Intelligent Auto or one of its predefined scene modes, the camera disables the WB button and sets itself to

Automatic White Balance (AWB) so it can compensate for the variations in lighting. For the most part, it does a good job to ensure that colors will appear natural.

However, if you control exposure semiautomatically or manually, the white balance you set will not be overridden. There are some predefined scene modes, such as Close-up and Portrait, where this button is activated as well. We will describe this button's role and its menu structure in chapter 6.

Drive Mode Lever

Drive Mode	Drive Mode Lever Icon	Display Screen Icon
Single	☐	☐
Burst	▨	▨ + burst rate set in MENU/SET>REC>(*pg* 4) BURST RATE
Auto Bracket	▣	▣
Self-timer	⟲	⟲ + no. of seconds set in MENU/SET>REC>(*pg* 5) SELF-TIMER

Table 2-4: The drive mode lever icons

When taking pictures, the camera is fired either semiautomatically (one shot for each press of the shutter-release button) or automatically (the camera collects a burst of images as you hold down the shutter-release button). Use the drive mode lever to select which of these functions to use. The drive mode lever sits on the top-right side of the camera (figure 2-2 and table 2-4).

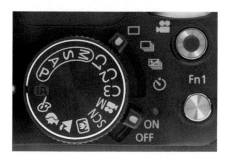

Figure 2-2: Drive mode lever set for Single Mode firing

Single Mode
The camera fires once upon depressing the shutter-release button. The automatic focusing is for only that one shot.

Burst Mode

The camera can automatically fire bursts when the shutter-release button is depressed. The firing rate can vary from 2 to 40 frames per second (table 2-5). You select automatic firing with the lever, and you select the frame rate by using software menus.

BURST RATE Option	Description
SH	Super High speed: 40 pictures/second with a maximum of 40 pictures. QUALITY set to a JPEG option.
H	High speed: 5 pictures/second when QUALITY is set to a JPEG option. 4.5 pictures/second when QUALITY is set to a RAW option.
M	Middle speed: 3 pictures/second
L	Low speed: 2 pictures/second

Table 2-5: BURST RATE command options

Keep in mind that live view, where the LCD screen displays what the camera sees, will not be available when the camera is firing at the highest rate. This is obviously a disadvantage for shooting live action.

The camera's rapid-fire capability can be advantageous for sports photography, but there are certain limitations. The image files must be transferred to the memory card, and the transfer can be delayed if the memory card is slow. To compensate for this, the Panasonic GH2 camera has a fast internal memory of limited capacity that can rapidly store the images. However, when this internal memory, or buffer, is filled, the rate of firing slows as images are offloaded to the memory card. When the files are large, such as when shooting in RAW format, the camera can fire a burst of only four to seven shots before the buffer is filled and a bottleneck occurs. When the buffer is full, the firing rate will slow down until sufficient memory is cleared to take the next shot.

This is where an expensive memory card with a high rate of data throughput is desirable. To improve the number of frames that can be captured in a burst, choose settings in the REC menu that will limit the file size. For example, you can shoot JPEG instead of RAW, choose more compression for JPEG files, and reduce the pixel array by shooting smaller-sized pictures. It is difficult to predict how many files can fill the cache in Burst Mode. The limit depends on how you size your pictures and compress your JPEG files.

The burst rate is controlled by the value assigned to the BURST RATE command in the REC menu (figure 2-3):

MENU/SET>REC>(*pg* 4) BURST RATE>[SH], [H], [M], [L]

Super High [SH] is a new feature not found on earlier models of the Panasonic G series. It can fire up to 40 shots in 1 second, and the files are in JPEG format and are S size (2336 × 1752 pixels in a 4:3 aspect ratio). The [H] option captures roughly five frames per second, [M] captures about three frames per second, and [L] captures about two frames per second. You will have live view and be able to pan the camera and frame when using [M] or [L]. This capability is lost when you shoot [SH] and [H].

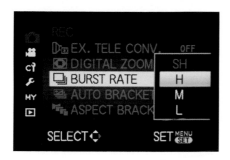

Figure 2-3: BURST RATE command options

Self-Timer Mode

This function is straightforward (figure 2-4). When the Self-timer Mode is set, it prevents the shutter-release button from firing the camera immediately. Instead, there is a delay, usually 10 seconds, so that when the shutter-release button is pressed, you can move from the back of the camera to the front so you can be in a group shot. It is possible to set the Self-timer to a shorter delay of 2 seconds. This is commonly used when you do not have the accessories for firing the camera remotely, such as an electronic shutter release control that is attached to the camera body. This provides a means of firing the camera so that the motion arising from pressing the shutter-release button subsides and a vibration-free picture is taken.

Figure 2-4: SELF-TIMER command options

An unusual setting is a Self-timer option that fires three shots after a 10-second delay. Presumably, since it seems inevitable that someone blinks or turns away in a group photograph, this command is a safety net. It fires three shots after the delay of 10 seconds, increasing the odds that one of the three shots is satisfactory. Table 2-6 contains the SELF-TIMER command options. The selected delay will be

2

utilized when the Self-timer option is chosen on the drive mode lever. The actual Self-timer delay is controlled by the value assigned to the SELF-TIMER command in the REC menu:

MENU/SET>REC>(*pg 4*) SELF-TIMER>[*see table 2-6 for options*]

SELF-TIMER Option	Description
\circlearrowleft_{10}	10-second delay. Single picture taken.
\circlearrowleft_{10}	10-second delay. Series of three pictures taken at about 2-second intervals.
\circlearrowleft_{2}	2-second delay. Single picture taken.

Table 2-6: SELF-TIMER command options

Auto Bracket Mode
The Auto Bracket function is used to take a series of shots in which one of the settings is varied to provide a range of effects. For example, the exposure may be altered in the shots. However, this command can also provide variations in white balance. Auto Bracket will be described in chapter 7.

Videos

How to Take Videos
The Panasonic GH2 is a hybrid, equally adept at taking videos and still pictures. There are two ways to take videos. The simplest is to press the red Motion Picture button on the top-right of the camera. This button is always available regardless of the mode dial selection. This allows you to switch immediately to recording movies. Although this button works independently of the selected mode dial option, it will record videos based, in part, on the selected mode.

To start taking videos, press the Motion Picture button and then raise your finger; do not hold the button down. To stop recording, press the button again. A neat trick with this mode is that you can take a still picture while recording a movie by fully pressing the shutter-release button while the video is recording.

This camera will also record sound in stereo. It has two microphones on top of the camera, and they will activate one-half second after you press the Motion Picture button. This minor delay is of little consequence, but it will avoid some of the startup noise when the camera is recording. The microphones are sensitive enough to capture the sound of the lens focusing motor. Panasonic has a lens, the 14–140 mm zoom, that is designed to be stealthy and ensure your movies are not disturbed by lens noise.

Advanced videographers can turn the mode dial to the Creative Motion Picture Mode. This will maximize your ability to make recordings. When you record, you can either speed up the motion by 1.6×, 2.0×, or 3.0×, or you can slow it down by 0.8x. We will discuss this in chapter 10. This mode provides advanced controls suitable for professionals. However, if you are just starting to use your camera and feel uncertain about some of its controls, stay away from this mode. It deprives you of the ability to take a still picture while you are in the middle of recording a movie.

Transferring Videos to Your Computer

To load your videos onto your computer, you should make sure that you have either PHOTOfunSTUDIO 6.0 BD Edition (Windows users) or iMovie (Apple users). Panasonic includes PHOTOfunSTUDIO 6.0 BD Edition with your camera. Both of these programs work with the highest resolution movies and can translate the high-definition AVCHD files. If you do not have these programs, you should record the videos using the Motion JPEG option:

MENU/SET>MOTION PICTURE>REC MODE>[MOTION JPEG]

This file format is commonly used on computers, and after you load your video file onto your hard drive you can begin working with it. This is very convenient if you need short clips for your website or if you wish to attach them to an e-mail.

Recommendations

Before you start to record videos, think about how you will be using them. If you intend to display them on your HD television directly from the Panasonic GH2 body, by all means save the files in the highest resolution mode, AVCHD. However, if you will be downloading them to your computer, you need to make a decision. AVCHD is a highly compressed file format, and its translation to an editable form requires a powerful computer. If you have a computer that is five years old, you may experience some delay while you edit. But having said that, it is still worth experimenting with this format with PHOTOfunSTUDIO 6.0 BD EDITION software. Because AVCHD is a high-resolution, highly compressed format, Panasonic claims it is best used for display on a HD television.

If you intend to send your files to your friends as an attachment or use them on your website, follow Panasonic's recommendation to save the files as Motion JPEG. This format is not as highly compressed, and after you transfer this type of file to your computer, you can easily work on it.

If you're just starting off doing video, try your hand at using the Motion Picture button. As you gain skill in composing and putting videos together, move to the Creative Motion Picture Mode on the mode dial.

Exploring the Power of
Two Electronic Displays

3

Introduction

The Panasonic GH2 camera electronic display screens (viewfinder and LCD screen) serve two purposes. The first is to frame the subject, helping the user to compose the image, check the focus, and ensure that the exposure and automatic modes are suitable for image capture. The second is to evaluate the picture after it is captured and, if needed, fine-tune the camera settings to ensure that subsequent images are properly captured.

Only one of the two display screens works at any one time. The viewfinder is enabled when the camera senses the presence of something, presumably your eye, near its window. When detected, the viewfinder turns on and the LCD screen turns off. You can view either screen with the assurance that the battery is not being drained unnecessarily.

Although they both serve the same purpose, each has its advantages. The LCD screen can swivel and has touch screen capability. It allows you to view the subject conveniently while manipulating the camera's controls. The viewfinder blocks the outside light, enabling you to frame the subject when the lighting is too bright for the image to be seen on the LCD screen. When using the viewfinder you also have the benefit of steadying the camera while shooting long telephotos or when taking videos. Both the LCD screen and viewfinder have benefits—be flexible and use whatever gives you the best results for a given situation.

The LCD Screen

The Panasonic GH2 camera has a more advanced liquid crystal display (LCD) interactive system than the early G series models. The LCD screen is large, composed of 460,000 dots, and is found on the rear of the camera (figure 3-1). It has a diagonal measurement of three inches and is large enough to be viewed at arm's length. Unlike the viewfinder, you don't have to raise the camera up to your eye for viewing. Instead, you simply hold the camera, frame the picture, and activate the shutter by pressing the shutter-release button or touching the screen.

Figure 3-1: Swivel capability of the LCD screen

The LCD screen's hinged display enhances the camera's usability by allowing you to position it at any angle, an advantage when working in cramped or awkward

locations. For example, to photograph a mushroom, it may be necessary to rest the camera base on the ground. With the viewfinder, or even a nontilting LCD screen you would have to lie down behind the camera. But thanks to the tilting LCD screen, it can be adjusted so the screen faces up. Now you can view the image from a kneeling position and compose the photograph. It is even possible to take a self-portrait by pointing the camera toward yourself and turning the LCD screen to face you.

An additional advantage of the LCD screen is being able to look down on it while you're setting menu commands: you can see both the menu and the camera buttons together, making it much easier to navigate through the camera's menu structure, review stored pictures using the directional arrow buttons, and zoom in and out of each picture using the rear dial. You can also use the LCD touch screen to accomplish many of the same actions.

The Viewfinder

The Panasonic GH2 viewfinder consists of a small screen of 1,530,000 dots with a magnifier; its function corresponds to the optical viewfinder of a DSLR. Some periodicals refer to it as an electronic viewfinder (EVF) or simply a viewfinder. Panasonic typically uses the term "viewfinder" but at times also refers to it as "Live View" or "LVF," standing for Live Viewfinder. Unless necessary, we will refer to it as simply the viewfinder.

The viewfinder is an excellent display. In comparison to optical viewfinders of DSLRs, it provides an enlarged bright image, making composition easier. Its magnifier allows you to conveniently view fine details. As described in chapter 1, you should focus the viewfinder to your eye by using the diopter adjustment dial.

Unlike an optical viewfinder, you can display the camera's menu options in the viewfinder, as well as graphical displays such as a histogram. The directional arrow buttons and the rear dial both function in the same manner as they do for the LCD screen. For example, when reviewing stored pictures and videos files, you will use the directional arrow buttons to scroll through the stored files and rotate the rear dial to zoom in or out of a displayed image. You will also see the camera's settings when framing and after taking the picture or video, as you do when you use the LCD screen.

Viewing your subject on the LCD screen in bright light can be difficult. The controls for brightening the LCD screen are inadequate in full sunlight. Using the viewfinder is the way to go in these situations. Since your eye is close to the viewfinder, your face shields the screen from bright light, enabling you to easily view your menu options and subject. Another advantage of using the viewfinder is the stability you gain by holding the camera against your face. This is invaluable

when working with a long telephoto lens where every tremor is magnified. Steadiness is even more critical when capturing videos since camera movement will be recorded.

I Want to View My Pictures Only through the LCD Screen

There may be times when you find the automatic switching from the LCD screen to the viewfinder annoying. If your hand passes close to the viewfinder eyepiece while you are setting commands, the LCD screen may turn off while the EVF turns on. This can be avoided by having just the LCD screen enabled exclusively. To do this, set the following command:

 MENU/SET>CUSTOM>(*pg* 5) LVF/LCD SWITCH>AUTO SWITCH>[OFF]

This turns off the automatic switching between the two display screens. Use the LVF/LCD button (at the top-left of the back of the camera) to toggle between using the LCD screen and the viewfinder.

Framing Pictures

Data Display Formats

The camera has several features for controlling data display in the viewfinder and on the LCD screen. Two commands control the style or format of how the camera settings are presented when framing images. In addition, the DISPLAY button, located at the center-right of the back of the camera, defines the amount of data displayed both when framing images and reviewing stored pictures and videos. The following information covers the style and display structure. The selected mode dial option, command buttons, and menu settings determine the actual displayed data values.

How you display the camera's data is a personal preference. We recommend you try out the different display styles and formats to see what works best for you.

Display Style Commands

There are two different styles or formats (table 3-1) available for displaying camera settings when framing images on the LCD screen or viewfinder: LCD Monitor Style and Viewfinder Style. Although the names suggest otherwise, you can set the LCD Monitor Style for the viewfinder and the Viewfinder Style for the LCD screen. Both display styles show the same data.

Display Style Option Name	Display Style Option
LCD Monitor Style	
Viewfinder Style	

Table 3-1: Menu value options for setting the camera's viewfinder and LCD screen data display format

To set a display style for the LCD screen, use the following menu command (figure 3-2):

MENU/SET>CUSTOM>(*pg* 5) LCD DISP.STYLE>[*Viewfinder Style*], [*LCD Monitor Style*]

To set a display style for the viewfinder screen, use the following menu command (figure 3-3):

MENU/SET>CUSTOM>(*pg* 4) LVF DISP.STYLE>[*Viewfinder Style*], [*LCD Monitor Style*]

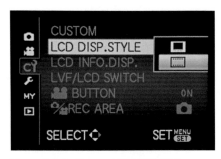
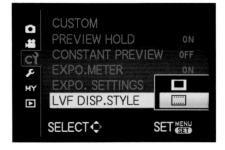

Figure 3-2: Setting an LCD DISP.STYLE **Figure 3-3:** Setting an LVF DISP.STYLE

In both cases, you have the LCD Monitor Style and Viewfinder Style formats available.

The Viewfinder Style display has a border around three sides (right and left sides and bottom) and displays the camera settings within the bottom border. Some data is superimposed on the top edge of the image in the viewfinder or on the LCD screen. Although the black borders emphasize the camera settings data, making it easier to see, it is obtained by reducing the size of the viewed scene.

The LCD Monitor Style (figure 3-4) obscures parts of the image by overlaying the camera settings data on the displayed image. Although the edges of the scene are partially obscured by icons, numbers, and lettering, we prefer this display style because the framed image is larger.

Figure 3-4 shows the LCD Monitor Style with data superimposed on the displayed image, obscuring a small portion of the image. In contrast, the Viewfinder

Style will have a smaller image with the data superimposed only on the top portion of the image.

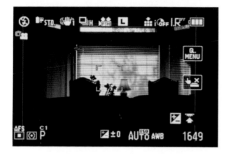

Figure 3-4: Image framed using the LCD Monitor Style

Panasonic colors its icons red, yellow, or green to alert the photographer of critical items. Red is a warning signal and indicates the setting for an icon should be changed or else the picture will be of poor quality. Yellow is an action signal and indicates the value will be changed when you turn the rear dial. Green is a normal signal and indicates the camera is in focus or identifies regions on the display screen that indicate the points of focus.

Menu navigation is independent of the display screen's style except when using the Q.MENU button at the center-right of the back of the camera. See the "Quick Menu" section in chapter 5 for further information.

Although the LCD screen and viewfinder can be set to different style values, we do not recommend this. There are several ways to navigate through this camera's vast amount of controls, and it makes little sense to complicate things by varying how you view information or set command values. Keep in mind that these styles will display only when you're framing images, not when viewing your saved pictures and videos.

Image Data Display Screen Formats

The DISPLAY button will present different data display formats. The critical data on focusing, exposure, and sensitivity is found on the lower half of the display. Figure 3-5 shows only the bottom row icons. Starting from left to right is a description of the automatic focusing mode, type of field coverage by the light meter, exposure mode, f-stop, shutter speed, Exposure Compensation, ISO value, White Balance value, and frame number.

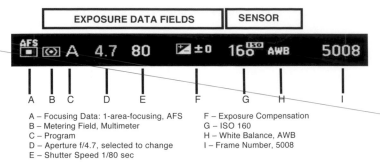

A – Focusing Data: 1-area-focusing, AFS
B – Metering Field, Multimeter
C – Program
D – Aperture f/4.7, selected to change
E – Shutter Speed 1/80 sec

F – Exposure Compensation
G – ISO 160
H – White Balance, AWB
I – Frame Number, 5008

Figure 3-5: LCD screen display with setting data

As mentioned earlier, the Panasonic GH2 camera has a large number of commands, recording modes, buttons, and settings that can be displayed and maintained via the viewfinder or the LCD screen. When reviewing an image prior to taking its picture or video, there are a maximum of four different data display screen formats to choose from:

1. Display maximum image setting data
2. Display minimal image setting data
3. Display only control settings data
4. Blank screen

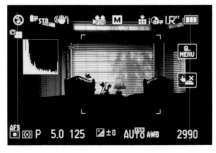
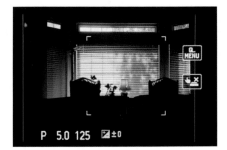

Figure 3-6(a-b): Eliminating data clutter

While looking at the LCD screen, you can cycle through the four formats by repeatedly pressing the DISPLAY button on the right side on the back of the camera. Figure 3-6a displays the maximum numerical data with the subject and shows you the camera settings. By pressing the DISPLAY button, you can eliminate most of the data clutter to have a clearer view of the subject (figure 3-6b).

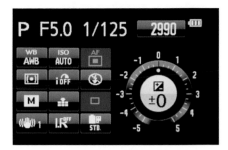

Figure 3-7: The camera setting control panel

Another press of the DISPLAY button displays just the camera settings (figure 3-7). This can also serve as a control panel by using the touch screen for changing the camera settings. This display format is available only for the LCD screen and not the viewfinder. Another press of the DISPLAY button blacks out the display to minimize battery drain. Additionally, it is advantageous for theater work when the monitor's brightness may annoy members of the audience.

In the case of the viewfinder, there are only two available data display format views: one displays maximum data and the other displays the subject with no overlying data. Pressing the DISPLAY button will toggle back and forth between the two. Keep in mind that the DISPLAY button acts only on the screen that is being used. You may have the maximum data display for the LCD screen and the minimum data display for the viewfinder. The camera will remember which format you selected for each of the display screens, so when you turn them off and then back on, you will see a familiar screen.

Note that what is displayed depends on what recording mode (mode dial) is selected. For the mode dial options P, S, A, M, C1, C2, C3, Creative Motion Picture, and My Color, the selected data display format appears when you switch to the mode. The Custom Modes (C1, C2, and C3) will use whatever data display format was selected when they were set up. For the mode dial's predefined scene modes, the selected display format is presented after you have selected a specific scene mode.

Compositional Controls

In addition to data, the camera can project lines and grids onto the screen to aid in composition. When they are set, these overlays help you align and frame your pictures and videos. They are not recorded or visible when the file is played.

Use the following command to set these lines and grids (figure 3-8):

MENU/SET>CUSTOM>GUIDE LINE>[OFF], [*3x3 grid*], [*diagonal grid*], [*crosshairs grid*]

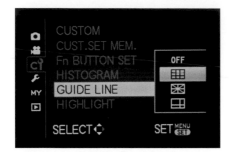

Figure 3-8: Available GUIDE LINE command options

Table 3-2 shows the menu command guide lines options and descriptions. No guide lines will display when the command is set to [OFF]. The remaining three options each have a specific pattern, and each pattern has benefits. The 3×3 matrix pattern helps ensure that the picture is well balanced and not tilted (figure 3-9). The diagonal pattern separates the screen into a 4×4 matrix overlaid with diagonal lines radiating from the center to help you center the image in the frame. The final overlay, the movable crosshair pattern, consists of two lines—one vertical and the other horizontal—each of which can be positioned within the screen. By taking advantage of the touch screen, it is possible to center the intersection of the two crossing lines and use them to precisely align an off-centered subject.

GUIDE LINE Option	GUIDE LINE Description
OFF	No guide lines displayed
⊞	3×3 matrix
⊠	Diagonal (with 4×4 matrix)
⊟	Movable crosshair

Table 3-2: GUIDE LINE command options and descriptions

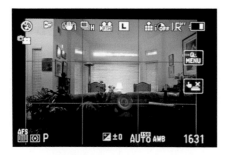

Figure 3-9: 3×3 grid superimposed on framed image

All three guide line patterns are useful in architectural photography or scenic shots with a horizon. They help you avoid canting the subject by providing an alignment

guide for either a building or the horizon. Which one you use will depend on where you are positioning the subject within your picture.

Additionally, the 3 × 3 matrix guide line pattern comes in handy for employing the so-called rule of thirds, which recommends that you compose objects in regions that are one-third or two-thirds of the distance from the borders of the frame. Since the grid pattern is a 3 × 3 array of rectangles, this will allow you to position the main subject of the image one-third or two-thirds of the way up from the bottom, down from the top, or from either side of the screen.

Determine Image Exposure

This is a complicated subject, and several factors determine the optimal exposure for a picture or video. Although the camera's Intelligent Auto and predefined scene modes create excellent pictures, there will be times when their recommendations will need to be overridden. The Panasonic GH2 camera has several tools to help you determine how to obtain the optimum image for your needs.

Histograms

A histogram is a graphical representation of the distribution of light intensities being recorded by the sensor. Intensity values are on the horizontal axis (black to white), while the vertical axis represents the number of pixels.

Theoretically, the histogram has the shape of a classic bell curve whose maximum is near the center of the graph, indicating that most of the image's pixels have a brightness level in the middle—not too bright, not too dark. Figure 3-10 shows three histogram plots taken from the Panasonic GH2 LCD screen.

Figure 3-10: Histograms

The middle histogram is white and is at the exposure setting recommended by the camera. When the Exposure Compensation is changed with the rear dial, you can

underexpose the image. The histogram turns yellow[1] and shifts to the left, causing the graph to pile up on that side. If you decide to overexpose the subject with the Exposure Compensation tool, turn the rear dial in the opposite direction. Notice how the histogram's shape and position changes. Although the image is over-exposed, the histogram does not necessarily move to the extreme right, but it does change from white to yellow, indicating the exposure is not optimum.

As you do more photography, you will notice that many histograms have multiple peaks, none of which are centered on the x-axis. This does not necessarily indicate poor exposure. Instead, you should watch for large numbers pixels appearing at either end of the x-axis. In this case, there is an out-of-balance lighting situation at one end of the spectrum, which will need to be fixed to get a properly exposed picture. The large number of pixels at the extreme right or left of the graph indicates maximum intensity or minimum intensity, respectively. Either way, you will have problems—at the extreme right the image has burned-out highlights, and at the extreme left the image has black shadows that lack detail.

The camera's software will attempt a proper exposure when using Intelligent Auto or a predefined scene mode. In these cases, the Panasonic GH2 camera displays a histogram in white—a signal that its software considers this the optimal exposure. Overriding the camera's recommended settings will cause the graph to turn yellow, signaling that you have deviated from the recommended values.

To display the histogram when viewing an image, use the following command (figure 3-11):

MENU/SET>CUSTOM>HISTOGRAM>[ON]

Figure 3-11: Available HISTOGRAM command options

When the histogram is displayed, it can be moved off to the side using the directional arrow buttons, or you can touch the histogram and drag it to a new location.

1 The Panasonic GH2 manual states that the color is orange, but it looks more yellow to us. Either way, it is no longer white.

> ### A Histogram in Intelligent Auto Mode
>
> The histogram display is activated by the MENU/SET> CUSTOM>HISTOGRAM option being set to [ON]. But when the camera is in the Intelligent Auto Mode (iA option on the mode dial), the CUSTOM menu does not show this command.
>
> While in Intelligent Auto Mode, the camera assumes much of its settings are already set. If you would like the histogram displayed in this mode, select another option, such as P, on the mode dial and press the MENU/SET button. Then navigate to the CUSTOM menu. The HISTOGRAM command should display on the CUSTOM menu's first page. Set the option to [ON] and press the MENU/SET button to save the setting. Change the mode dial back to the Intelligent Auto Mode, and the histogram should now appear.

Camera Exposure Control

In the automated modes, such as Intelligent Auto or the predefined scene modes, several elements go into controlling the camera's optimal exposure for the image. The camera uses the shutter speed, lens aperture (f-stop), and focus approach (1-area-focusing or 23-area-focusing averaging) to calculate the image exposure. The camera sets and displays a recommended exposure in most of its operating modes. However, it also allows you to increase or reduce the exposure depending on what you see in the screen.

A useful tool in this regard is the histogram. The results are displayed via the histogram with the camera's suggested exposure shown as a white histogram curve. As mentioned earlier, the histogram will be recalculated and changes to yellow if the camera's f-stop or shutter speed setting recommendation is overridden.

The camera has an additional tool, Exposure Compensation, that you can use to obtain an optimally exposed image even when the camera's computer is fooled by unusual lighting conditions or you wish to change the camera's automatic settings. The beauty of the Panasonic electronic display is that it shows you, in real time, the effects of the camera's recommended exposure and the effects when you override the camera's recommendations.

Exposure Compensation

Use this function when you suspect that the camera's exposure recommendation may not be the best. You might feel that darkening or brightening the image provides a better mood to the scene. Or, it may be that the lighting situation is so extreme that you have to decide what area, the bright highlights or the dark shadows, have to be sacrificed in order to capture the image.

The Exposure Compensation tool is displayed as a scale at the bottom of the display screen. It allows the exposure to be set within a range of −5 EV (Exposure

Value) to +5 EV for pictures and −3 EV to +3 EV for videos. If the icon appears white, no exposure compensation is applied. To adjust Exposure Compensation, the icon must turn yellow, and this is accomplished by pressing the rear dial. At this point you can turn the rear dial to apply more exposure (bar moves to the right) or less exposure (bar moves to the left) (figures 3-12a-c). The scale does not display until you adjust the exposure away from the camera's recommendation.

The extent of compensation is shown graphically. When the moving bar appears you will see five dots. Each dot represents one f-stop. As you turn the rear dial, you will see vertical tick marks beneath the dots. Each of these tick marks represents a 1/3 f-stop increment. By using the dot and tick marks, you can rapidly determine how many f-stops of compensation are being applied. For example, 1 1/3 f-stops is shown by a series of four tick marks—the third tick mark under the dot and the fourth just beyond the dot.

The Exposure Compensation scale displays only +/− 3 EV for videos. This will be evident when the mode dial is set to Creative Motion Picture mode. Since you can also initiate a video by pressing the red Motion Picture button, the Exposure Compensation scale will initially appear as +/− 5 EV. The scale will immediately change to +/− 3 EV as soon as the Motion Picture button is pressed. If you have compensated the exposure to more than 3 EV, the camera will truncate the setting to 3 EV.

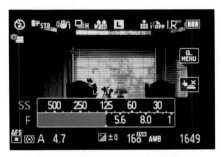

Figure 3-12a: Exposure Compensation scale at optimum exposure

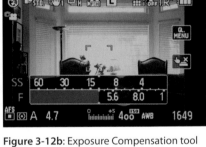

Figure 3-12b: Exposure Compensation tool to increase exposure

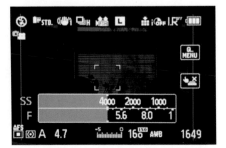

Figure 3-12c: Exposure Compensation tool to decrease exposure

The shutter speed and/or aperture settings will change as you add or subtract ticks on the Exposure Compensation scale. The Exposure Meter allows you to see the validity of the compensated exposure. Without it you will have to rely on pressing the shutter-release button halfway to see if the exposure is acceptable.

Exposure Meter

Contrary to its name, the Exposure Meter tool does not set the exposure directly. Instead, as you adjust the camera controls, it shows the available shutter speed and aperture values (figure 3-13). Its purpose is to prevent you from adjusting the camera beyond the aperture limit of the lens.

Figure 3-13: The Exposure Meter scales

The Exposure Meter consists of two rows of numbers: the top row contains the available shutter speeds (SS), and the bottom row contains the available aperture settings (F). As you adjust the aperture or shutter speed, the Exposure Meter shows the new settings. Prompts on how to navigate and toggle between the two rows are also displayed on the screen.

At times, sections of the Exposure Meter's shutter speeds and/or aperture numbers are displayed on a red background. These values are greater than the limit of the lens shutter speed settings or aperture openings. Although you can set the shutter speed and/or aperture numbers to a setting in the red section, they are unusable. In this way, the Exposure Meter helps you avoid impossible exposure settings when overriding the camera's recommendation using Exposure Compensation.

This is important because when you exceed these limits and attempt to take the picture, the camera will not fire. You will see both the shutter speed and aperture values turn red. Worse, without the Exposure Meter display, you could set the camera controls so far beyond the range of the lens that you do not know how much you need to reverse your compensation. The Exposure Meter can save valuable time.

To enable the Exposure Meter, use the following command:

MENU/SET>CUSTOM>(*pg* 4) EXPO.METER>[ON]

The EXPO.METER command enables you to display the Exposure Meter when the Exposure Compensation tool is displayed. Setting this option to [OFF] means the Exposure Meter will not be displayed. Setting this option to [ON] activates the Exposure Meter.

Depth of Field Preview

Optically, when you focus on a subject there is only one distance from the lens that is maximally sharp. Depth of field covers the areas in front of and behind this distance that remain acceptably sharp. It is critical in photographic composition because it determines whether the foreground, the subject, and the background have definition or whether the foreground and background are blurred and only the subject is sharp.

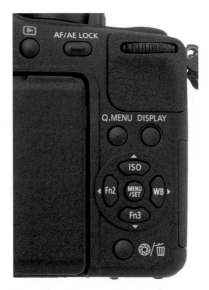

The lens aperture controls the depth of field. A larger f-stop number increases the depth of field, which can be seen directly by using the Preview button (figure 3-14) in the lower-right corner on the back of the camera. The button has two functions. If you are viewing an image, it stops down

Figure 3-14: Rear panel Preview button

the lens aperture and you see the depth of field. If you are reviewing a saved picture, it will delete the picture. Hence, this button is labeled with two icons: an aperture and a trash can.

When you're viewing the image, the lens is wide open and you will not see the effect of the f-stop in terms of the depth of field. When you press the Preview button, the lens is stopped down to the set aperture, and the depth of field becomes apparent. When you press the rear dial to change the aperture, the depth of field will change and its affect on the subject will be displayed on the screen. You may not notice much difference in the focus for images that are a normal distance away from you, but if you are shooting macro work, this becomes an invaluable aid where the depth of field is critical to obtain a well-focused image.

3

Evaluating Depth of Field: DSLR versus Panasonic GH2

The lens aperture controls the depth of field of the recorded image—the smaller the aperture, the greater the depth. In the old days of photography, when we worked with mostly single-focal-length lenses whose aperture was controlled with a ring surrounding the lens, the lens would have a depth of field scale. This would show the zone of sharpness in feet or meters. If our subject fell within this zone, we would be confident that it would appear reasonably sharp in print.

Modern camera lenses lack an aperture control ring and a depth of field scale. To gauge whether the subject will be blurred or sharp at a given distance and aperture, we use the depth of field Preview button. Pressing this control closes down the lens aperture, with its effects displayed on the screen of DSLRs. Unfortunately, this control darkens the screen, making it difficult to see the increase in depth of field. In contrast, the Panasonic's electronic display automatically compensates for this by brightening the image, allowing the photographer to better view and judge the depth of field.

An additional benefit of the Preview button is that it provides an approximation of the effects of slow shutter speed on moving subjects. If you press the Preview button and then the DISPLAY button, you will see the effects of your shutter speed on a moving subject and you can get an idea of how much blur will result when you select a slow shutter speed.

Exposure Summary

How does this all come together when taking a picture? In all cases, other than the Manual Mode (with the mode dial set to M), the camera will generate a shutter speed, aperture, and/or focus setting based on the selected mode. Generally, the camera does an excellent job determining exposure. Regardless, there are times when you will want to change the settings to better conform to your artistic desires for the final photograph or video.

Review your image's histogram. The displayed graph ideally should have its light intensities concentrated in the center. If the intensities are concentrated on either the left side (underexposure) or the right side (overexposure), you should consider making changes to the camera settings. These conditions indicate, respectively, that either shadow or highlight details are not being recorded, and you must decide which details to sacrifice. If you desire details in these regions, you need to apply some exposure compensation to shift the histogram to either the left or the right. As you change the exposure, the histogram and the view through the camera will change accordingly. Remember, simply changing the aperture or shutter speed by itself will not alter exposure in the automatic exposure modes.

Reviewing Pictures, Burst Groups, and Videos

An advantage of digital recording is its immediacy. You can review your captured pictures, determine if you need to alter the exposure a bit more, or whether the image is sharp enough.

Unlike a DSLR, the Panasonic G series cameras allow you to review saved images in two areas—the LCD screen and the viewfinder. Most people use the LCD screen because it is larger and the controls for scrolling through saved images, enlarging them, and deleting the unsatisfactory ones can be easily operated. However, keep in mind that there may be instances where the viewfinder would be a better choice, such as in direct sunlight when the ambient light makes it difficult to view the pictures on the LCD screen.

The Panasonic GH2 camera gives you the ability to either automatically review your pictures immediately after they have been captured or to defer this to a later time. Postponing image review is important for action photographers who need to fire their camera in a rapid sequence.

The GH2 has the capability of recording up to 40 pictures in a one-second burst. These recorded pictures are bundled together in a group called a Burst Group. Burst Groups and videos cannot be automatically reviewed immediately after they are recorded. Instead, you will need to review them in play back.

Reviewing Pictures Immediately

The camera has an AUTO REVIEW command that allows you to view a picture immediately after it is taken and before you take the next picture. Note that this command does not affect Burst Groups or videos:

MENU/SET>SETUP>(pg 2) AUTO REVIEW>[OFF], [1 SEC.], [3 SEC.], [5 SEC.], [HOLD]

This command allows you to set the amount of time a picture is displayed after it is taken. You can choose to display the picture for 1, 3, or 5 seconds, or indefinitely [HOLD]. Reviewing a stored picture is terminated upon pressing the shutter-release button. This returns you to a live view for taking the next picture.

The advantage to briefly seeing the recorded picture is to determine if it is a keeper. For example, for a portrait, are the subject's eyes visible or did he blink just when you clicked the shutter-release button? You will be able to review your image automatically when AUTO REVIEW is set to a value other than [OFF].

Also, for difficult lighting conditions, you can activate the HIGHLIGHT command to determine if areas in the image are overexposed:

MENU/SET>CUSTOM>HIGHLIGHT>[ON]

The HIGHLIGHT command displays overexposed regions with black and white blinking. You can then decide if you want to retain more detail in these areas by

using the Exposure Compensation tool to reduce the exposure for the follow-up image capture.

Remember, for rapid-sequence photography, you can turn off automatic reviewing of the pictures with the following command:

MENU/SET>SETUP>*(pg* 2) AUTO REVIEW>[OFF]

Reviewing (Playback) Pictures, Burst Groups, and Videos Later

The Playback button, just above the LCD screen and denoted by a green arrow, provides more information and control while you review pictures. First, Burst Groups and videos can be reviewed using this button, whereas you can't review them automatically as part of the image capture process.

Second, you can increase the magnification of your saved images by turning the rear dial to the right or touching the screen. You can zoom in up to 16× to critically examine the image for sharpness. When you are zoomed in, you can move around the picture to see different portions.

Figure 3-15(a-c): Methods to cycle through saved images

The next benefit is being able to locate a saved image to review. By turning the rear dial to the left, you can see 12 of your last saved images (figure 3-15a). The screen has a sliding bar on the right side so you can reposition the display to other locations within your saved files. Another turn of the rear dial allows you to see 30 images (figure 3-15b). One more turn to the left and you are presented with a calendar that allows you to select a date and review your saved images taken on that date. Only those dates that have saved files are bolded and available for

selection. Select a date and cycle through the associated saved files (figure 3-15c). Note that if you have not set the camera clock, the saved date for each file will be January 1, 2010.

To do all of this, you will use a combination of the LCD touch screen, directional arrow buttons, and rear dial. Fortunately, there are prompts on the LCD screen to guide you while navigating through its many steps and capabilities.

In addition, there are different display formats when viewing single pictures or the first frame of a Burst Group or video in Playback. This will be covered in the section titled "Evaluating Playback Data Display Screen Formats Using Playback" later in this chapter.

How to Tell the Difference Between Pictures, Burst Groups, and Videos

How do you know when you are looking at a saved picture, Burst Group, or video? For Burst Groups, look for the Burst Group icon along with the number of frames displayed on the screen (figure 3-16a). A large arrow (Playback) icon is displayed in the center of the image. In addition, "BURST, PLAY" appears briefly on the screen when the file is first displayed.

For videos, the recorded elapsed time and motion picture icon are displayed on the screen, and a Playback icon is displayed in the center of the image (figure 3-16b). As with Burst Groups, "PLAY MOTION PICTURE" will appear briefly when the video is first displayed on the screen.

Pictures are distinguished by what they don't have—there is no identifying icon, Playback icon, or message displayed (figure 3-16c).

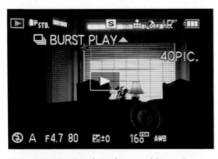
Figure 3-16a: Display of a saved Burst Group

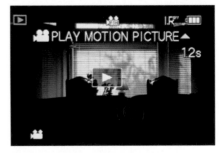
Figure 3-16b: Display of a saved video

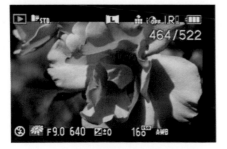
Figure 3-16c: Display of a saved picture

Altering the Playback Display

Pressing the Playback button displays the image files on the memory card. You will initially see either the last image played back or the last image saved.

> **Playback Button, Playback Mode, PLAYBACK Menu, and PLAYBACK MODE Command**
>
> The Playback button provides you with a fast method to review your captured images. You use this to determine if the quality of the saved image is satisfactory.
>
> Playback Mode is the state the camera is in when you have initiated playing back pictures, Burst Groups, and/or videos.
>
> The PLAYBACK menu is an elaborate system of commands for creating a still and/or video presentation for an audience.
>
> The PLAYBACK MODE is a command in the PLAYBACK menu that enables play back of a selected group of pictures and/or videos one at a time.
>
> We will discuss both the PLAYBACK menu and the PLAYBACK MODE command in chapter 11.

You navigate through the group of saved images (pictures, Burst Groups, and videos) by using the left or right directional arrow buttons or by sweeping your finger across the LCD screen. Each sweep of your finger will take you to the next saved file in your memory card. Pressing the left directional arrow button or sweeping your finger from left to right will display the previously stored file. Conversely, pressing the right directional arrow button or sweeping from right to left will move forward through your stored files. Note that continued requests to view the next saved file wraps around and cycles through them again.

You can also zoom in for a better view of your image by turning the rear dial to the right or by touching the LCD screen up to four times. Each turn of the rear dial to the right or touch of the LCD screen will enlarge the image by 2×, then 4×, then 8×, and finally 16×. In addition, there are two touch Zoom icons.

We found that using the LCD touch screen method for zooming is problematic, and using the rear dial for zooming is much more reliable. Regardless of which method you use, after you have enlarged the image at least once, yellow directional arrows will display at the edges of the image. You can use either the directional arrow buttons or your finger to move right or left or up or down through the image. In addition, a map showing where you are on the image is displayed in the upper-right corner.

In the case of videos, the zoom and mobility within the enlarge image functionality works only on the video's first frame. You will not be able to zoom in while the video plays back for your review.

Zooming in can give you an idea of the image quality and how well it will hold up to being enlarged in a printed format. For example, you took a picture of a bird at your backyard bird feeder. It looks good, and you want to make a large print, frame it, and hang it on your wall. Will the picture hold up when it is enlarged? Although it is not ideal, by zooming in you can view how well the image is focused and determine if the detail will withstand enlargement.

Note that if you turn the rear dial to the right more than three times, nothing more changes—you are left with the final review option. You can return to the original image display size by turning the rear dial back three times to the left.

Evaluating Playback Data Display Screen Formats Using Playback

When you're playing back images, the DISPLAY button has a new set of display screen formats. You can use the displayed information to help determine the image quality and decide if you should reshoot it to get better results. These data display screen formats are independent of the set of data display screen formats available when you frame your images.

There are five different data display screen formats to choose from. When you are in Playback Mode, press the DISPLAY button to cycle through the formats to find the one you want. The camera will remember your selection and display the next picture, Burst Group, or video with that format. To change it, simply press the DISPLAY button to select another data display screen format.

When you are viewing the LCD screen, pressing the DISPLAY button four or five times will cycle you through each of the available views. The following list describes each view in order:

1. Display a full-size picture plus camera setting data. Data is superimposed on the image (figure 3-17a).
2. Display a smaller picture insert with more numeric data shown in an easier to read, larger font (figure 3-17b).
3. Display a small picture insert with a histogram containing the three color channels and the luminosity (figure 3-17c).
4. Display a full-size image with the overexposed regions flashing between white and black. Note that this display view does not occur when the camera is in Intelligent Auto Mode or if the HIGHLIGHT command is set to [OFF]. In either of these situations you will go directly to display mode 5, described next.
5. Display picture only (figure 3-17d). There is no data overlay or overexposure indicators (HIGHLIGHT).

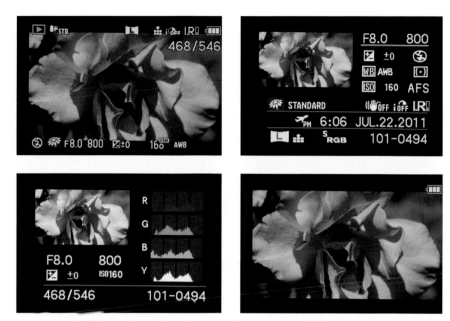

Figures 3-17(a-d): Press the DISPLAY button multiple times for different image views

Keep in mind that if you want to know if a file is a picture, Burst Group, or video, you can see the indicators only on the first three data display screen formats.

In the fourth screen format, the highlighted areas will flash black and white if an area is overexposed. This can be distracting. You can press the DISPLAY button again to see a view without the blown-out areas marked, or you can turn the highlights off by executing the following command:

MENU/SET>CUSTOM>HIGHLIGHT>[OFF]

Remember that the highlight display format will be available only if the HIGHLIGHT command is [ON] and the camera is not in Intelligent Auto Mode. Experiment with the different display formats. You may find you will want to vary the formats depending on the type of pictures you plan to review.

Evaluating Exposure
The histogram display screen format shows the intensity range of the color channels and the overall luminosity (figure 3-17c). Thus, you will be able to see if the overall light intensity, or one or more colors (red, green, blue), is under- or overexposed. This is indicated when the pixel values spike at the borders of the graph. For example, underexposed images show intensity values accumulating and spiking on the left border of the graph. This is corrected by reshooting with an increased exposure. The converse is true for overexposure.

Studying the color channels is important because the red, green, and blue channels have different sensitivities to light. So if one channel goes into over- or underexposure, as evidenced by its histogram, your picture may take on a color cast. The luminosity histogram may miss this detail. Luminosity is at best an averaging of light intensities, which is made of intensities from the red, green, and blue photo sites.

Playing Back Videos

Only the first frame of a video is seen as you cycle through your memory card files in Playback Mode. This frame will show a Playback button in the center of the LCD screen. To play the video, touch the Playback button in the center of the screen or press the up directional arrow button. Whatever data display screen format was selected will disappear, and you will see the actual video with the number of seconds played displayed. Note that if the displayed image has no Playback button, you can press the up directional arrow button to start the playback.

In addition, as the video starts to play, video touch screen controls appear on the screen. Use these touch screen controls to play/pause, fast forward, rewind, or stop the video, or to adjust the audio volume. These controls display only briefly but will reappear if you touch the LCD screen again during the video playback. If you prefer, you can also use the directional arrow buttons and rear dial to initiate the same controls. Table 3-3 contains the available video and Burst Group playback operations so you can get the most out of reviewing your saved files.

Playing Back Burst Groups

Burst Groups are displayed much like a video, with the first frame displayed and an on-screen Playback icon to start the playback.

Figure 3-18: Burst Group playback touch screen menu

You can play back a Burst Group using either a touch screen menu or the directional arrow buttons. A set of playback icons appear when the Burst Group playback is initiated (figure 3-18), but disappears after a short time. To redisplay the menu, touch the screen again. Because of their constancy, we prefer using the directional arrow buttons (table 3-3) to navigate through the playback.

Video and Burst Groups Playback Navigation Operations		
Function	**Key**	**Process**
Play/Pause	Up directional arrow	Toggle between these two functions.
Stop	Down directional arrow	Stop playing the video or Burst Group
Fast Forward	Right directional arrow	Increase the playback speed. Push the right directional arrow again (up to 2 additional times) to increase the fast forward speed. Press the up directional arrow to return to the normal forward speed.
Rewind	Left directional arrow	Increase rewind speed. Push the left directional arrow again (up to 2 additional times) to increase the rewind speed. Press the up directional arrow to return to the normal rewind speed.
Frame-by-Frame Forward	Up directional arrow (Pause) then right directional arrow	Playback one frame at a time.
Frame-by-Frame Rewind	Up directional arrow (Pause) then left directional arrow	Rewind one frame at a time.
Reduce volume level	Rear dial	Turn rear dial to the left to reduce the volume level (video only).
Increase volume level	Rear dial	Turn rear dial to the right to increase the volume level (video only).

Table 3-3: Video and Burst Groups playback operations

Deleting Saved Pictures, Burst Groups, and Videos

Not every picture, Burst Group, or video is going to be a keeper. As you play them back on the camera, you may want to delete one or more saved files.

The Delete function is activated when you press the Trash Can button in Playback Mode. The function walks you through each step to ensure that you do not make any mistakes. You will have the option to delete a single file or multiple files at one time. Prior to deleting any selected files, the function will ask you to validate your intent. When you delete a saved file, it is permanently gone from the memory card.

The Delete function pertains to only the unprotected, saved files on the memory card. The PROTECT command will be covered in chapter 11 when we discuss the PLAYBACK menu commands.

Deleting a single file is easy. After pressing the Trash Can button, select the [DELETE SINGLE] option. You will be asked to confirm your intent. Select [YES] and press the MENU/SET button. The selected file will be deleted.

To delete several files at one time, select the [DELETE MULTI] option from the Delete function screen. You will be presented with the six most recently saved files with the cursor positioned on the last file and that file's number highlighted in yellow. Use either the rear dial or the directional arrow buttons to scroll through your saved files. To select a file for deletion, press the DISPLAY button while the cursor is positioned on the file. A red Trash Can icon will appear in the upper-left corner of each file you have selected. When all the files you want to delete are selected, press the MENU/SET button. You will be asked one more time to confirm your intent. Answering [YES] will erase the files, and [NO] will return you to the previously displayed image in Playback Mode.

You can also delete all of your saved, unprotected files at one time by selecting the [DELETE ALL] option. Once selected, you are asked to choose between two options: [ALL DELETE EXCEPT *favorites*] and [DELETE ALL]. If you have saved files identified as favorites, the [ALL DELETE EXCEPT *favorites*] option will delete all unprotected files that are not marked as favorites. The [DELETE ALL] option will delete all unprotected files regardless of their status as a favorite. After you have selected one of these two options, you will be asked to confirm your request. Select [YES] to delete the unprotected files from the memory card according to your selection. Select [NO] to stop the deletion process and return to the previously displayed image in the Playback Mode.

We are judicious about deleting files while photographing in the field. It is most often done to weed out the unacceptable pictures or to make room on the card to record more pictures and videos. To minimize the chance of being caught short of memory, we download the pictures to our computer after a major shoot and then do a bulk erasure on the card.

Recommendations

When we are in the field actively taking pictures, we make sure that the LVF/LCD SWITCH>AUTO SWITCH command is active:

MENU/SET>CUSTOM>(*pg 5*) LVF/LCD SWITCH>AUTO SWITCH>[ON]

This setting minimizes battery drain. The only time we turn it off is when we are reviewing pictures and do not want to inadvertently turn off the rear LCD screen. This command is usually set to [ON] at the factory; however, it is good to ensure that it has not been altered in the course of working with the camera.

We also like to make sure the following commands are on:

MENU/SET>SETUP>(*pg 2*) AUTO REVIEW>[3SEC.]
MENU/SET>CUSTOM>HISTOGRAM>[ON]
MENU/SET>CUSTOM>HIGHLIGHT>[ON]

Normally, the AUTO REVIEW command defaults to on, but the next two commands, HISTOGRAM and HIGHLIGHT, do not.

Setting the HISTOGRAM command to [ON] will cause a histogram to be displayed before an image is recorded. If you do not see the histogram when in Intelligent Auto Mode, execute the following steps:

1. Exit Intelligent Auto Mode by turning the mode dial on top of the camera to another mode and press MENU/SET button.
2. Using the down directional arrow button, navigate to the CUSTOM menu icon in the vertical bar on the left side of the screen.
3. Use the right directional arrow button to enter the CUSTOM menu and proceed down to the HISTOGRAM command.
4. Set the command to [ON].

Normally, if you press the MENU/SET button while in Intelligent Auto Mode, this command is invisible—but you can use the aforementioned trick to make it active, if you so desire.

The HIGHLIGHT command works differently and does not work if the camera is in Intelligent Auto Mode, even if the HIGHLIGHT command is [ON]. To see the overexposed portions of the image blink on and off, you must take the camera out of Intelligent Auto Mode.

Although we enjoy using the touch screen functionality, we have found that the LCD screen does not always recognize our taps and swipes, especially with zooming and moving within an image. Instead, we tend to use the directional arrow buttons and rear dial to navigate through different functionalities.

Automatic Settings

Introduction

The way in which you use the Panasonic GH2 camera depends on your level of expertise, your desire to control different aspects of your picture taking, and the degree of creativity you want to introduce. You can start taking technically excellent pictures and videos using the camera's Intelligent Auto Mode with minimal knowledge and prior photographic experience. The camera software allows the user to point and shoot while the camera determines if the subject belongs within a list of scene types (categories) and selects the most efficient aperture, shutter speed, ISO, and auto-focusing mode.

Essentially, the camera identifies the scene type in order to optimize camera settings; for example, a person sitting indoors will be photographed with the focus set on the face and red-eye flash reduction, while a landscape shot will have a slow ISO, small aperture, and slow shutter speed to record a panoramic view with maximum fidelity.

The Intelligent Auto Mode will do its best, but scene recognition is not 100 percent accurate. You may decide to take over and use the camera's predefined scene modes. They allow you to classify your subject into a scene category. There are two groups of predefined scene modes: advanced scene modes and the Scene Mode. Both groups have multiple predefined scene modes to choose from covering a wide range of both picture and video scenarios.

In this chapter, we will cover the camera's Intelligent Auto Mode and predefined scene modes, their options, and how they might work best for you. But first we must cover one more camera feature. The GH2 is equipped with software that can recognize a human face and identify the person to whom the face belongs.

As mentioned in chapter 2, the camera can be set to detect a person's face in the frame and use it as the preferred object for focusing. The Face Recognition feature allows the camera to go beyond detecting that there is a face and enables it to assign a name to the face. Face Recognition can be activated in all modes except the following:

- Creative Motion Picture Mode
- Close-up's Food predefined scene mode
- SCN's Night Scenery predefined scene mode
- SCN's Peripheral Defocus predefined scene mode

Although not everyone will want to use this feature, you should be aware of how it works so you can determine if it is something you wish to use.

Face Recognition

Face Recognition functionality is unique to cameras that have live view sensors, such as those in the Panasonic G series. It is available only for pictures, and it can slow down your camera's operating time. It is an interesting feature and we recommend you experiment with it. It is uncanny to look in the camera's finder and see that it has correctly identified a specific person. You will see the recognized person's name on display as you compose the picture. If you determine at a later time you don't need Face Recognition functionality, you can always turn it off. Also, if you don't want to use the Face Recognition feature, feel free to jump to the "Mode Dial" section later in this chapter.

Remember that Panasonic distinguishes facial detection from facial recognition. The former describes the identification of a generic face so it can be used as the point of focus. Face recognition goes a step further in that the camera executes software to determine whether the photographer has registered a detected face. If the face is registered, the camera can recognize the face while you are framing the image; the person's name and age will be displayed on the screen and will be stored with the saved picture.

For the software to work, you will have to compile a library of portraits and assign a name and birth date to each. There are limitations. You can register up to six people for Face Recognition. Each requires up to three different portraits with the person directly facing the camera, along with the person's name and birth date. These images should not be identical and should include typical facial expressions for the person. The software bases its determination on recognizing two eyes, a nose, and a mouth, so facial recognition will fail if the camera sees only the person's profile. Also, certain conditions, such as the face being too small in the frame or harsh shadows falling on the person's face, may interfere with correct recognition.

To make the image library, you will have to decide which people you wish to register and place images of them in the Face Recognition system. Suppose you wish the camera to recognize your sister. This is accomplished by taking three different photographs of her full face, showing a range of facial expressions and environments, such as a big grin outdoors, a serious contemplative look indoors, and a subtle Mona Lisa smile taken with an electronic flash. This sampling ensures a higher percentage of correct individual identification. We recommend you take three sample images for each person you register. This improves the software's accuracy in recognizing and identifying the person.

The Face Recognition software works for group shots too, recognizing up to three people in a single picture. Of course, to be recognized, each registered person must be facing the camera so that his or her facial features are clearly presented. Also, if the faces occupy too small of an area on the sensor, they may not be recognized. When you frame a picture and one or more faces are detected, the camera

software will go through the stored, registered sample images and determine if it can identify anybody in the frame as any of the six people registered in Face Recognition. If so, the saved registered name and the person's age will be super-imposed on the image below the framed face. In addition, if Intelligent Auto Mode is used, an R will be displayed in the category icon, which is displayed in the lower-left corner of the display screen (figure 4-1).

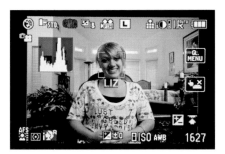

Figure 4-1: The iA category icon contains an R when the subject's face is recognized in Intelligent Auto Mode

The person's registered name and calculated age in years, months, and days are stored with the saved picture and displayed on the screen when the picture is played back and when you print the picture. In addition, the person's registered name will download with the picture to your computer when you use the supplied PHOTOfunSTUDIO 6.0 BD Edition software.

If The Person's Age Does Not Display When a Saved Picture Is Reviewed...

There is a delay in displaying the recognized person's age. The name displays first, and the person's calculated age displays soon after. The name disappears after a few seconds, but the age continues to display with the picture on the screen.

The Face Recognition functionality is enabled in many of the predefined scene modes, in several of the iA categories, and when Face Detection is turned on for the modes. Face Recognition is automatically set to on when any of these predefined scene modes are chosen:

- All of the predefined scene modes within Portrait Mode
- Night Portrait , Party, Baby1, and Baby2 predefined scene modes within Scene Mode

Face Recognition requires the auto focus mode dial to be set to Face Detection. This is the default setting in the previously listed predefined scene modes. All other modes have a different default auto focus mode, so to use Face Recognition in those modes, you must manually set the auto focus mode dial to Face Detection.

The Face Recognition function is not enabled, even if the command is set to [ON] in the menu, in the following situations:

- When the focus mode lever Is set to MF
- Motion Picture Mode
- Night Scenery and Peripheral Defocus predefined scene modes within the Scene Mode
- Food predefined scene mode in the Close-Up Mode

Activating Face Recognition

Getting the Face Recognition software to work is very simple. You must have three items in place:

1. You must have Face Detection functionality enabled:
 Turn the auto focus mode dial to the Face Detection setting
2. You must enable the Face Recognition software using the following command:

 MENU/SET>REC>FACE RECOG.>[ON]

3. You must have a person who is registered in Face Recognition in your framed image

The criteria for items 1 and 2 are automatically met in the following situations:
- Intelligent Auto Mode is selected on the mode dial
- A predefined scene mode that allows Face Recognition is selected

Registering Faces

There are two different times when you have the opportunity to register faces for future face recognition: prior to taking a picture and when you are actually taking a picture. The actual face registration is the same in both cases; how you enter into the process is different.

Registering Faces Prior to Taking Pictures

The Face Recognition registration system is pretty extensive, but fortunately it is simple to follow. The camera gives you plenty of help along the way. The FACE RECOG. command is initially set to [OFF] and will automatically be set to [ON] once a face is registered.

First, to register a face, you will need to have your subject available for picture taking. Then you can follow these general steps to register a face:

1. Enter MENU/SET>REC>FACE RECOG.>[MEMORY].
2. Six boxes are displayed on the screen. Each box represents a slot to register a

person. The first available slot will have [NEW] superimposed on it (figure 4-2a). When a person is registered, the person's image will be displayed in the box, and [NEW] will be superimposed on the next available slot. Select the box labeled [NEW]. You can navigate through the screen using the rear dial or the directional arrow buttons. When the [NEW] box is selected, press the MENU/SET button.

If you have already registered six faces, you will have to delete one before you can register another. We cover deleting registered faces in the section "Keeping Face Recognition Up to Date" later in this chapter.

3. You will be directed to take the first of up to three images of the person you wish to register. Choose carefully. You want to make sure the images represent a good sampling of the person's appearance and facial expressions. Use indoor and outdoor settings to vary the lighting. The camera software will walk you through the necessary steps for taking the picture.

4. After you have saved the image, a screen appears with the image you just took along with the following menu options: NAME, AGE, and ADD IMAGES. Use the directional arrow buttons to navigate through each of the menu option screens.

To enter the person's name (up to nine characters), select NAME>[SET]. The resulting text entry screen may look complicated, but it is really quite simple. The DISPLAY button controls the keyboard pad. Pressing the DISPLAY button will cycle through a capitalized alphabet, lowercase alphabet, and number/symbol keyboard, as indicated by the three icons in the upper-right corner.

Use the directional arrow buttons to navigate through the screen and the MENU/SET button to enter selected values. Once you have entered the name, highlight the SET icon in the upper-left portion of the screen and press the MENU/SET button to accept the entered name.

To enter the person's age, select AGE>[SET]. You will be presented with a screen to enter the person's birth date (in the date format selected when the camera's clock was set). Use the directional arrow buttons to navigate through the date components and their values. Press the MENU/SET button to accept the subject's birth date.

Select the ADD IMAGES option to add another sample image (figure 4-2b).

5. Review the images to make sure they cover a diverse representation of how the person typically looks (figure 4-2c). If you are not satisfied with one of the sample images, select it and press the MENU/SET button to select it for deletion. Press the up directional arrow to select [YES], then press MENU/SET.

6. If you are happy with the sample images, press the Trash Can button to accept the sample images and exit the process (figure 4-2d).

7. Press the Trash Can button to exit the Face Recognition system.

You can also press the shutter-release button halfway to exit the Face Recognition Registration process.

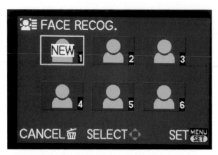

Figure 4-2a: Empty Face Recognition registration screen

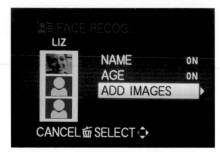

Figure 4-2b: Adding face registration information

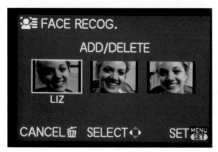

Figure 4-2c: Three sample images added

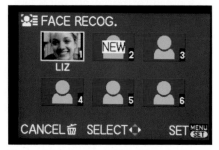

Figure 4-2d: Completed Face Recognition registration for one person

How Is a Person's Age Calculated?

As part of Face Recognition, the camera's software will calculate the person's age based on the date the picture was taken (using the camera's [CLOCK SET] value) and the birth date entered when the person was registered. The person's age and name will be stored with the saved picture, so when you take a picture of your sister one day and then take another picure the next year, the camera will calculate her age in the second picture as a year older.

If you registered your subject with the wrong birth date or your camera's clock was set incorrectly, all of the pictures saved prior to making the correction will be based on the original birth date, and all of the pictures saved after the correction will be based on the corrected birth date.

Registering Faces as You Take Pictures

First the camera needs to be set to a mode that does face detection, such as Intelligent Auto. Then MENU/SET>REC>FACE RECOG.>SET>AUTO REGISTRATION>[ON] needs to be set. This will cause the FACE RECOG. screen to be displayed after taking several pictures of the same face in succession. The camera will ask if you wish to register the person's face at that time. Select [YES] and follow steps 3 through 7

in the section "Registering Faces Prior to Taking Pictures" earlier in this chapter. Remember, if all six slots are filled, you will have to delete one of them before you can add a new person. The software will walk you through that process.

All Six Slots in Face Recognition are Filled, but I Want to Add More

In this case you have only two choices. You can delete one of the existing registered faces and add a new one in its place, or you can handle the face recognition outside of the camera by downloading your pictures to your computer and using third-party face recognition software.

Keeping Face Recognition Up to Date

Keep in mind that you can always change the sample images for a registered face and still retain the registered information both in the Face Recognition system and on the previously saved pictures stored on your memory card. This is especially important for your children's photographs as they mature from preteen, to teenager, to young adult. You can delete old sample images that no longer reflect how the person looks. You can also delete a registered face if you no longer plan to take pictures of that person. In doing so, the three associated sample images will be deleted.

To delete a registered face along with its three sample images, follow these steps:

1. Enter MENU/SET>REC>FACE RECOG.>[MEMORY].
2. Six boxes are displayed on the screen; each contains an image representing a person you have registered. Select the box of the person you wish to delete and press the MENU/SET button.
3. Select [DELETE]. Press the MENU/SET button.
4. Select [YES]. Press the MENU/SET button.
5. You can either register another person or press the Trash Can button and exit the Face Recognition system.

Change Sample Images

To change a sample image, follow these steps:

1. Enter MENU/SET>REC>FACE RECOG.>[MEMORY].
2. From the six displayed boxes, select the image you wish to change.
3. Select [INFO EDIT]. Press the MENU/SET button.
4. Select the [ADD IMAGES] option. Press the right directional arrow button.
 At this point you will execute the same steps as when you set up the Face Recognition registration prior to taking pictures.
5. Press the Trash Can button to exit the Face Recognition system.

Enhancing Face Recognition Capability

As mentioned earlier, the Face Recognition software does not always recognize a person's face. To improve its accuracy, you might want to register your sister twice, using two of the six registration slots. This way you can have a total of six sample images for her—three for each of the registrations. You can repeat this strategy with two other people. This approach improves the chances of correct recognition, but at the expense of the total number of individuals you can register.

Another option is to increase the sensitivity of face recognition using its SENSITIVITY command:

MENU/SET>REC>FACE RECOG.>SET>SENSITIVITY>[HIGH], [NORMAL], [LOW]

This command increases or decreases the Face Recognition software's sensitivity. Increasing the sensitivity can increase false positives (giving the wrong person a name). Decreasing the sensitivity can cause more false negatives (greater failure to identify the person). We recommend setting this option to [NORMAL] and changing it only if you have problems obtaining matches. Review your subject's sample images first. If they appear to be good choices, then consider changing the SENSITIVITY value.

Mode Dial

The mode dial contains 14 different modes (figure 4-3). The dial rotates 360 degrees in either direction. Turn the dial until the chosen mode is in line with the white line on the camera body next to the dial. You will hear and feel a click when the selected mode is in position.

The mode dial is the starting point for exerting control in your pictures and videos. It provides

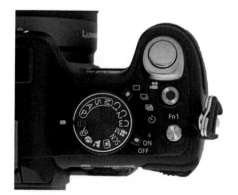

Figure 4-3: Mode dial is set to SCN Mode

you a mixture of automatic and semiautomatic settings, additional artistic features, and the ability to save a group of custom settings for easy recall.

We will cover the Intelligent Auto Mode and the predefined scene modes in this chapter, and the remaining modes will be covered in later chapters.

Intelligent Auto Mode

As mentioned in chapter 1, the Intelligent Auto Mode is activated by setting the mode dial to the iA option. When it is selected, an iA icon will appear in the lower-left corner of the display screen. In a sense, this is a master command in that it can override your camera settings by substituting replacement options and commands (table 4-1). Note that these values cannot be changed unless they are listed in the INTELLIGENT AUTO menu, with the exception of the HISTOGRAM command.

While in Intelligent Auto Mode, you can view and modify the available menu command options. Press the MENU/SET button to access the main menu screen. INTELLIGENT AUTO will appear in the screen's title bar, and an iA icon menu option will be at the top of the main menu list on the left side (figure 4-4). The displayed screen contains only the available main menu commands, with paths to their associated submenu commands and values. The list is a small subset of the total list. Don't be surprised by the disappearance of commands you might have seen when surfing the menu structure outside of Intelligent Auto Mode. It isn't that most of them are not being used; it is that Intelligent Auto will determine their values automatically for you when it is presented with a framed image.

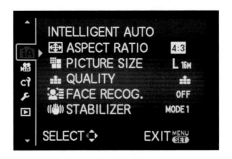

Figure 4-4: Intelligent Auto Mode's MENU/SET screen

When you are in Intelligent Auto Mode, find and frame your subject. Under ideal conditions, the camera identifies what it sees and quickly sets the aperture, focusing, color balance, and exposure that are appropriate for the subject. You can press the shutter-release button halfway to apply Intelligent Auto Mode's decisions and have them posted on the display screen—of course, what you see depends on your chosen data display screen format. This will give you advanced information on how the camera interprets the image.

Intelligent Auto Preset Command and Setting Values	
Command	**Value**
MENU/SET>SETUP>(pg 2) ECONOMY>SLEEP MODE	5 MIN
MENU/SET>REC>(pg 2) FLASH	⚡A (Auto) or ⊘ (Flash Off)
MENU/SET>REC>(pg 2) FLASH SYNCHRO	1ST
MENU/SET>REC>(pg 4) BURST RATE	H (High speed)
MENU/SET>REC>(pg 4) AUTO BRACKET>SETTINGS	⊟ (Burst)
MENU/SET>REC>(pg 4) AUTO BRACKET>STEP	3 1/3
MENU/SET>REC>(pg 4) AUTO BRACKET>SEQUENCE	0/−/+
MENU/SET>REC>(pg 3) ISO LIMIT SET	800
MENU/SET>REC>(pg 2) METERING MODE	[(•)] (Multiple metering)
MENU/SET>REC>(pg 2) RED-EYE REMOVAL	ON
MENU/SET>REC>(pg 3) i.DYNAMIC	STANDARD
MENU/SET>REC>(pg 3) LONG SHTR NR	ON
MENU/SET>REC>(pg 5) COLOR SPACE	sRGB
MENU/SET>MOTION PICTURE>PICTURE MODE	🎥 (Motion Picture Priorities)
MENU/SET>CUSTOM>(pg 2) PRE AF	Q·AF (Quick AF)
MENU/SET>CUSTOM>(pg 2) FOCUS PRIORITY	ON
MENU/SET>CUSTOM>(pg 3) AF ASSIST LAMP	ON
Setting	Value
AF Mode = AFS or AFC and face is detected	😊 (Face Detection)
AF Mode = AFS or AFC and face is not detected	⊞ (23-area-focusing)
ISO	iISO
White Balance button	AWB

Table 4-1: Intelligent Auto Mode's automatically set commands and camera settings

There may be times when the camera cannot obtain focus for your framed subject. When this occurs, the preset Intelligent Auto command MENU/SET>REC>FOCUS PRIORITY>[ON] prevents the camera from firing. Typically this occurs when there is too little contrast or light in the image. It can also occur when the subject is closer than the minimum-focusing limit of the lens. When this happens, reposition your subject so there is more light, or if the subject is too close, back away until the camera establishes focus. You cannot alter the contrast of the subject; however, increasing the light intensity helps the sensor. The camera can usually find focus if

the ambient intensity is raised sufficiently. There are additional solutions when you are outside of Intelligent Auto Mode. They will be covered in chapters 6 and 7 when we cover taking control of your camera's settings.

Watch out for any icons glowing red because they represent warnings. For example, a too-slow shutter speed for taking a handheld exposure will display a Jitter icon (figure 4-5). This is your signal to use the flash to increase the light and thereby increase the shutter speed. If a flash is unavailable, mount the camera on a tripod to prevent any camera movement. This warning helps you prevent taking pictures when the chances are high that they will be blurred. The Intelligent Auto function generally makes excellent camera setting decisions for your image, and for many people the settings will be sufficient for recording pictures or videos.

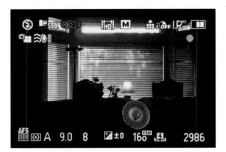

Figure 4-5: The red Jitter icon in the upper-left corner of the display screen

My Settings Are Not Working in Intelligent Auto Mode
This is an easy mistake to make. The Intelligent Auto Mode has its own default settings. So if you had set the camera's BURST RATE command to [SH] and then turned the mode dial to iA, the camera software will use a burst rate of [H] instead. Table 4-1 lists the Intelligent Auto Mode command settings. You can also view the camera settings by pressing the MENU/SET button while in Intelligent Auto Mode. As soon as you exit Intelligent Auto Mode, the camera's command settings will revert back to your previously set values. In the previous example, the BURST RATE command value will revert back to [SH].

Intelligent Auto Scene Detection

As part of Intelligent Auto Mode, the camera will evaluate the scene and assign it to a category from the following list: i-Portrait, i-Scenery, i-Macro, i-Nighttime Portrait, i-Nighttime Scenery, i-Sunset, i-Low Light, i-Baby, and General (table 4-2). This is significant, because it is more than automatic exposure—it is matching the subject for the best settings. When the category is determined, the camera displays its icon (figure 4-6) in the lower-left corner of the display screen in blue for two seconds and then changes it to a smaller icon displayed in red.

Figure 4-6: Picture's selected category displayed in blue

In addition, the software will save the category with the picture or video so you can use it as a search item. As you can see in table 4-2, there are fewer available categories when you are recording videos. For videos, nighttime portraits and scenery will be assigned the i-Low Light category.

There are times when the camera software is unable to determine a specific category, so the iA icon is displayed on the screen and the camera chooses generic settings. You will get a good exposure, but the shutter speed, aperture, and ISO may not be the best setting.

Intelligent Auto Category	Display Screen Icon	Available for	
		Still Pictures	Videos
i-Portrait		X	X
i-Scenery		X	X
i-Macro		X	X
i-Nighttime Portrait		X	
i-Nighttime Scenery		X	
i-Sunset		X	
i-Low Light			X
i-Baby		X	
General (Default)		X	X

Table 4-2: Intelligent Auto Mode available categories and icons

Each of the Intelligent Auto Mode categories has predefined camera settings to optimize the resulting picture or video per the software's interpretation. For example, the camera is capable of detecting when there is a human face in the image. When it is detected, the camera's intelligent software will assign the appropriate scene category, depending on the ambient light intensity and whether you're taking a picture or a video. In both cases, the focus and exposure is set on the face. When you're taking pictures, if FACE RECOG. is [ON], the software will also check to see if the face has been registered.

Why Isn't the iA category for an Image of My Cat Identified as a Portrait?

Yes, your cat has two eyes, a nose, and a mouth, and we are sure it is very cute. Face detection and recognition software is for human features. That means the camera is looking for structures and proportions characteristic of a human physiognomy. A cat's eyes, nose, and mouth are uniquely feline.

Intelligent Auto Categories

Some of the parameters used for classifying a picture are based on what is lacking. The failure to identify a face means the scene is not categorized as i-Portrait. The failure to focus on a close subject (i.e., within about one foot) means the scene is not categorized as i-Macro. Frequently, the camera may identify a distant shot as a scenic shot, but as we mentioned earlier, this is not always the case. In other words, scene identification as practiced by Intelligent Auto is imperfect. It should be viewed as a convenience, and as you become more comfortable with using the camera, you can categorize the subject yourself and select the appropriate predefined scene mode.

i-Portrait and i-Nighttime Portrait (Daytime and Nighttime)

The Intelligent Auto Mode assigns a portrait category when the camera's software detects a human face in the image. The software goes a step further and determines if the image's setting is daytime or nighttime. In both daytime and nighttime portraits, if there is insufficient light, the camera will prompt you with the message PLEASE USE THE FLASH when the shutter-release button is pressed. The camera will prevent you from taking the picture until you either pop up the flash unit or supply additional lighting to the image.

For pictures in which the Face Recognition option is enabled (MENU/SET> INTELLIGENT AUTO>FACE RECOG.>[ON]), the camera software will search for a registered face. If it is found, the camera software will display an R within the category icon and the registered name beneath the face. In addition, the camera will determine if the registered subject is a baby when the calculated age is 3 years

or less. If the subject is a baby, the resulting picture will be assigned the i-BABY category for future playback and group selection identification. If the subject's calculated age is greater than 3 years, the resulting picture will be categorized as an i-Portrait or i-Nighttime Portrait, depending on the camera software.

i-Scenery and i-Nighttime Scenery (Daytime and Nighttime)

The Intelligent Auto Mode determines that an image should be in a scenery category based on a combination of what it is and what it is not. It is unclear what parameters are important for this function. We have noticed when taking multiple pictures of the same scene within seconds of one another, one can be categorized as i-Scenery and the next can be undetermined and therefore assigned the general iA category.

As with portraits, the software goes a step further and determines fairly accurately if the image is of daytime or nighttime scenery. In the case of videos, the category classification is either i-Low Light or i-Scenery. Videos recorded in dim light, regardless of the location, are assigned the i-Low Light category. Videos recorded with sufficient lighting are assigned the i-Scenery category.

i-Macro

This category is assigned when the Intelligent Auto software determines that the subject is close to the lens and the camera is able to obtain focus on the subject. This second point is very important. If the camera cannot obtain focus on the subject, the Intelligent Auto category will not be set to i-Macro, and the shutter-release button will be disabled and will not allow you to take the picture.

How close is close? For the picture to be considered in the macro category, the subject should be about 0.3 meters or about 1 foot away from the camera when using the standard 14–42 mm f/3.5–f/5.6 lens that is included with the Panasonic GH2 camera.

When the camera obtains focus on the subject, its software will attempt to close down the aperture to increase the depth of field and ensure that the subject and its surroundings appear sharp. In close-up work, the depth of field is narrow, so objects rapidly lose sharpness as their distance from the plane of focus increases or decreases. For example, when you photograph a butterfly, its body may be recorded sharply, but its wings become blurred. Because of this, i-Macro will bias its setting to prioritize maximum depth of field. This may require a long shutter speed, and it may be necessary to steady the camera by using a tripod or placing the camera on a solid surface.

i-Sunset

The Intelligent Auto software has the ability to identify rich red- and orange-hued sunset (and sunrise) scenes. Not all sunsets will have sufficient coloring for the

Intelligent Auto Mode to generate this category. If you intend to take a picture of a sunset and it is not registering in Intelligent Auto Mode, switch over to the Scene Mode option on the mode dial and select the Sunset predefined scene mode. This will ensure that the camera is set to capture the scene and emphasize the rich reds and oranges commonly displayed in beautiful sunsets.

i-Baby

The assignment of the i-Baby category is a three-step process. As in the case of i-Portraits, the camera must be able to first identify that it there is a face in the image and obtain focus. Then the camera must recognize that the face is registered within the camera's memory. The third step is to calculate the registered face's age by using the stored birth date. This is the same process as for Portraits. If the person's calculated age is 3 years or younger, the subject is classified as a baby and will be assigned the i-Baby category.

 This category causes the camera to adjust for a softer flash, which is less disturbing for the baby. As with i-Portrait, the camera software will display an R within the i-Baby icon along with both the baby's registered name and age. This information will be stored with the picture for use in future playback, printing, and downloading to your computer.

i-Low Light

This Intelligent Auto category is chosen only for videos recorded in low-light environments. Although the camera's software can adjust its settings to capture more light for pictures, video capture does not have the same flexibility. As an example, the i-Macro category may be identified when you're framing a picture, but when you switch over to record a video, the lighting that was sufficient for an i-Macro picture may be insufficient for the video. In this case the displayed icon will change to i-Low Light.

General (Default)

If the Intelligent Auto Mode is unable to determine a specific category for the image you intend to record, it will set the camera to a general exposure (shutter speed and aperture), select 23-area-focusing mode, and assign the iA icon as the picture or video category.

Changing Intelligent Auto Settings

You have the option to modify some of the camera's Intelligent Auto settings. There are a couple of ways to do this. By viewing the potential picture, you can use the Q.MENU button on the back of the camera or the Q.MENU icon on the LCD screen to review and possibly change the camera settings selected for your image. When you play back the picture or video with the Playback button, you can also review the resulting camera settings by pressing the DISPLAY button.

In doing so, you may decide to change the camera settings and reshoot. Note that most of the available setting adjustments will have nothing to do with the exposure, focus, or aperture—Intelligent Auto Mode controls those functions, as seen in table 4-1. You can view the available settings and make changes by pressing the MENU/SET button and going through the menu structure. (See appendix B for a list of available Intelligent Auto Mode MENU/SET commands.) Changes to the shutter speed and aperture are made with the Exposure Compensation tool, as described in chapter 3.

Predefined Scene Modes

For a new camera user, Intelligent Auto Mode is a convenient means for taking pictures and videos. But occasionally it will fail to categorize a scene correctly, and the resulting camera settings will not be optimal. For example, an image identified as scenery might better be identified as a sunset. To remedy this, the camera allows you to select a specific scene identification with predefined camera settings.

There are four mode dial options (table 4-3) and each contains predefined scene modes to choose from. Three of these mode dial options—Close-up, Scenery, and Portrait—act as a classification with subcategories. Panasonic calls these options advanced scene modes. For example, the Close-up mode dial option contains a group of four related scenes: Flower, Food, Objects, and Creative Close-up. Each of these themed subcategories has predefined camera settings based on what the camera sees.

Predefined Scene Mode	Predefined Scene Mode Dial Icon	Description
Scene (miscellaneous scene mode)	**SCN**	Gives you a selection of miscellaneous scene scenarios. Generates specific camera settings for selected scene.
Close-up (advanced scene mode)	🌷	Gives you a selection of close-up scenarios. Generates specific camera settings for selected option.
Scenery (advanced scene mode)	🏔	Gives you a selection of scenery scenarios. Generates specific camera settings for selected option.
Portrait (advanced scene mode)	👤	Gives you a selection of portrait scenarios. Generates specific camera settings for selected option.

Table 4-3: Mode dial options containing predefined scene modes

The fourth mode dial option is called the Scene Mode and is marked with the letters SCN. The Scene Mode option could just as easily have been described as miscellaneous. It contains a wide list of unrelated predefined scenes from which to choose. To simplify things, we refer to all of the individual scenes within each of these four mode dial options as predefined scene modes. This covers their function exactly and, hopefully, removes some of the confusion in Panasonic's rather arbitrary distinction between the Scene Mode and the advanced scene modes.

To use the predefined scene modes, move the mode dial to the desired mode and press the MENU/SET button. The selected mode's associated predefined scene menu will display automatically. Use the rear dial or directional arrow buttons to navigate and select the predefined scene that will best reflect the scene for the picture or video you are about to take. The camera will apply its settings based on the selected scene mode and the characteristics of the image.

Here is a tip before we move on to describing each of the predefined scene modes. The Panasonic GH2 camera has a Help function represented by a bold lowercase i to the left of the word DISPLAY at the bottom of the LCD screen. When you see this icon, press the DISPLAY button. A helpful explanation about the selected predefined scene mode will appear (figure 4-7a, figure 4-7b). To exit, press the DISPLAY button again and you will be returned to the selected predefined scene mode.

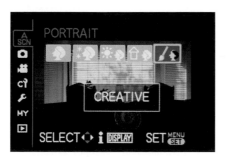

Figure 4-7a: The lowercase i means helpful information is available when you press the DISPLAY button

Figure 4-7b: Information screen for the Creative Portrait predefined scene mode

The following sections cover each of the predefined scene modes. Remember, the camera will set its shutter speed, aperture, exposure, and other criteria to best record the selected scene. As mentioned earlier, you still have the option to override the camera's selected values using the Exposure Compensation function. In addition, you can make changes to some of the command settings within the main menu, but in most cases the applied settings will give you a quality picture or video for the subject you desire to record.

> ### What Menu Commands Are Automatically Adjusted in the Predefined Scene Modes?
>
> The camera software will automatically adjust the following commands to the optimal setting, based on the selected predefined scene mode and the image brightness, contrast, movement, and interpretive content:
>
> MENU/SET>REC>FACE RECOG.>SENSITIVITY
>
> MENU/SET>REC>METERING MODE
>
> MENU/SET>REC>(pg 2) FLASH SYNCHRO*
>
> MENU/SET>REC>(pg 3) I.RESOLUTION
>
> MENU/SET>REC>(pg 3) I.DYNAMIC
>
> MENU/SET>REC>(pg 3) ISO LIMIT SET
>
> MENU/SET>REC>(pg 4) DIGITAL ZOOM
>
> Items other than [STANDARD] and [STANDARD (B&W)] in Film Mode
>
> * FLASH SYNCHRO can be modified for the Scene Mode's PERIPHERAL DEFOCUS scene mode.

Scene Mode

The Scene Mode contains nine predefined scene modes covering a wide variety of scene types (table 4-4). Each of these predefined scene modes set the camera's optimum exposure and hue to obtain the desired picture for the selected scene. Select the SCN icon on the mode dial and press the MENU/SET button. The predefined scene modes display as separate icons (figure 4-8). Rotate the rear dial or press the left or right directional arrow buttons to move through the list. Press the MENU/SET button to select the highlighted predefined scene mode.

SCN Predefined Scene Mode	Display Screen Icon	Description
PERIPHERAL DEFOCUS		This mode allows the focus to be set on the subject and the background to be blurred to further enhance the subject. This uses 1-area-focusing auto focus. You can position the area of focus via the directional arrow buttons or by touching the screen.
NIGHT PORTRAIT		This mode is used to take photographs of people in a nighttime setting. The exposure and shutter speed are set to capture enough light to create a detailed portrait with accurate color.
		Both Face Detection and Face Recognition are turned on. If a face is detected, the camera will focus on it. For pictures, the camera software will try to identify the registered face and display the person's name and age. The flash will be reduced if the recognized face is determined to be of a person 3 years old or younger.

SCN Predefined Scene Mode	Display Screen Icon	Description
NIGHT SCENERY		This mode uses a slow shutter speed to allow the camera to capture enough light to vividly record the total scene.
SUNSET		This mode captures the rich red and orange hues featured in sunsets. It can also be used for sunrises. Use this mode if you are unable to get i-Sunset to register in the Intelligent Auto Mode.
PARTY		This mode captures the natural hues of people and objects in both the foreground and background. It's great for weddings, parties, and other indoor activities.
SPORTS		This mode allows you to capture a rapidly moving subject by using a fast shutter speed. It uses 1-area-focusing initially but you can change the focusing mode using the auto focus mode dial.
BABY1		This mode offers you an opportunity to enter a child's name and birth date. Once they're entered, each time Baby1 Mode is selected, the child's name and calculated age is displayed on the screen and will be stored with the picture for playback and print purposes. When used, the flash strength is reduced. Automatic focus is set to AF Tracking so the camera can maintain exposure and focus as the baby moves. Note: This is not the same as Face Recognition and does not identify the baby through the camera software. The subject could be anything, but the purpose is for the user to group all of one baby's pictures together under BABY1 and another baby's pictures under BABY2. Use this mode when you have not registered the baby's face in the Face Recognition software.
BABY2		This mode is the same as BABY1. It offers you an opportunity to enter another child's name and birth date. See BABY1 for specifics.
PET		This mode offers you an opportunity to enter one pet's name and birth date. Once entered, each time Pet Mode is selected, the pet's name and calculated age is displayed on the screen and will be stored with the picture for playback and print purposes. Automatic focus is set to AF Tracking so the camera can maintain exposure and focus on a rapidly moving pet. Note: As with BABY1 and BABY2, the camera software does not recognize the pet, only that you have selected the Pet predefined scene mode.

Table 4-4: The SCN Mode's available predefined scene modes

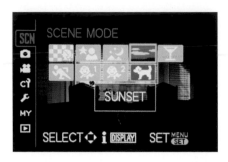

Figure 4-8: The SCN Mode's SUNSET predefined scene mode selected

The camera allows you to store the name and age (birth date) of the subject in the Baby1, Baby2, and Pet predefined scene modes. This stored information will be displayed on the image when the mode is selected, and it will be stored with the resulting picture for playback and printing of the picture. Figure 4-9a shows a picture that was taken using Scene Mode's Pet predefined scene mode. The pet's name is displayed initially for a few seconds, but then only the age remains (figure 4-9b).

Figure 4-9a: The pet's name is initially displayed

Figure 4-9b: The pet's name disappears after a few seconds

Note that the camera does not know if you are framing an image of your pet or something else, like a flower. If you select the Pet predefined scene mode, the camera will assume you are recording your pet and will assign the stored information to it.

Advanced Scene Modes

Each of these three mode dial options acts as a classification or theme containing a group of predefined scene modes that pertain to the parent mode. Each predefined scene mode will determine some of the camera settings, although the CREATIVE option gives you the opportunity to alter the shutter speed with the aperture. Depending on which predefined scene you've selected, you can control the shutter speed to create blur in a moving subject, or you can vary the depth of field to limit sharpness to the plane of your subject or expand sharpness to encompass

a much greater area (figure 4-10b). Here you will start moving into the realm of controlling the outcome of the image capture yourself. This is a preliminary step toward semiautomatically operating the camera and exerting your own creativity in your pictures and videos.

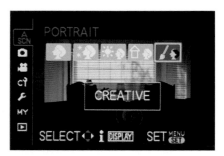

Figure 4-10a: Portrait Mode's Creative predefined scene mode selected

Figure 4–10b: Creative predefined scene mode screen

Close-Up Mode

The Close-up Mode (figure 4-11) recognizes that macro photography is sensitive to camera movement, and therefore a tripod is recommended. You should use a shutter-release cable to prevent additional movement resulting from pressing the shutter-release button. Table 4-5 contains this mode's predefined scene modes.

Figure 4-11: Close-up Mode's FLOWER predefined scene mode selected

Close-up Predefined Scene Mode	Display Screen Icon	Description
FLOWER		This mode helps record the natural colors of outdoor flowers. Note: Guide lines will be displayed according to the MENU/SET>CUSTOM>GUIDE LINE command setting.
FOOD		This mode helps record pictures of food with their natural hues without being affected by restaurant ambient light.
OBJECTS		This mode is tailored for taking close-up pictures of small objects while maintaining focus and accurate colors.
CREATIVE		This mode allows you to change the aperture to increase or decrease the depth of field.

Table 4-5: Close-up Mode's available predefined scene modes

Scenery Mode

Scenery Mode (figure 4-12) is used for a variety of landscape scenes, mostly outdoor scenes that require a greater depth of field and include a variety of colors. This mode has the scenarios listed in table 4-6.

Figure 4-12: Scenery Mode's NORMAL predefined scene mode selected

Scenery Predefined Scene Mode	Display Screen Icon	Description
NORMAL		This mode helps create sufficient depth of field to capture the depth and vastness of a normal landscape scene.
NATURE		This mode is the best setting for capturing images of natural scenery. The focus is broad and covers the complete scene.
ARCHITECTURE		This mode displays guide lines according to the MENU/SET>REC>CUSTOM>GUIDE LINE option. The displayed guide lines help you to center and/or align the subject.
CREATIVE		This mode allows you to adjust the lens aperture to control the depth of field.

Table 4–6: Scenery Mode's available predefined scene modes

Portrait Mode

Portrait Mode (figure 4-13, table 4-7) should be used when you are taking a picture or video containing at least one person. Make sure the auto focus mode dial is set to Face Detection so the camera will find and set focus on the face. In addition, Face Recognition functionality is enabled when you're taking pictures.

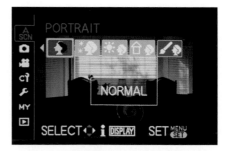

Figure 4-13: Portrait Mode's NORMAL predefined scene mode selected

When a face has been detected, the camera software will also search through its maximum six registered

faces to see if there is a match. If so, the person's registered name and age will be displayed with the image and resulting picture.

Portrait Predefined Scene Mode	Display Screen Icon	Description
NORMAL		This mode shades the background and adjusts the image to better capture the subject's skin tones.
SOFT SKIN		This mode makes exposed skin appear smoother, much like airbrushing. Note: Part of the background will also be blurred out if its coloring is close to the subject's skin color.
OUTDOOR		This mode prevents the image from appearing as though the subject is in shadows and is too dark to recognize.
INDOOR		This mode sets the ISO sensitivity to ensure that the image is in focus with proper lighting.
CREATIVE		This mode allows you to set the aperture value to create background blurring for an artistic picture.

Table 4-7: Portrait Mode's available predefined scene modes

Recommendations

It is not always obvious what is going on within the camera software in Intelligent Auto Mode or one of the predefined scene modes. We recommend that you review your work and evaluate your saved files to determine if the results satisfy your needs. Check out the camera command setting nuances for a specific predefined scene mode. You can always view the camera settings of an image in the selected data display screen format as described in chapter 3. You can also review the camera settings after the fact with the Playback button. Keep in mind that the camera software is doing a best guess and implementing decisions based on what is considered a typical picture. Just because the Intelligent Auto or predefined scene modes determine your camera's settings, it doesn't mean you can't make some adjustments of your own.

We recommend that you review the image's histogram to determine whether the exposure appears optimum. You can activate the Exposure Compensation scale, make exposure adjustments prior to taking pictures, and review your results. Experiment with your options. You can view the available camera commands through the Quick Menu or through the menu controls using the MENU/SET button. Play with them and become familiar with how they can change your picture-taking experience.

If the results are satisfactory, you may decide that there is no need to learn more about the camera. However, we believe you will grow out of using these predefined scene modes and will wish to explore using the camera semiautomatically or manually, which is covered in chapters 6 and 7. Panasonic has done an excellent job of making sure what you learn when you first start using the camera is useful later as you explore more of the camera's capabilities and your picture taking and video recording creativity.

Setting the Camera Using Shortcuts

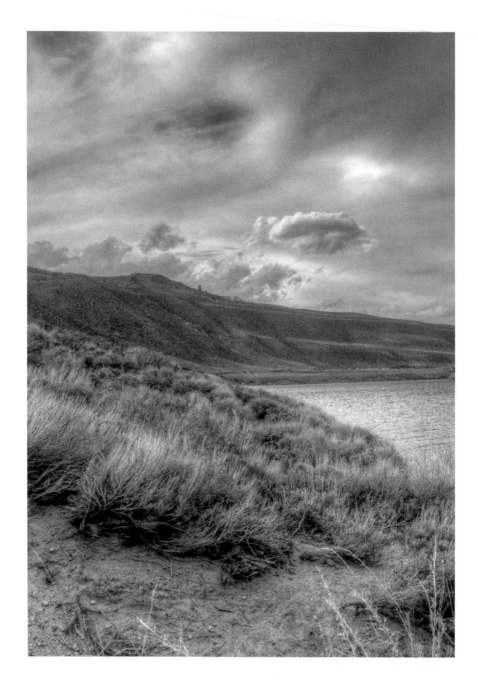

Introduction

Navigating the menus and setting the commands on the Panasonic GH2 can be laborious. The number and diversity of commands makes it difficult to find and select the setting you need. To remedy this, the camera has six shortcuts available: Quick Menu, My Menu Mode, Function buttons, Custom Modes, My Color Mode, and Film Mode. They range from dedicating a single button for one command, to quickly modifying a few commands, to using a complete set of command values for a specific scenario. Mastering these shortcuts will simplify camera operation.

Quick Menu and My Menu Mode allow you to set a few commands easily and quickly by avoiding the MENU/SET menu structure. The three Function buttons can each be assigned a command or action so the camera can execute it at a press of the button. Custom Modes do as their name implies. Instead of setting and resetting your camera's command values, you can store a customized set of command values for instant recall. This can give your camera a whole new personality, and it will be as if you have four cameras rather than just one. My Color Mode and Film Mode allow you to set a color scheme for your pictures and videos that will be in place until that scheme is deactivated.

Quick Menu

When you are out in the field, selecting settings is simplified and quickened by using the Quick Menu option. It lists only the most commonly used commands so they can be quickly found and their values can be changed by touching the LCD screen. The Quick Menu is available in Intelligent Auto Mode and all of the mode dial options except My Color.

One major advantage of the Quick Menu is that you can easily see what commands and associated values are available for you to change. This saves you from spending time navigating through the MENU/SET menu structure to find a command, only to learn that it is unavailable.

There are three points to keep in mind when using Quick Menu. First, the Quick Menu option can be activated in two ways. You can press the Q.MENU button at the upper-right on the back of camera (figure 5-1a) or you can touch the Q.MENU icon on the LCD screen (figure 5-1b). Both will display the Quick Menu data on the display screen.

To display the Q.MENU icon on the LCD screen, ensure the following command is set:

MENU/SET>CUSTOM>(*pg* 6) TOUCH Q.MENU>[ON]

Second, how you initiate the Quick Menu determines how you navigate through its data. If you used the Q.MENU button on the back of the camera, you use the rear

dial and the directional arrow buttons to navigate through the command options and available values. The navigation rules depend on the LCD screen's display style (MENU/SET>CUSTOM>(*pg* 4) LCD DISP.STYLE). The LCD Monitor Style displays the Quick Menu options, with the selected option's available values in a drop-down list that enables you to see your command options immediately. The Viewfinder Style highlights the command to be changed. To see the values of the selected option, push the MENU/SET button or push in the rear dial. To navigate through the available options, use the up and down directional arrow buttons or rotate the rear dial. As always, experiment with the different styles and determine what works best for you.

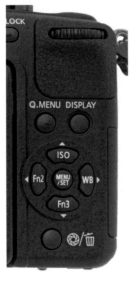

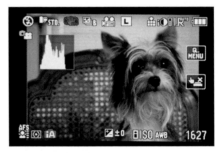

Figure 5-1b: Q.MENU icon on the LCD screen

Figure 5-1a: Q.MENU button on the back of the camera

If you initiate the Quick Menu using the touch Q.MENU icon on the LCD screen, data display and navigation is much simpler and more straightforward. All of the available commands are displayed across the top of the screen. The available options of the highlighted command are displayed on the right side of the LCD screen. To select a value, just touch the associated icon.

If you initiate the Quick Menu using the Q.MENU button, the menu navigation is dependent on which LCD display style you select. The LCD Monitor Style displays the Quick Menu options with the selected option's available values in a drop-down list. The Viewfinder Style displays only the Quick Menu options. To see the values of the selected option, press the MENU/SET button or push in the rear dial. Rotate the rear dial or use the up and down directional arrow buttons to navigate through the available options.

One advantage of the Quick Menu display is that you can navigate to a command without having to navigate through the MENU/SET menu structure. Another advantage is that you can easily see what commands and associated values are available for you to change. This is a time saver because you don't have to navigate through the MENU/SET menu commands to find the command, only to learn of its unavailability by its grayed-out appearance.

The third point to remember is that regardless of how you entered the Quick Menu, the changes you make are reflected immediately; they are stored as the command's value and will be utilized in all subsequent pictures and/or videos. The next time you initiate the Quick Menu or the MENU/SET button, the previously set command values will display.

You can exit the Quick Menu display several ways: touch the Q.MENU OFF icon on the LCD screen, press the shutter-release button halfway, press the Q.MENU button a second time, or take a picture or initiate a video. The Quick Menu will disappear, and you will be returned to the normal screen format.

Quick Menu Recommendation

We prefer to use the Quick Menu touch method to set menu items. This is much easier and allows us to navigate through the available commands and their values quickly and with minimal effort.

My Menu

MY MENU displays the last five commands you have viewed with the MENU/SET button (figure 5-2). If you view or change a command's value with Quick Menu or a Function button, or if you make temporary changes with Custom Mode, that action is not reflected in the MY MENU list.

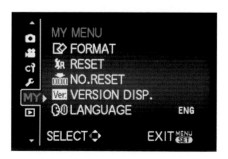

Figure 5-2: MY MENU menu option

This useful shortcut assumes you will most likely need to change the commands that you had previously viewed or set. This list of commands is ever changing. Don't be surprised if you don't see the command you want to review or reset. It doesn't take long to view or set more than five command options. To minimize changes to the MY MENU list, use the Quick Menu or Function buttons. Since neither of their

command settings are reflected in the MY MENU command list, the last five commands you used will stay on the list longer.

If you find that you are constantly changing a specific command value, you may want to set the command to a Function button instead. That way it will always be ready at your fingertips.

My Menu Recommendation

We have found the My Menu shortcut to be very convenient when experimenting with a specific command setting. We can select a command value, quickly shoot a picture, retrieve the command in MY MENU, change the command setting to the next available value, and reshoot. But in those cases when you are not frequently adjusting a command value, we have found it best to use the Quick Menu or Function buttons to view and change command settings.

Setting the Function Buttons

The Panasonic GH2 camera has three Function buttons: Fn1, Fn2, and Fn3. Each Function button is set to one of 18 choices, including commands, modes, and predetermined camera settings (table 5-1). This shortcut gives you immediate access to a specific camera setting by pressing a function button.

Fn BUTTON SET Option	Description
INTELLIGENT AUTO	Sets the camera to Intelligent Auto Mode
FILM MODE	Displays the Film Mode's menu
FOCUS AREA SET	Displays the focus target box for positioning and sizing
ASPECT RATIO	Displays the ASPECT RATIO command's options
QUALITY	Displays the QUALITY command's options
1 SHOT + RAW	Sets Quality to RAW + JPEG Fine for one shot only
METERING MODE	Displays the METERING MODE command's options
1 SHOT + *Spot Metering*	Sets Metering Mode to Spot for one shot only
FLASH	Displays the FLASH command's options
FLASH ADJUST.	Displays the FLASH ADJUST. command's options
ISO LIMIT SET	Displays the ISO LIMIT SET command's options
EX. TELE CONV.	Displays the EX. TELE CONV. command's options
BURST RATE	Displays the BURST RATE command's options
AUTO BRACKET	Displays the AUTO BRACKET command's options
GUIDE LINE	Displays the GUIDE LINE command's options
SHUTTER AF	Displays the SHUTTER AF command's options
PRE AF	Displays the PRE AF command's options
REC AREA	Displays the REC AREA command's options

Table 5-1: Function button options

Decide which three camera features you most frequently use and assign them to a Function button. For Function button options in which a command's available values are displayed, use the directional arrow buttons to select the command value and press the MENU/SET button to set it. In contrast, for modes and predetermined camera settings that don't require additional input, a second press of the Function button serves as a toggle. For example, if Fn1 is set to [INTELLIGENT AUTO] and the camera is currently on P Mode, pressing the Fn1 button sets the camera to Intelligent Auto Mode. Pressing Fn1 again resets the function, effectively alternating the camera setting between the two modes.

The Function buttons are located at various spots on the camera. Fn1 is on the top-right of the camera. The Fn2 and Fn3 buttons are on the back of the camera and they double as the left and down directional arrow buttons. Which role these two buttons play is determined by whether you are reviewing a saved image or viewing a scene in preparation for taking a picture. In the former case, the two keys function as directional arrow keys. In the latter case, when composing a scene for picture taking, they serve as function keys. The Fn BUTTON SET command will help direct you to where each button is during setup. Use the following command to set a Function button:

MENU/SET>CUSTOM>Fn BUTTON SET>[Fn1], [Fn2], [Fn3]

Figure 5-3a displays the Fn BUTTON SET command's available options and current values. Notice that the screen also contains a representation of the camera along with the highlighted Function button's location. Press the down directional arrow button to highlight the next Function button value to display the newly highlighted Function button's location.

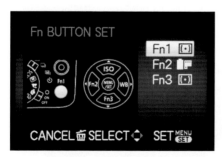

Figure 5-3a: Available Function buttons and assigned values

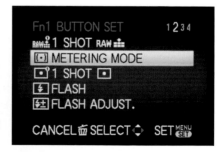

Figure 5-3b: Fn1 BUTTON SET available settings

The camera's Fn1 Function button is originally set to [INTELLIGENT AUTO], Fn2 is set to [FILM MODE], and Fn3 is set to [METERING MODE]. Note that if you execute the camera's RESET command, the Function buttons will retain your specific settings.

Execute the following steps to assign a value to a Function button:

1. Select MENU/SET>CUSTOM>Fn BUTTON SET.
2. Press the right directional arrow button to access the available Fn BUTTON SET values. Use the up and down directional arrow buttons to scroll through them.
3. Highlight a Function button value: [Fn1], [Fn2], or [Fn3]. Press the MENU/SET button to display the list of options (figure 5-3b).
4. Using the up and down directional arrow buttons, scroll through the list of options. Highlight one and press the MENU/SET button to select it. The specified Function button is now set to initiate the specific function when it is pressed.
5. You will be returned to the Fn BUTTON SET command menu with the icon of the selected option displayed next to the specified Function button.
6. At this point you can repeat the process to set another Function button value or exit the CUSTOM menu.

Setting the Function buttons will allow you easy access to commands, modes, and specific settings when needed. When you press a function button, the option is initiated. As your needs change, you can always reset a Function button to another command, mode, or setting.

Function Button Recommendation

We recommend that you set and use the Function button capability. It eliminates the need for you to navigate through the complicated menu structure or set and reset your camera. We set Fn1 for EX. TELE. CONV., Fn2 for setting the BURST RATE, and Fn3 for setting the AUTO BRACKET series. These are commands we cannot execute with Q.MENU. Our rule is anything that can be changed on Q.MENU should not be made into a dedicated function key. As always, experiment. We are sure you will find at least one option you want access to with a Function button.

Custom Modes

The setting and use of custom settings has been simplified and improved with the Panasonic GH2 camera. The camera has three Custom Modes available on the mode dial: C1, C2, and C3. Each mode will hold a set of menu command settings and can be applied to your pictures and videos with a turn of the mode dial (figure 5-4).

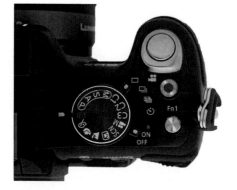

Figure 5-4: Mode dial positioned on the C1 option

Setting a Custom Mode

Custom Modes are set using the CUSTOM menu option:

MENU/SET>CUSTOM>CUST.SET MEM.>[C1], [C2], [C3]

Use the following steps to set a Custom Mode:

1. Set the Menu commands to the values you will want to save in a Custom Mode.
2. Enter the CUSTOM menu structure and select the CUST.SET MEM. command.
3. Select a specific Custom Mode value—[C1], [C2], [C3]—and press the MENU/SET button.
4. You will be asked the following question:

 OVERWRITE CURRENT CAMERA STATUS AS CUSTOM SET *n*? [YES], [NO]

 Note that *n* will be the number 1, 2, or 3 associated with the selected custom setting group.
5. Select [YES] and press the MENU/SET button to replace the selected custom settings group with the new settings. Select [NO] to stop the process and return to the live view display screen.

Any changes to the menu command values after this will not change the saved command values associated with the selected Custom Mode.

Not all of the command values will be saved in the custom setting groups. The following commands are not saved: [CLOCK SET], [WORLD TIME], [TRAVEL DATE], [LCD MODE], [FAVORITE FUNC.], [MENU GUIDE], [LANGUAGE], [TOUCH GUIDE], and [TOUCH SCROLL].

In addition, [FACE RECOG.], [BABY1], [BABY2], and [PET] birthday and name settings are not saved with the saved custom settings.

View Saved Custom Settings

To view the saved custom settings, position the mode dial on a specific Custom Mode icon. Press the MENU/SET button and the displayed command setting values are the values saved in the selected Custom Mode.

Utilize Saved Custom Settings

To utilize a Custom Mode, turn the mode dial to the desired Custom Mode icon (C1, C2, or C3). The saved menu command values of the selected Custom Mode will be in place for you to use.

As long as the Custom Mode icon is selected, you will be using its saved custom settings. You can temporarily override any of the saved settings by selecting a command in the menu structure and changing the value or using the Function buttons to reset a command value. This does not change the saved custom setting group

value, but the new command value will be in effect until you exit the selected mode dial's Custom Mode.

Custom Mode Recommendation

This time-saving feature can be very useful if you take pictures with a specific group of camera settings over and over again. Panasonic has made this a very easy feature to save, view, and repetitively use a group of command settings without slowing you down. The only concern you might have is which Custom Mode is for what type of pictures or videos. In this case, we recommend you keep some simple notes outlining which Custom Mode is for what type of images so you can easily refer to them, especially if you do not use each of the Custom Modes often.

Setting Color Schemes

My Color Mode

The mode dial's My Color Mode provides an optional set of color schemes for capturing images. These color schemes are seen in still photographs and Burst Groups when the camera saves the file as a JPEG. If you create dual JPEG and RAW files, you will be able to see the chosen color scheme in both file types in PHOTOfunSTUDIO 6.0 BD Edition, but you may not see the alternate color renderings in the RAW file format when using some other third-party software. This is most evident when you select the [MONOCHROME] option—the JPEG file will show the image with its colors muted so it almost appears as a black-and-white image. In contrast, the RAW file will show a full-color image. We did find an exception when using Apple's Finder for Snow Leopard. When it is set to display icons, the computer will show the RAW file colored identically to the JPEG. But when you load the photographs into Aperture, you will see the JPEG displayed with the selected My Color Mode and the RAW file displayed in color with minimal processing.

The color scheme selected in My Color Mode is also captured in videos taken via the red Motion Picture button, but is not available when you move the mode dial off of My Color Mode and onto Creative Motion Picture Mode.

Although using My Color Mode is not really a shortcut when taking pictures or videos, it can help eliminate the need to post-process the image in your computer to get color effects that the camera can initially create when recording the image.

There are eight different color schemes that provide a different ambience to the photograph: [EXPRESSIVE], [RETRO], [PURE], [ELEGANT], [MONOCHROME], [DYNAMIC ART], [SILHOUETTE], and [CUSTOM].

The effects of these settings are best evaluated on the LCD screen. To do so, set the camera mode dial to the My Color Mode icon. The last viewed color scheme will be displayed. Use the right or left directional arrow buttons to cycle through the different color schemes. When you find a pleasing color scheme, select it by

pressing the MENU/SET button or by pressing the shutter-release button halfway (figure 5-5a and figure 5-5b).

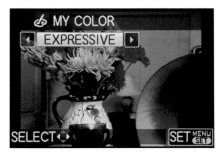

Figure 5-5a: My Color Mode [EXPRESSIVE] color scheme

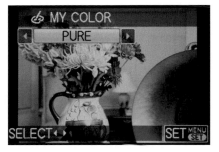

Figure 5-5b: My Color Mode [PURE] color scheme

My Color Mode's [CUSTOM] selection allows you to customize your settings by shifting colors from light blue to red and adjusting their brightness and saturation (figure 5-6a). You can scroll through the various options using the up and down directional arrow buttons. After you have selected one of the customizing options, use the right and left directional arrow button to adjust the option's setting. You will see the changes immediately on the screen. Adjust these to your taste following the prompts on the screen (figure 5-6b). In the event you need to start your customization over, the [CUSTOM] selection has a reset option to return the settings to the camera's default.

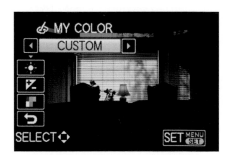

Figure 5-6a: My Color Mode's [CUSTOM] color scheme

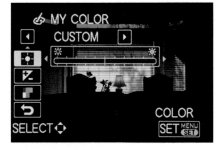

Figure 5-6b: Color control has been selected

There are several restrictions when using My Color Mode:

- Auto Bracket cannot be used
- ISO sensitivity will be fixed to [AUTO]
- Both the [I.DYNAMIC] and [COLOR SPACE] commands can be set only when the My Color Mode is set to [CUSTOM]
- [FILM MODE], [FLASH], [FLASH SYNCHRO], and [ISO LIMIT SET] are automatically adjusted for My Color Mode

At first, My Color Mode seems to be a duplication of Film Mode, which also provides a customized color-processing step to the final image, but this is not the case. Aside from the fact that the color repertoire is different, the hues selected in My Color Mode are lost when you shift the mode dial to any other operation. That is to say, if you go to a semiautomatic, manual, or predefined scene mode, the color interpretation provided by My Color Mode is lost. This is not the case for Film Mode. In addition, the Film Mode has more advanced customization options.

How Is My Color Option Selection Applied to Videos?

Since My Color Mode is an option on the mode dial, you obviously can't set the mode dial to both My Color Mode and Motion Picture Mode at the same time. This is where the red Motion Picture button on the top-right side of the camera comes into use. You can have the mode dial set to any option and you can take motion pictures just by pressing the Motion Picture button. So if you want to record a video in black and white, set My Color Mode to the [MONOCHROME] option and press the Motion Picture button to record.

Film Mode

Film Mode provides you the opportunity to build a customized color setting that can be applied to both videos and picture files. Film Mode provides greater control than My Color Mode in that it provides sharpening filters for enhancing details and smoothing filters for removing the noise when high ISO settings are used. You can also change the color saturation and adjust the contrast. Functionally, Film Mode is the image processor for those who do not care to do image processing on their computers.

Film Mode can be used for all of the mode dial options except My Color and the Portrait, Scenery, Close-up, and SCN predefined scene modes. You can also save a Film Mode setting within each of the three Custom Modes. The Film Mode is initiated by selecting the FILM MODE option within the camera's menu structure:

MENU/SET>REC>FILM MODE

Press the right directional arrow button to enter into the FILM MODE command's values. You will see the last color scheme option selected. The 10 available standard color scheme options are [CINEMA], [STANDARD COLOR], [DYNAMIC COLOR], [SMOOTH COLOR], [NATURE COLOR], [NOSTALGIC COLOR], [VIBRANT COLOR], [STANDARD B&W], [DYNAMIC B&W], and [SMOOTH B&W].

These options are available except when the mode dial is set to Intelligent Auto Mode. In this event, only the [STANDARD] and [STANDARD B&W] options are available to choose from.

Press the right or left directional arrow button to move through the list of available color scheme options (figure 5-7a). The color scheme's colors are applied to the subject displayed on the LCD screen, allowing you to see the effects on the image (figure 5-7b). This way, you will be able to judge if the setting will give you the effect you are looking for in your picture or video. The camera remembers the last color scheme you selected, so it will be retained until you reenter Film Mode to change it.

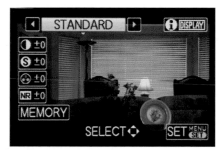

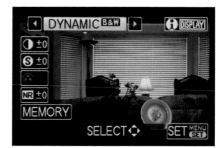

Figure 5-7a: Film Mode with last viewed color scheme displayed

Figure 5-7b: Color scheme [DYNAMIC B&W] image as it will be captured

As you continue to press the horizontal directional arrow buttons, you will eventually find two settings that do not have a descriptive color or black-and-white label: [MY FILM 1] and [MY FILM 2]. These are customized color schemes that you make. If you keep pressing the horizontal directional arrow button, you will also find the [MULTI FILM] option. This is an entry command that allows you to choose up to three Film Mode options and fire a burst of three shots, with each shot recording one of your selected Film Mode options.

After you have selected a color scheme, you can customize it by pressing the down directional arrow button and selecting a color scheme control. You can adjust contrast, sharpness, color saturation, and noise level. Figure 5-8a shows the [Contrast] option selected.

When you find the customization control you wish to adjust, press the left or right directional arrow button and view the changes on the LCD screen. You can also adjust the settings by touching the horizontal slider bar and sliding it to the left or right. In figure 5-8a, the contrast value is shown on the slider bar. Your changes will be saved with the color scheme and will be applied whenever you have selected this specific My Film color scheme. Figure 5-8b shows that the NR (Noise Reduction) customization option has been selected.

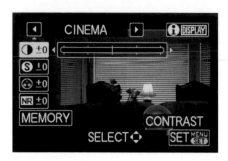
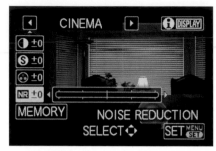

Figure 5-8a: Column of controls that indicate available adjustments, with Contrast selected

Figure 5-8b: Color scheme controls with NR (Noise Reduction) selected

There is an additional color scheme customization option called [MEMORY]. This option allows you to save your color scheme in [MY FILM 1] or [MY FILM 2] and frees up the original color scheme so you can either re-customize it or set it back to its standard settings. Select the [MEMORY] option and press the MENU/SET button. Select either the [MY FILM1] or [MY FILM2] option and press the MENU/SET button again.

You don't have to use [MEMORY] option to populate [MY FILM1] and [MY FILM2] options. Simply go to [MY FILM1] or [MY FILM2] color schemes directly and enter or modify any values within the options. The [MY FILM 1] and [MY FILM 2] color schemes gives you the ability to save two additional color schemes.

Note that the [MEMORY] control is missing from the [MY FILM 1], [MY FILM 2], and [MULTI FILM] options—contrast this to figure 5-7a where it is present. The [MEMORY] option is available only if you are altering one of the standard color schemes provided by Panasonic.

The final option in Film Mode is [MULTI FILM]. This option allows you to select three Film Mode color schemes and then fire a burst of shots, one for each of the selected color schemes. Scroll through Film Mode's color schemes to find [MULTI FILM] (figure 5-9). The [MULTI FILM] color scheme has three options, labeled [MULTI FILM1], [MULTI FILM2], and [MULTI FILM3]. Press the down directional arrow button once to move to the [MULTI FILM1] row. Then you can cycle through the selections using the left and right directional arrow buttons and select one of the Film Mode color schemes for [MULTI FILM1]. When you find one you like, press the down directional arrow button to select the option and go down to the [MULTI FILM2] setting. Again, cycle through the color schemes and select one, then press the down directional arrow button to access [MULTI FILM3]. Repeat the process to select a color scheme for [MULTI FILM3]. If you wish, you can select [OFF] and stop with only two colors schemes selected, as was done in figure 5-9.

Press the MENU/SET button to save and exit the [MULTI FILM] color scheme. When you fire the camera, it will take a picture using each of the selected color

schemes. One word of warning: when you fire the camera, make sure it is set to fire in Burst Mode. Otherwise you will have to press the shutter-release button for each picture to collect the series. In Burst Mode, a single depression of the shutter-release button will take the full set of pictures automatically.

Figure 5-9: [MULTI FILM] command with [MULTI FILM1], [MULTI FILM2], and [MULTI FILM3] each assigned to a different color scheme

My Color Mode and Film Mode Recommendation

Film Mode and My Color Mode provide interesting color effects with some limitations. For still photographs, you will retain these effects only when you use JPEG for saving your images. RAW format saves the original data from the camera sensor and not the applied color scheme changes. In these cases, you can always change the RAW file colors using image processing to duplicate the effects seen in your JPEG file—but it seems easier and simpler to save the images directly in JPEG. Perhaps the best approach is to save the image as both JPEG and RAW; the JPEG file shows the effects of Film Mode or My Color Mode, and the RAW file is amenable to image processing.

A perfectionist would argue that a higher-quality picture can be generated from the RAW file, and although that is theoretically correct, the difference in quality is not that great—especially if the photographer takes care to ensure that the exposure and white balance is correctly set. For our black-and-white work, we use Film Mode to provide a black-and-white image and save it in both JPEG and RAW formats. When we are viewing our images on our Apple computers, they will display as either black-and-white or color, depending on the software we use. Table 5-2 lists how they are displayed in various software.

Program	RAW	JPEG
Aperture	Full color	Selected color scheme
Finder	Selected color scheme	Selected color scheme
iPhoto '11	Full color	Selected color scheme
Photoshop	Full color	Selected color scheme
Preview	Full color	Selected color scheme

Table 5-2: Color schemes for RAW and JPEG files viewed on Apple computers

This is another reason to save your image files in both RAW and JPEG formats. By doing so, you will have the benefit of having the customized color work you developed as well as the unaltered picture from the camera. When you work with videos, you will not have the dual-file approach for saving the images, and therefore the My Color Mode and Film Mode colors are an important control for making videos.

Recommendations

If you are going to take the same type of pictures or videos over and over again with very few changes to the command settings, consider saving the group of command settings in a Custom Mode. If you find that you frequently change a few commands, set them up as one of the Function buttons. If you like to review multiple command settings and change them quickly, use the Quick Menu. To change a recently changed command, use MY MENU.

If you wish to capture pictures and videos using a specific color scheme, investigate the available options within Film Mode and My Color Mode. Although your selected My Color option remains in use only when the mode dial is set to My Color Mode, the selected Film Mode value is retained until you change it. In both cases, using these features will save you image processing time.

5

Taking Control of the Camera

Introduction

This chapter is about taking more control of the camera's operation. You will be set-ting virtually all the camera settings. This means you will first need to understand them and know what they can do for you. Where Intelligent Auto and predefined scene modes dictate camera values based on the camera's interpretation, you will now need to set your own command values. This is not for everyone, but if you enjoy experimenting with what the camera can do and controlling its outcome, or if you wish to expand your photographic horizons and push your creativity, learning about the commands, their effects, and how best to use them will be required.

Taking more control involves shifting the mode dial on the top of the camera off the automated predefined scene modes and selecting one of the following modes: Shutter-Priority AE (S), Aperture-Priority AE (A), Program AE (P), or Manual Exposure (M), where AE stands for automatic exposure. We will refer to the modes using their mode dial letters: S, A, P, and M. We will cover S, A and P Modes in this chapter, and M Mode will be covered in chapter 7.

Three Semiautomatic Modes: Shutter-Priority AE (S), Aperture-Priority AE (A) , and Program AE (P)

Using the S, A, and P Modes gives you greater control over the camera. Unlike the prede-fined scene modes or Intelligent Auto Mode, you will control the shutter speed, aperture, white balance, and ISO (figure 6-1). This will allow you greater artis-tic latitude in creating the image; however, there is an increased risk in selecting a setting that will detract from the image quality.

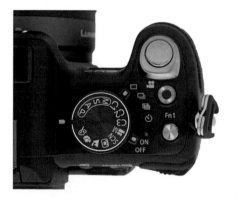

Figure 6-1: The mode dial is the largest knob on the top of the camera

Shutter-Priority AE (S) Mode

When you turn the mode dial to S, you select Shutter-Priority AE Mode. This mode allows you to control the camera's shutter speed while the camera selects the aperture for a proper exposure. This is an excellent mode for action shots. It can help prevent blurring the image while your subject is moving.

When this mode is selected, the letter S appears in the lower-left corner of the display screen, with the shutter speed glowing yellow. The yellow number 125 in

figure 6-2a indicates that the camera is set at 1/125 second exposure. For shutter speeds of one second or longer, the number is followed by a double prime symbol. For example, 2" means the shutter is set for two seconds. Pressing the shutter-release button halfway reveals the aperture number in white (figure 6-2b). If the exposure is incorrect, the image on the display screen will be either too bright or too dark. If the histogram is visible, it will also indicate over- or underexposure.

Figure 6-2a: Display screen when set to S Mode

Figure 6-2b: Display screen with camera set at 1/125 seconds, resulting in an aperture of f/10 (number 10 displayed in white)

To correct the exposure, press the rear dial to activate the Exposure Compensation tool. This will change the Exposure icon to yellow (figure 6-3a). Rotating the rear dial to the left or right will display the Exposure Compensation scales. If the histogram is displayed, its position and shape will change as exposure compensation is applied, and its color will change from white to yellow. Note that the shutter speed stays fixed while the lens aperture opens or closes.

Figure 6-3a: Exposure Compensation scale turns yellow when activated

Figure 6-3b: Exposure Meter with allowable aperture and shutter speed combinations displayed

As mentioned in chapter 3, the Exposure Meter (EXPO.METER command) will show the usable shutter speed and aperture settings for the image (figure 6-3b). You should enable this command and use it as a guide to prevent you from going beyond the limits of either proper exposure for the lens or camera. Turn the rear dial and the Exposure Meter scale will be displayed.

Anomalous Behavior of Exposure Compensation and False Information

A potential problem when using the Exposure Compensation tool is adjusting beyond the lens aperture range. You can continue turning the rear dial to values that are impossible to attain on the lens, yet the Exposure Compensation scale fails to show that your adjustment has no affect on the captured image. If you press the shutter-release button halfway, the aperture and shutter speed numbers in the viewfinder will change color from yellow to red, and the camera will not fire. Now you will have to turn the rear dial in the opposite direction.

Shutter speed awareness is important for two reasons. The most obvious is for action photography when you wish to freeze the motion of a rapidly moving subject (figure 6-4a). A shutter speed of 1/500 second or faster is desirable to freeze a rapidly moving athlete. Conversely, a shutter speed of 1/60 second, for example, may blur rapidly moving parts of the subject (figure 6-4b). With experience, you can combine these two effects so that an image of a flying bird, for example, will have a sharp head and body, but its flapping wings are blurred.

The second reason you should be aware of shutter speeds is that a slow shutter speed records the camera's movement. A shutter speed slower than 1/30 second may show your inability to hold the camera steady enough to record the subject's fine detail. The camera has a Jitter icon that warns you when the shutter speed is too slow for reliable handholding. When this icon appears, you should increase the light, raise the ISO, or mount the camera on a tripod.

Figure 6-4a: A small stream recorded with a shutter speed of 1/320 second

Figure 6-4b: The impression of movement is enhanced with a longer shutter speed (1/15 second)

Aperture-Priority AE (A) Mode

Aperture-Priority AE (A) Mode is the converse of S Mode. You select the aperture, and the camera selects the shutter speed. This gives you better control of the depth of field. This is critical in close-up photography where the depth of field is shallow. If the lens aperture is opened, the decreased depth of field will blur parts

of the image. This can be avoided by using A Mode. Turning the rear dial prior to initiating Exposure Compensation will change the lens aperture (figure 6-5a), with the Exposure Meter showing the valid shutter speed and aperture settings for the image. When Exposure Compensation is activated, the aperture value is maintained and the shutter speed changes as you override your camera's recommendation, unlike S Mode. As before, you know which function is active by studying the display. When the f-stop number is yellow, you can adjust the lens aperture. Conversely, you control the exposure when the Exposure Compensation scale is yellow (figure 6-5b).

Press the Trash Can button to see the effect of closing down the aperture and ascertain if you have sufficient depth of field.

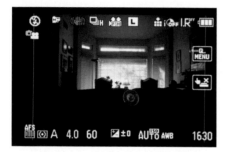
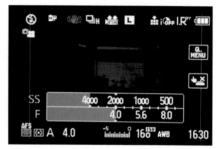

Figure 6-5a: A Mode with aperture at f/4 (yellow) and shutter speed at 1/60 second (white)

Figure 6-5b: Active Exposure Compensation set to five f-stops of underexposure

Program AE (P) Mode

Program AE (P) Mode is similar to Intelligent Auto Mode in that it sets both shutter speed and aperture, but with an important difference: you can change either. You will have to make the decision whether a fast or slow shutter speed is preferred or if the aperture should be opened or closed. The Program Shift function, which is activated by turning the rear dial, allows you to vary the shutter speed with a commensurate shift of the aperture while maintaining the same exposure. If you change one control, the other will be altered automatically to maintain a constant exposure. An icon consisting of a double-arrowed diagonal line is displayed with the P on the display screen when you use the Program Shift function. If you use the iISO setting (described later in this chapter), Program Shift is not available.

Initiate this mode by turning the mode dial to P. You will not see the aperture or shutter speed values (figure 6-6a) until you press the shutter-release button halfway. Once you do so, the aperture and shutter speed values will be highlighted in yellow (figure 6-6b). Turning the rear dial to the left or right will implement the Program Shift function, allowing you to change the shutter speed and aperture

setting. Your exposure will not vary, and this control allows you to affect both the aperture and the shutter speed simultaneously.

Figure 6-6a: When P Mode is selected, the shutter speed and aperture are not initially displayed on the screen

Figure 6-6b: Press the shutter-release button halfway to display the aperture and shutter speed (f/4.0 and1/80 second in this example)

Exposure Compensation is also available within the P Mode, but with an interesting twist. As you apply increasing or decreasing compensation, the camera alternates between changing the aperture and shutter speed, and the Exposure Meter displays the valid shutter speed and aperture settings for the image. This alteration continues until the aperture limit for the lens is reached, then the camera changes only the shutter speed.

ISO

Earlier, we referred to ISO as the gain control for the sensor. Functionally, an increase in ISO value increases the sensor's sensitivity to light so it can record a dimmer scene. This expands your photographic options. For example, when taking action pictures, raising the ISO for a given f-stop will allow you to use a faster shutter speed. This enables you to capture a sharp image of a rapidly moving subject. In contrast, setting the ISO to the low value of 160 renders the sharpest scenic images, but with a slower shutter speed a rapidly moving subject will appear blurry.

There are several ways to control the ISO. It all starts by pressing the ISO button on the back of the camera (figure 6-7a). The ISO menu, comprised of a series of numbers (ISO

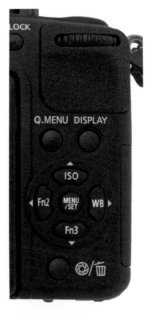

Figure 6-7a: The ISO button on the back of the camera

values), is displayed on the screen (figure 6-7b). The ISO values are represented in 1/3 f-stop increments and you will see numbers such as 160, 200, 250, 320, 400, and so on as the numbers increase up to 12800.

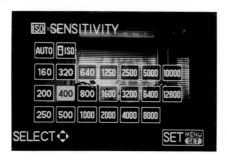

Figure 6-7b: Use the left and right directional arrow buttons to select the ISO value

Letting the Camera Set the ISO

Along with selecting a specific ISO value from the displayed ISO numbers, there are two additional settings: [AUTO] and [iISO] (Intelligent ISO). Both of them allow the camera to select an ISO setting for your framed image.

Auto ISO

Auto ISO, as the name implies, adjusts the camera sensitivity automatically. Essentially, when ambient light levels are low, the camera raises its ISO so you can use a faster shutter speed. A faster shutter speed increases your chances of getting a sharp photograph when hand holding the camera. If the ISO setting is too low to allow a shutter speed faster than 1/30 second, you will have to mount the camera on a tripod or accept some blurring of the resulting picture. If the camera thinks you are using too slow of a shutter speed, the red Jitter icon will appear and warn you to switch to a flash or a tripod.

You can set a ceiling for how high Auto ISO increases the camera's sensitivity. Remember that as ISO increases, the image quality degrades, and setting an upper ISO limit is your safety net to keep you from getting an unsatisfactory image. The number you select in the following command will set the upper limit of your camera's ISO:

MENU/SET>REC>(*pg* 3) ISO LIMIT SET>[OFF], [200], [400], [800], [1600], [3200]

A legitimate question is, how high should the limit be set? Unfortunately, there is no definitive answer. The upper limit can be established only by personal use and preference. We recommend 1600 as a starting point, with the assumption that most people will find results at settings higher than that unacceptable for 8" × 10"or larger prints. If you are using the camera for sending e-mail attachments and postcard-sized prints, you will be very pleased by the camera's performance at ISO 1600, or even higher.

ISO and Image Degradation: Our Recommendation

The most obvious defect introduced by raising the ISO value is noise, which is the granular appearance of blotches of color appearing within regions that should have a smooth tone. Many reviews on the Internet, as well as messages from photographers on online forums, have commented that the Four Thirds and Micro Four Thirds cameras have higher noise levels than APS or full-frame cameras.

The Panasonic GH2 has more noise at ISO 3200 (and higher) than DSLRs made by Nikon and Canon. Rather than avoid shooting at these higher ISOs, experiment and find out for yourself the performance limits of your camera.

If your goal is to make images strictly for web use, you might be pleasantly surprised that the quality of your Panasonic GH2 camera at ISO 3200 is acceptable. We have been using an upper limit of ISO 3200 and have been pleased with the results. For critical work, we make sure we shoot in RAW and use third-party software (Noise Ninja) to help reduce the effects of noise. In comparison to our Nikon D300, images from the Panasonic GH2 are noisier, but the quality is good and the images are by no means unusable.

iISO

Panasonic's Intelligent ISO (iISO) option is similar to AUTO ISO, but it has the twist of using the subject's movement to raise the shutter speed and freeze the motion. This assumes you want to capture moving objects with maximum sharpness. You cannot use this mode if you set the camera to S Mode, which locks the shutter speed to the value set by the rear dial.

Intelligent Dynamic Range Control: Taming Extremes in Brightness

The I.DYNAMIC command (Intelligent Dynamic Range Control) is a replacement for an earlier Panasonic G series command called I.EXPOSURE (Intelligent Exposure Adjustment). Its function is to tame extremes in brightness, lightening blackened shadows and revealing detail in brilliant highlights. But this is a capricious command, and although it may be enabled in the menu, it may not be applied to the image. Apparently, the scene has to have a certain extent and range of shadows and highlights; if this criterion is not met, the command is not executed.

For example, it frequently does not work when the subject is front illuminated. We see it more when a backlit subject is shot and the subject casts deep, dark shadows. For example, it can be activated in an interior photograph of a window with bright sunlight streaming through it and lighting the room. The walls surrounding the window lie in deep shadows and trigger the command. The photographer will see the i.Dynamic icon on the display screen change from white to yellow after

pressing the shutter-release button halfway.

The I.DYNAMIC command is enabled as follows:

MENU/SET>REC>(*pg* 3) I.DYNAMIC>[OFF], [LOW], [STANDARD], [HIGH]

The reduction in contrast is graded from low to high. As the name indicates, high provides the greatest reduction in contrast. You will have to experiment with this command and find, by trial and error, what the best setting is for certain lighting. This command is unavailable in the predefined scene modes and Intelligent Auto Mode.

To Use or Not to Use the i.DYNAMIC Command

When taking still photographs, we do not use Intelligent Dynamic Range Control. We work with RAW files and obtain equivalent effects with software. Indeed, because we can leisurely study images on a large monitor, we believe our results are superior to what we would get if we had allowed the camera to do the contrast reduction. Intelligent Dynamic Range Control is more useful when recording videos.

Recommendations for using S, A, and P Modes and ISO

When we want to use the Panasonic GH2 as a point-and-shoot camera, we use the P Mode and Auto ISO. Think of it as iA without scene recognition and the ability to override your camera settings. We set the upper limit of Auto ISO to 800 and trust the camera to make all the settings.

When we want to exercise greater control, we choose either the A or S mode. A is used for static subjects, and S is used for moving subjects. Here we dial in our own ISO values with the goal to use the lowest ISO value possible. In brief, we usually shoot at ISO 160 during the day, but we may decide to increase it to 640 for sunset shots and to 1600 as the available light decreases. If you have a tripod, you can explore dim light shots with long exposures. In terms of exposure, shooting at ISO 160 at 1/8 second gives the same exposure as shooting at ISO 640 at 1/30 second.

Whenever we shoot in very dim light, we back up our shoots by saving the images in both RAW and JPEG formats. RAW allows us to limit the loss of image sharpness when applying noise suppression software.

We do not use either the iISO or I.DYNAMIC commands. The iISO command costs us some control in setting our shutter speed in A or P mode. With the unpredictable nature of the I.DYNAMIC command, we prefer to control the camera's operation to generate a specific image output rather than have the camera take control. We have found value in using the command with video recording, but not with still photography.

White Balance

The camera has to be calibrated to record colors accurately. In effect, it has to be told what type of light source is illuminating the subject. This used to be performed manually; however, this is inconvenient and can result in an image with horrible colors if the wrong light source is selected. This was especially true with DSLRs that relied on optical viewfinders. To get around this problem, camera designers developed automatic white balance (AWB), enabling the camera to calibrate itself to the light. In essence it takes a statistical sampling of the image and makes a best-guess estimate on the identity of the light source. For the most part, it does a good job, and many photographers always use AWB. But like all statistical sampling techniques, it can be fooled, and this is most evident when working with indoor lighting. Fortunately, the Panasonic GH2 has tools to override this. To better control the appearance of your photograph, you should become accustomed to setting your own white balance (WB). Your results will be more consistent and more reproducible if you get into this habit. The Panasonic GH2 has special icons for controlling WB (table 6-1).

Open Sunlight	Overcast Skies	Shade	Indoor Light	Electronic Flash
☼	☁	⌂	☀	⚡WB

Table 6-1: WB icons and the light source they represent

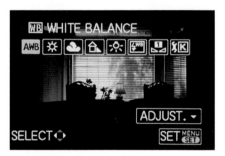

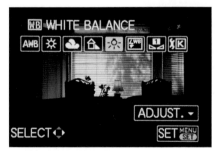

Figure 6-8a: WB menu after pressing the right directional arrow button

Figure 6-8b: WB for indoor lighting (tungsten bulb light source)

To set the WB with the icon that represents your light source, follow these steps:

1. Press the WB button on the back of the camera (right directional arrow button).
2. Select the icon representing the image's light source—either touch the icon or highlight it using the directional arrow buttons or the rear dial (figure 6-8a, figure 6-8b). Remember, AWB means automatic white balance.
3. To accept the changed setting, touch the SET icon on the display screen, press the shutter-release button halfway, or press the MENU/SET button.

The icons in table 6-1 graphically represent light sources, making them easy to remember. However, they serve only as a rough guide of the illuminant's color. For example, the Indoor Light icon assumes an idealized bulb emitting a specific color. In fact, indoor bulbs can emit a wide variety of colors; depending on the operating voltage, the light can be ruddy red or brilliant white. If you need to set the light value more rigorously, use the color temperature scale (table 6-2).

Color Temperature Scale	Calibrating to a White Source: Select Icon 1 through 4
🕺🄺	1 ◣ 2 ◣ 3 ◣ 4 ◣

Table 6-2: Icons for quantitatively setting color temperature

In the WB display, the letter K is on the icon for the color temperature scale. Chemists and physicists know this stands for *kelvin*, a quantitative way of specifying color temperature. Rather than discuss the scientific and physical basis of the scale, it is sufficient to say that dialing in the correct value gives you an accurate color balance. This is especially handy when using photographic lights whose output is specified in degrees kelvin.

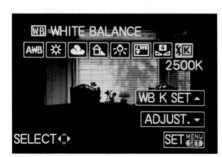

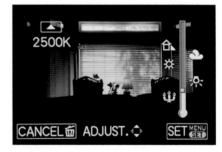

Figure 6-9a: Selecting the K icon for setting the color temperature to a numeric value

Figure 6-9b: Color temperature scale set to 2500 K

Follow these steps to use the color temperature scale:

1. Press the WB button on the back of the camera (right directional arrow button). Highlight the Color Temperature Scale icon (K icon; figure 6-9a). Press the up directional arrow button to display the color temperature scale. The vertical color temperature scale displays on the right side with a number sandwiched between an up and down arrow key (figure 6-9b).

 Select the color temperature either by using the up or down directional arrow buttons or by touching the bar on the thermometer with your finger and raising or lowering the temperature setting. You can also turn the rear dial to raise or

lower the temperature setting. The numbers on the left side of the screen will change according to the height of the yellow temperature bar. The number will range from 2500 K to 10000 K.

2. When the number reaches the value you want, touch the SET icon in the lower-right corner of the display screen, or press the MENU/SET button.

To adjust the color temperature scale accurately, you need to know the color temperature of the light source. An expensive color light meter is the most accurate way to determine this value. Lacking that, check if the manufacturer of the light source provides a k value. Unfortunately, many light sources are not rated. Worse, the bulbs that are rated fail to maintain a constant light temperature. Tungsten bulbs age and become cooler. Also, their color temperature is dependent on their operating voltage, and they become warmer with a drop in voltage.

We used the color temperature scale most commonly in a science laboratory or a photography studio, where the color temperature of a light source was known and its value could be set accurately. For example, the tungsten illuminator on a microscope is rated at 3200 K, a value provided by the lamp manufacturer, and this is dialed into the camera's white balance scale.

For those who need the utmost rigor in recording their data, this scale is invaluable. However, for the majority of us it is of limited use, especially considering that in practical terms there is an even better way to set the color temperature: manually.

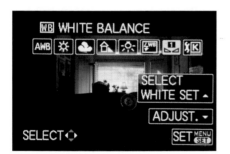

Figure 6-10a: White balance set to a previously calibrated value stored in memory 1

Figure 6-10b: The display of a yellow-bordered rectangle for placing white piece of paper

Our favorite method of setting the color temperature is to set the white balance manually. To do this, all you need is a blank sheet of white paper and to follow these steps:

1. Press the WB button on the back of the camera (right directional arrow button).
2. Highlight the icon for calibrating to a white source (yellow icon; figure 6-10a) by using the touch screen or the right and left directional arrow buttons.

3. Press the up directional arrow button and you will see a set of four icons, each containing a 1, 2, 3, or 4. Each numbered icon will remember a calibration setting, so you will be able to store four settings.
4. Use the left or right directional arrow buttons to select one of the icons. Press the up arrow key or touch the WHITE SET icon on the screen.
5. The screen changes. The periphery is grayed out, and a targeting rectangle with yellow borders becomes visible (figure 6-10b).
6. Aim the camera at the sheet of white paper, making sure the paper fills the targeting rectangle.
7. Touch the SET icon on the screen, or press the MENU/SET button.

This operation calibrates the camera to the light source (reflected off the white paper) and stores this value in the selected Calibrating to a White Source memory icon. Note that when you initiate manual WB, the displayed Calibrating to a White Source icon will contain the number of the last selected slot.

After you manually set the WB and then select one of the four icons, the camera will use the calibration value for the WB. We have found this procedure to be very reliable, and it has become our preferred method of manually adjusting the camera to the light source. When we work with a microscope, we remove the specimen from the field of view and calibrate against a clear region. The camera is then calibrated to the light. We find it to be a more accurate adjustment; colored specimens are rendered better than when the camera was calibrated with the kelvin setting. An 18 percent gray card can substitute for the white paper.

Fine-Tuning WB

On occasion, the white balance calibration procedures may generate an unacceptable coloration to your image. When using fluorescent or LED light sources that emit a discontinuous spectrum of light, you may find skin tones to be off. There is a command for touching up white balance and adjusting it to your satisfaction. This operation, as well as color bracketing, will be covered in chapter 7. However, we prefer using a software program for correcting these tints. We find that the SILKYPIX Developer Studio software provided with the camera, or Photoshop or Aperture for adjusting RAW images, provide a convenient means of touching up the colors.

Earlier we recommended saving your files in both RAW and JPEG formats. Each file format has its advantages. A major benefit of saving in RAW format is the ease with which white balance errors can be corrected outside of the camera. The SILKYPIX Developer Studio software opens the RAW files. Figure 6-11 shows a slider and a color temperature scale in a side screen for fine-tuning the white balance. The slider allows you to rapidly evaluate the different color temperature settings, which simplifies this task if you captured the image with the wrong setting. Additionally,

there is a pull-down menu listing a variety of light sources, enabling you to find your illumination type.

Figure 6-11: SILKYPIX Developer Studio controls for adjusting a RAW image file's color temperature

Recommendations for WB

The majority of our photographs are taken with the AWB setting. The Panasonic GH2 camera does a satisfactory job of rendering pleasing colors from subjects illuminated with different light sources. However, we have noticed that indoor lighting with incandescent lamps can throw off AWB. Under these conditions, our images have an orange-red hue. To obtain more neutral colors, we use the WB setting for indoor lighting. For very difficult lighting conditions where there are several different light sources (i.e., a mix of incandescent and fluorescent bulbs), we calibrate the white balance against a sheet of white paper.

After some experimentation, we rarely preset the color temperature with the aid of the color temperature scale. At first, we used this method for studio work, close-up work with indoor lighting, or microscope work. However, we abandoned this procedure and started using the Calibrating to a White Source method.

Again, this is where we recommend saving the files in RAW format. Virtually all programs that read RAW files have a straightforward command for readjusting white balance.

Revisiting Aspect Ratio and Pixels

image's aspect ratio is an expression of its width to height with the two numbers separated by a colon. The nominal image array of the Panasonic GH2 is 4608 × 3456 els, which is an aspect ratio of 4:3. When you record an image, you can alter this ect ratio to 3:2, 16:9, or 1:1.

You can specify the aspect ratio before you take a picture, then you can compose your image to fit within the frame:

MENU/SET>REC>ASPECT RATIO>[4:3], [3:2], [16:9], [1:1]

When we work with other cameras, we select the aspect ratio during post-processing by cropping the captured image. But in the Panasonic GH2 camera, selecting this option results in a slightly superior image. The camera does not just crop the field of view. Instead, it takes advantage of its oversized sensor.

The camera's sensor is larger than 16 megapixels (MP); it is actually 18 MP in size. This enables the camera to use more pixels to capture images in optional aspect ratios. Table 6-3 shows the difference between the 16 MP Panasonic G3 sensor and the 18 MP Panasonic GH2 sensor. Looking at the 16 M G3 sensor data, you will note that when you go to a 16:9 aspect ratio, your image shrinks to 12 M. But for the GH2, note that the 16:9 aspect ratio results in a 14 MP image and that its width is 4976 pixels, which is greater than the width of the original 4:3 ratio and much greater than the width of the G3 sensor's 4576 pixels for the same aspect ratio. When all is said and done, the use of the GH2's ASPECT RATIO command gives you an increased resolution of about 10 percent over images captured with the G3.

Panasonic 16 M G3 Sensor		
Total Pixels in Array	**Pixel Numbers**	**Aspect Ratio**
16M	4592 × 3448	4:3
14M	4576 × 3056	3:2
12M	4576 × 2576	16:9
12M	3424 × 3424	1:1
Panasonic Oversized GH2 Sensor		
Total Pixels in Array	**Pixel Numbers**	**Aspect Ratio**
16M	4608 × 3456	4:3
15M	4752 × 3168	3:2
14M	4976 × 2800	16:9
12M	3456 × 3456	1:1

Table 6-3: Number of pixels (size) and the pixel array by aspect ratio

You will find a command in the Panasonic GH2 called ASPECT BRACKET; as its names indicates, it will record all four aspect ratios with a single press of the shutter-release button:

MENU/SET>REC>(*pg* 4) ASPECT BRACKET>[OFF], [ON]

We do not use this command for the following reasons:

1. It will not record in RAW, so if your camera is set to record both RAW and JPEG, you will find only JPEG files after the bracket sequence is completed.
2. It can override the picture size of the JPEG in spite of your previous setting. It will not record an [S] sized picture, so if you had set this size in the REC menu, you will get an [M] sized picture.
3. This command can be replicated in post-processing by simply cropping in your imaging software. Indeed, the quality benefit of using the ASPECT RATIO command in your Panasonic GH2 is lost when you use ASPECT BRACKET.

Advantages of saving in JPEG

Earlier, we recommended saving your image files as both JPEG and RAW so you can have the advantages of both file formats. Eventually there will be a point when you need to select one file format over the other. This section is a nutshell comparison of the advantages and disadvantages of JPEG.

You can compress JPEG files to varying degrees, thereby controlling the file size by using the MENU/SET>REC>QUALITY command. When shooting JPEG, you have the option of saving it as Fine or Standard. Fine provides the highest image quality and larger file size, and Standard sacrifices image quality by reducing the file size by half.

So what are the benefits of being able to change the overall number of pixels or shrinking the JPEG file by half? The first advantage is that with smaller files you can store more images on your memory card. This is obvious, but an even more important advantage in keeping the file size small is the increased efficiency when the camera is fired rapidly. When firing in Burst Mode at 5.0 images per second (BURST RATE is [H]), the images are stored in a fast, but small, memory buffer that can rapidly take in images.

When the buffer is filled, the speed with which the images are offloaded to the memory card is determined by the memory card, which takes in image files at a slower rate. With large files, only seven or eight images might be offloaded before there is a bottleneck in the transfer, causing the camera to stop firing until the buffer has been cleared.

The fast memory buffer can take in more images if the file sizes are small, so if you need to fire long bursts of shots at 5.0 frames per second, you may wish

ɔ compress them using the QUALITY command or minimize the file sizes by ʼrinking them overall with the PICTURE SIZE command:

MENU/SET>REC>PICTURE SIZE>[L], [M], [S]

ʼe Picture Size and Quality options can be combined for greater effect. Remember that the selected picture size works only on JPEG files. Therefore, for rapid sequence photography you may decide not to save the files in RAW format since it is the largest file size.

Recommendations

As mentioned earlier, we always recommend storing both JPEG and RAW files. However, you can see that there are a couple of situations when saving files in JPEG alone is desirable. If you are firing many photographs rapidly, you can fire more shots and download them to your memory card without interruption by using the JPEG file format.

Customizing Automatic Focusing

One takes automatic focusing for granted; however, it can be customized. This ranges from total automatic focusing to fully manual focusing. We will discuss the focusing commands here and in chapter 7. In addition, you can tell the camera where and what it should focus on.

On the top of the camera you will find the auto focus mode dial. It moves among 1-area-focusing, 23-area-focusing, AF Tracking, and Face Detection. These auto focus settings can be customized by adjusting the display region and size to be used for focusing.

1-Area-Focusing

We mentioned in chapter 2 that 1-area-focusing uses only one defined area in the screen. This is indicated by a set of white brackets, which serves as a rectangular sight for aiming at a target (figure 6-12a). The size (figure 6-12b) and position of this rectangle can be changed by using the directional arrow buttons or the touch screen, as described in the following instructions:

1. Turn the auto focus mode dial to the 1-area-focusing icon.
2. Press the Q.MENU button for several seconds.
3. Wait until the displayed AF target (yellow border) and side bar appears. Adjust the size of the AF target by either rotating the rear dial or by touching the slider displayed on the side and moving it up and down to increase or decrease the size of the targeting square.

4. Position the AF target by using the directional arrow buttons or by touching the AF target and moving it to the desired position. (Note that this will not change the size and shape of the metering spot). To return the target to the center of the screen, press the Trash Can button.

5. To complete the operation, execute one of the following: touch the SET icon, press the MENU/SET button, or press the shutter-release button halfway.

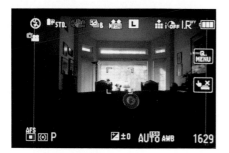

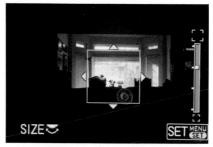

Figure 6-12a: The white brackets indicate the area used for focusing

Figure 6-12b: The target has been enlarged to one size greater

If you have a small object to focus on, you can have greater precision by reducing the size of the focusing target (figure 6-13a). When focus is achieved, the target turns green and a green circle appears in the upper-right corner of the screen (figure 6-13b). Which size you use is dependent on your scene. Enlarging the AF target helps the camera focus under difficult lighting conditions.

Figure 6-13a: The focusing target reduced to its smallest size

Figure 6-13b: Depicts the target being used for focusing

23-Area-Focusing

As mentioned in chapter 2, up to 23 areas are distributed throughout the viewing screen so any part of it is available for focusing. However, it is possible to divide the screen into nine evenly sized sectors and restrict focusing to specific sectors.

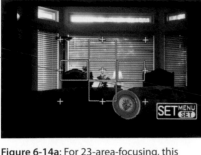

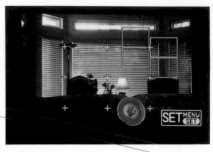

Figure 6-14a: For 23-area-focusing, this screen appears when the Q.MENU button is pressed for a few seconds

Figure 6-14b: Turn the rear dial or touch one of the white crosses to change the focusing region

Figure 6-14c: The yellow rectangles disappear; their position is marked with a small white cross

You can restrict focusing to one or more of these nine sectors by following these steps:

1. Turn the auto focus mode dial to the 23-area-focusing icon.
2. Press the Q.MENU button for several seconds.
3. Wait until the AF areas are displayed—yellow border rectangles each containing a white cross (figure 6-14a).
4. Select the area to be used for focusing by using the directional arrow buttons or by rotating the rear dial.
5. Press the shutter-release button halfway to set. The yellow-bordered rectangles showing the areas to be used for focusing will remain briefly (figure 6-14b). A white cross marking the center of the focusing area will remain (figure 6-14c).

You will probably not want to retain a restricted region for focusing permanently. To cancel the settings, press the MENU/SET button.

It may be simpler to use the touch screen commands for selecting a limited region for focusing. After selecting 23-area-focusing, do the following:

1. Touch the screen at the area you wish to use for focusing. A set of yellow rectangles will appear and mark the focusing areas. Within the center of the set of rectangles is a white cross.

2. Remove your finger; the rectangles will disappear and a white cross will mark the center point of the focusing area.

Again, you will probably not want to retain a restricted region for focusing permanently. To cancel the focusing area, press the MENU/SET button.

Recommendations

When shooting handheld, we seldom use the touch screen to modify the focusing targets. With 1-area-focusing, it is awkward to raise the camera with one hand and use the other hand to position the focusing target over the subject. It is faster to simply aim the camera, place the focusing target over the subject, and lock focusing by pressing the shutter-release button halfway. If you want your subject to be off center, maintain pressure on the shutter-release button to keep the focus locked and move the camera to frame the subject. The picture is taken by pressing the shutter-release button fully. It is more convenient to modify the Auto Focus targets when the camera is aimed for the best composition and locked into position on a tripod. Then the Auto Focus target can be positioned over the precise region to be used for focusing.

Automatic Focusing: Speeding Up Focusing at the Expense of Battery Power

The Panasonic GH2 automatic focus does not focus as rapidly as many DSLRs, and this delay is attributed to its design. To conserve battery power, focusing is not started until the user raises the camera and presses the shutter-release button halfway. To guarantee a sharply focused image, the camera does not fire until focus is established. There are commands for overriding this operation, but they involve some sacrifice and risk. Basically, one command uses more battery power by starting the focusing motor prior to pressing the shutter-release button halfway. The other command allows the camera to be fired even if focus is unconfirmed, increasing the chance of collecting a fuzzy, unfocused image.

To allow for focusing earlier in the picture-taking process, use the following command:

MENU/SET>CUSTOM>(*pg* 2) PRE AF>[OFF], [Q-AF], [C-AF]

The Q-AF (Quick AF) setting starts the focusing motor when the camera is motionless. When you are carrying the camera, it is always being moved, so the focusing motor is off. But when you aim it at your subject in preparation to take a picture, the camera stops moving, and this stability initiates the automatic focus motor. This can use battery power unnecessarily when you are sitting with the camera and it is not moving because the camera is constantly refocusing. The second setting, C-AF

(Continuous AF), is even more wasteful. It keeps the motor on continuously, even when you are not on the move, so the camera is always attempting to find focus. Eventually, the time will come when you aim the camera at a subject you wish to photograph. The continuous activity of the focusing motor will ensure that you are near focus, even before you start pressing the shutter-release button. Setting the PRE AF command to [Q-AF] or [C-AF] is fine, but please remember to turn your camera off when you are not using it. This will conserve your battery while also obtaining focus quickly when you want to take a picture.

The following command turns off the camera's safety device for ensuring sharply focused pictures:

MENU/SET>CUSTOM>(*pg* 2) FOCUS PRIORITY>[OFF], [ON]

By turning the FOCUS PRIORITY command to [OFF], the camera will fire whether or not focus is achieved. A full press of the shutter-release button is all that is needed to take the photograph. However, do not be surprised if the picture is blurry because true focus was not found.

Recommendations

We have worked with these commands and have not adopted either for our photography. From our experience, the major delay in camera firing is the time the lens motor drives it from slightly out of focus to in focus. Presumably, there is a little hesitation as the camera compares the in-focus and out-of-focus image. Although we don't doubt that firing the camera is faster with the FOCUS PRIORITY or PRE AF command, it is not a dramatic difference. For still photography, we recommend turning the PRE AF command to [OFF] and keeping the FOCUS PRIORITY set to [ON]. When we need the camera to fire immediately after pressing the shutter-release button fully, we set the camera to Manual Focus and forego the convenience of automatic focusing.

Automatic Focus in Dim Light

The automatic focus system in the camera needs light to operate. In dim surroundings when the lighting is too low for automatic focusing, the camera can provide more light by projecting a red beam to illuminate the subject. Normally, this provides enough light to achieve automatic focus. However, the beam can be annoyingly bright. Obviously, when you are shooting a stage production in a dimly lit theater, you do not want the red beam to highlight the actors. Panasonic provides a command to disable the red beam so it does not come on:

MENU/SET>CUSTOM>(*pg* 3) AF ASSIST LAMP>[OFF]

Locking Focus with AF/AE

At the rear of the camera there is a button labeled AF/AE LOCK, and as its name implies it can be used to lock in exposure or focus or both. The button's action is controlled by a menu command:

MENU/SET>CUSTOM>(*pg* 2) AF/AE LOCK>[AE], [AF], [AF/AE]

Select one of the options to determine how the AF/AE LOCK button will operate— AF (Automatic Focus), AE (Automatic Exposure), or AF/AE (both Automatic Focus and Automatic Exposure). When it is set, aim the camera at an area you wish to focus on or use to set the exposure. Press the AF/AE LOCK button to set and lock the focus, exposure, or both according to the setting you chose. As long as you continue to hold down the AF/AE LOCK button, you can move the camera while retaining these settings until the picture has been taken.

If you like using this button, you may be interested in its additional command, AF/AE LOCK HOLD. This allows you to press the AF/AE LOCK button once and retain the locked focus, exposure, or both until you press the button a second time. Also, the command is canceled when you take the picture. To activate AF/AE LOCK HOLD, use the following command:

MENU/SET>CUSTOM>(*pg* 2) AF/AE LOCK HOLD>[OFF], [ON]

Turning off the command forces you to keep the AF/AE LOCK button depressed to keep the camera set. Releasing the button loses the setting.

Recommendations
We do not use this button very much. Instead, we press the shutter-release button halfway to lock focus, and if we are unhappy with the exposure, we use the rear dial and use Exposure Compensation. We do a lot of nature photography, and we disable the AF Assist lamp. If automatic focus fails, we use manual focus.

Manual Focus: Overriding Automatic Focusing

Our discussion about using manual focus will continue in chapter 7. Here we will discuss overriding automatic focus with the lens-focusing ring. In chapter 7 we describe using manual focus as the sole means of focusing.

When using a Micro Four Thirds lens for this camera, you can readjust the automatic focus by turning the lens-focusing ring. To permit this action, use the following command:

MENU/SET>CUSTOM>(*pg* 3) AF+MF>[ON]

When this command is enabled, you first start automatic focus by pressing the shutter-release button halfway. After focus is locked, you can turn the lens-focusing ring and alter the focus point. Frequently in nature work or macro photography, the automatic focus will lock onto an object in front of or behind the subject of interest. This command provides a convenient means of fixing the error. The command works only with Auto Focus Single (AFS) and after the camera has locked in focus. It does nothing when Auto Focus Continuous (AFC) is used.

To obtain more precise focusing, it may be desirable to have a more magnified image of the subject within the display screen. You can raise the magnification with this command:

MENU/SET>CUSTOM>(*pg* 3) MF ASSIST>[ON]

This command, when coupled with AF+MF, will increase the magnification in the display screen. There will be a sacrifice in the field of view—that is, only the central portion of the screen is magnified. But this can be very useful in macro photography when you need to have precise control of your focus. If you need even more magnification, you can turn the rear dial one click and the image will be enlarged further. To return to the lower magnification to see the full field of view, press the shutter-release button halfway. Note that this function will not work if you use MENU/SET>REC>(*pg* 4) DIGITAL ZOOM [ON] or if you are taking a video.

Turning Off Automatic Focus

The focus mode lever can set the camera to manual focus, MF, where the automatic focus is disabled and you directly control focusing with the lens-focusing ring. Since the MF setting turns off automatic focusing, there is no delay in firing your camera when pressing down the shutter-release button. Subjectively this can make the camera feel more responsive in your hand. Depressing the shutter-release button fully results in a more rapid capture of the image. This can be used advantageously in photographing rapidly changing events—and the user should not avoid using MF Mode. Remember, many excellent action photographs were taken with manual focus lenses prior to the development of automatic focus. The percentage of in focus shots may be lower, but with practice you will get sharp action pictures.

Recommendations for Manual Focus

When using a Micro Four Thirds lens, we always turn on AF+MF so that we can refine the focus. This does not interfere with the normal operation of the camera, and having this capability is worthwhile.

When we are shooting rapidly changing events, we frequently disable automatic focus by setting the focus mode lever to MF so the camera will fire more quickly. The increased speed in the camera's operation obviates the disadvantage of losing automatic focus.

We do not use MF Assist when we capture fast-moving subjects—the reduction in the field of view with this command interferes with action photography.

Manual Operation of the Camera

7

Introduction

Where chapter 6 dealt with an automated camera setting its own aperture, shutter speed, or focus, this chapter is about taking absolute control of the camera and fine-tuning its settings. This provides the perfect tool for learning how to creatively use aperture and shutter speed. By working with these controls and keeping notes of their effects on your photographs, you can learn how to effectively use shutter speed and aperture settings to enhance your pictures. If you wish to go beyond the normal use of the camera, such as using it on a telescope or microscope to record astronomical events or scientific experiments, taking manual control is essential.

In addition, we will cover some advanced features in the S, P, and A Modes. This extends your control of the camera. In some cases, you can instruct the camera to set a command value incrementally for each picture in a series. This creates a series of images (a bracket) in which each image is slightly different in some discrete fashion. Then you can select and use the best image for your final purpose. For example, you can set a command to take a series of pictures where the exposure is varied for each shot. Simplistically, this is a shotgun approach to finding the proper exposure. For experts, it may create the basis for generating an image under difficult lighting conditions.

Manual Exposure Mode Controls

Turning the mode dial to M sets the camera to the Manual Exposure (M) Mode and displays M in the lower-left corner of the screen. The aperture and shutter speed numbers are displayed to the right of the M; unlike P, S, or A Mode, there is no need to press the shutter-release button halfway to see these numbers. This is due to the numbers being set and changeable only by turning the rear dial (figure 7-1a). Pressing the rear dial toggles the control between the two settings and changes the number that can be adjusted. The color of the active setting changes from white to yellow (figure 7-1b).

Figure 7-1a: Shutter speed (5) currently under the user's control, where the aperture (10) is not

Figure 7-1b: Aperture (10) currently under the user's control, where the shutter speed (5) is not

Your Exposure Compensation scale serves as a light meter. When the camera has too much or too little light for a correct exposure, a series of tick marks will appear underneath the scale of the Exposure Compensation tool. The scale is broken into dotted increments of one f-stop. Each tick mark represents 1/3 f-stop. Turning the rear dial will add or subtract one tick mark, or the equivalent of 1/3 f-stop. This translates into changing the camera's aperture or shutter speed. To use the camera's recommended settings, turn the rear dial so the tick marks for over- or underexposure disappear.

Extremely Long Exposure: B Shutter Speed

The M Mode will allow you to set exposures of up to two minutes. In M Mode, turn the rear dial to the left until the shutter speed numbers switch from a numeric value to the letter B. This will occur after you go beyond a 60-second exposure. At this setting, the shutter will open when the shutter-release button is fully pressed, and it will remain open as long as you continue to hold down the button, for up to two minutes. The B shutter speed is not available in the semiautomatic (P, S, and A) modes, Intelligent Auto Mode, or the predefined scene modes. When you use a long exposure, be sure the camera is mounted on a tripod and use a cable release to ensure that pressing down and releasing the shutter-release button does not jar the camera.

Knowing When Your Shutter Speed Is Longer than One Second

Normally, the Panasonic GH2 camera shutter speed is in fractions of a second. So when you see the number 4, it is actually 1/4 second. You know the shutter will be open for a second or longer when you see the symbol "following the shutter speed number; for example, 1" represents 1 second, and 30" represents 30 seconds.

Noise Reduction with Long Exposure

Images generated from long exposures may suffer from fixed pattern noise, such as pixels glowing a bright color. This image defect is corrected by a procedure known as dark-frame subtraction. Set the LONG SHTR NR command (figure 7-2) to [ON] to correct this problem:

MENU/SET>REC>(*pg* 3) LONG SHTR NR>[OFF], [ON]

The command has three behind-the-scenes steps:

1. The camera takes an image with the shutter open for the designated time. This will record the image plus the fixed pattern noise.

2. The camera takes another exposure but does not record an image. This is the dark frame, which is a reference map of the position of the glowing pixels.
3. The final step is to subtract the dark frame contents from the first image, thus removing the bright pixels. The image subtraction erases the glowing pixels and generates an accurate picture of the subject.

This command doubles the time it takes to record an image. For example, if you take a photograph with a 10-second exposure, the camera will, at the completion of the exposure, automatically run a second exposure of 10 seconds to create the dark frame. For exposures longer than several seconds, this can create a tedious wait, so some people turn this command off.

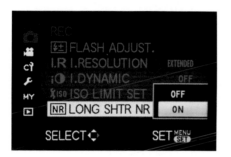

Figure 7-2: LONG SHTR NR command set to [ON]

The factory default setting for this command is [ON], and we recommend that you keep this setting to obtain the best possible picture.

Metering Modes

When using the camera in M Mode, it is important to know the method being used to measure light. There are three options used by the camera's built-in meter: [*Multiple*], [*Center Weighted*], and [*Spot*] (table 7-1). The default and most commonly used method is [*Multiple*], where light over the entire area within the display is measured to calculate the exposure. This measurement is more than a simple averaging of the entire scene; there is an algorithm that balances the exposure, helping to prevent overexposure of the highlights and underexposure of the shadows. Historically, various digital camera manufacturers have developed and refined these algorithms, and although they do an excellent job of generating a pleasing exposure, the strategy employed is complex and not explained to the photographer. You simply use this type of metering and trust it will do a good job.

The second option is [*Center Weighted*], which uses an easily understood algorithm for measuring light. Based on the assumption that the most important subject is in the center of the display screen, this metering pattern prioritizes the exposure so that the center of the display screen is well exposed. The peripheral areas are still evaluated for adjusting the overall exposure, but they are given less

priority. Historically, this has been a popular pattern for measuring light in SLR cameras. Although this older technology has the virtue of simplicity, it is not as reliable as [*Multiple*] area metering, and it results in more missed exposures.

METERING MODE Command Option	METERING MODE Command Icon	Description
Multiple		Meters whole area Complex algorithm
Center Weighted		Meters whole area Simple algorithm
Spot		Meters one spot Simple algorithm

Table 7-1: METERING MODE command icons

The third and most direct algorithm for metering is [*Spot*]. When it is selected, you see a small cross on the screen that marks the region being measured for light. You know precisely how much light is reflected from this one region. The area being metered does not have to occupy the center of the screen. If you set the camera to 1-area-focusing and move the focusing point, the cross will be in the center of the focusing target. If you use facial detection, the spot meter will be on the face that is selected for focusing.

The metering method is selected with the following command (figure 7–3):

MENU/SET>REC>METERING MODE>[*Multiple*], [*Center Weighted*], [*Spot*]

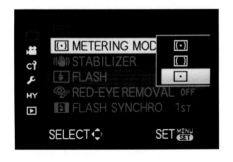

Figure 7-3: The METERING MODE command's three options

Recommendations for Metering

To have full control within the M Mode, you need to know where and how much light the subject reflects. In this respect, spot metering is the superior metering method since you know exactly where and what is being measured. This is best done with an immobile subject. It also requires experience in knowing how a sensor collects light of differing intensities. But its advantage is that an experienced photographer can predict the results from a single reading. For example,

we use spot metering for copy work of line drawings, taking a spot measurement of the area on the paper that has no markings. Experience has taught us that over-exposing that region by 1 2/3 f-stops best records our line copy work—black lines are recorded as jet black, and the white paper is recorded as brilliant white. For work with other subjects, we rely on [*Multiple*] metering and carefully study the resultant histogram. We rarely use [*Center Weighted*] metering.

Using Older Olympus and Panasonic Lenses on the Panasonic GH2

The Micro Four Thirds lens was derived from an earlier Olympus system called the Four Thirds system, which was designed specifically for digital cameras using the Four Thirds sensor. Four Thirds lenses share many characteristics with Micro Four Thirds lenses; however, they require a special adapter for mounting on the Panasonic GH2 camera body. The adapter ensures that the lens can communicate with the camera body, enabling automatic exposure, automatic focus, and manual control of the lens diaphragm with the rear dial on the camera body. Some of these lenses are extremely good optically and can be used advantageously on the Panasonic GH2 camera.

Recommendations for M Mode

Manual (M) mode is for perfectionists who want to know what their camera is doing. By controlling the shutter speed and aperture, the photographer has maximum flexibility in adjusting the exposure. However, the cost for this control is the increased chance for error in improperly exposing the sensor. When you adjust the camera for over- or underexposure, the display screen will show a constantly bright view; it does not show the effects of having a too-dim or too-bright image that arises from changing the exposure. This is in contrast to S, A, and P Modes, which darken or lighten the preview image when you apply exposure compensation. For this reason, we do not recommend M Mode for general photography.

Having said that, M Mode is an essential feature in a professional camera. There are times when we use a handheld digital spot meter to meter a specific region in the scene. We then transfer the values measured in the meter to the camera. Although this seems incredibly archaic, it is sometimes necessary.

One final advantage of using the M Mode is it can provide longer exposures than any other mode. If you need a two-minute exposure, you can get it in M Mode by adjusting the shutter speed value to "B". This setting is not available in A, P, or S Modes, for which the maximum exposure time is 60 seconds.

Manual Focusing Overriding Automatic Focusing

We described in chapter 6 how to focus a Micro Four Thirds lens by turning the lens-focusing ring. Normally the manual lens-focusing ring is inoperable when the focus mode lever is set to Auto Focus Single (AFS) or Auto Focus Continuous (AFC), but the AF+MF command will activate the lens-focusing ring when the camera is set to an auto focus mode:

MENU/SET>CUSTOM>(*pg* 3) AF+MF>[OFF], [ON]

We recommended that this be set to [ON]. Since the AF+MF command pertains only when the camera is in an auto focus mode, its setting does not impair automatic focusing. This command allows you to manually refine the focus when needed. The focus will be changed only when you turn the lens-focusing ring. To speed camera operation, you can turn off automatic focus and just focus manually. This is accomplished by turning the focus mode lever to MF, enabling the lens-focusing ring automatically.

To improve the focus accuracy of a stationary subject, you can use the following command:

MENU/SET>CUSTOM>(*pg* 3) MF ASSIST>[OFF], [ON]

When this command is set to [ON], turning the lens-focusing ring will magnify the image on the display screen. With this high-magnification view, fine details of the subject can be seen easily, thus facilitating focusing. When you wish to see the entire field of view, pressing the shutter-release button halfway will reduce the magnification. Note that the lens-focusing ring works only after the camera finds focus in the automatic mode. If the camera cannot find focus and the lens is "hunting" for a sharp image, turning the focusing ring will not override the automatic motor.

Manual Focusing of Four Thirds Lenses

To use older-style Olympus Four Thirds lenses, you will need a Panasonic adapter, model number DMW-MA1. These Four Thirds lenses, especially the telephoto zoom lenses, can provide a longer focal length and faster aperture than many Panasonic lenses. We have used the Olympus Zuiko 70–300 mm zoom, 50 mm macro, 12–60 mm zoom, and 50–200 mm zoom with our Panasonic GH2 camera. We have used all of these lenses in MF Mode, and they operate smoothly with the DMW-MA1 adapter. Be aware though these lenses may not provide all the features that the GH2 is capable of supporting such as OIS (Optical Image Stabilization).

There is no optical stabilization because Olympus builds its stabilization mechanism into the camera body, not the lens. Also, using automatic focusing with any Four Thirds lens is slow and not recommended. All of the commands related to manual focus, described earlier, work with Four Thirds lenses. However, it is simpler and faster to set the focus mode lever to MF and focus the lens manually.

Manual Focusing Any Lens

The Panasonic GH2 camera is the most versatile camera body for mounting lenses. You can make it work on telescopes, microscopes, and camera lenses from almost any manufacturer. We will discuss this in more detail in the next chapter, but we should point out a little-used command, SHOOT W/O LENS:

MENU/SET>CUSTOM>(*pg* 7) SHOOT W/O LENS>[OFF], [ON]

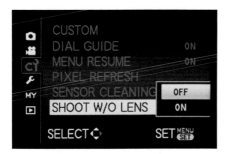

Figure 7-4: The SHOOT W/O LENS command options

This command controls if the shutter releases when there is no lens attached to the camera body (figure 7-4). The default command value is [OFF], meaning the camera will not fire unless it detects there is a Micro Four Thirds lens attached to the camera body. We set the command to [ON] when we use the camera on microscopes or telescopes, or with virtually any lens that can be mounted on the camera body. In essence, the camera can be used to take pictures with any optics that can project an image onto its sensor. Having this command active does not interfere with any of the camera's regular functions, so we just leave it on.

Focusing Using the Touch Screen

The Panasonic GH2 camera movable LCD display screen is a touch screen. At first, we thought the advantage of using a touch screen would be minimal. But we were wrong. This feature is invaluable when the camera is mounted on a tripod.

Focusing

Our change in attitude was a result of needing to find focus for different areas on the screen while the camera was mounted on a tripod. Remember, with 1-area-focusing, a target is placed on the subject to be focused. With a simple finger touch you can control the area and size of the focusing spot.

Use the following steps for setting the focus area using the touch screen:

1. With the camera mounted on a tripod, set the focus mode lever to AFS and the auto focus mode dial to 1-area-focusing.
2. Find the point where you want to focus on the display screen and touch it with your finger. A yellow-bordered square appears.
3. If the square covers the region you want to focus on, press the shutter-release button halfway and the camera will focus. Focus confirmation is signaled with a green circle and the target square brackets turning green.
4. Fully depress the shutter-release button to take the picture.

Activate Shutter

For even faster operation, you can fire the camera when you identify the point to focus on by simply touching the appropriate spot on the screen. You will need another command to accomplish this task:

MENU/SET>CUSTOM>(pg 6) TOUCH SHUTTER>[OFF], [ON]

When this command is set to [ON], the ability to fire the camera by touching the LCD screen is enabled. This is shown by the presence of one of two Touch Screen Shutter icons. To use target shooting as an analogy, an icon with an X indicates that the function is enabled but the firing safety is on, so you cannot fire the camera by touching the screen (figure 7-5a). When you touch this icon, the safety is released and you will see the icon turn yellow and the X disappears. The safety is switched off, so now the camera can be fired whenever you touch the LCD screen (figure 7-5b).

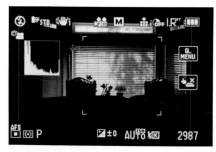

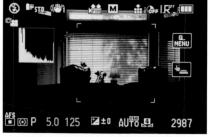

Figure 7-5a: Touch Screen Shutter icon indicates camera will fire only if the shutter-release button is pressed

Figure 7-5b: Touch Screen Shutter icon indicates camera will fire if screen is touched

Image Magnification

The touch screen facilitates manual focusing by increasing the magnification at the point you touch the screen. To accomplish this, ensure the MF ASSIST command is set to [ON], and set the camera's focus mode lever to MF. Touch the screen and the image will be magnified at the point of contact. This can be invaluable when you want to focus on a point away from the screen's center. To reduce the magnification back to the whole field of view, press the shutter-release button halfway.

Other Touch Screen Operations

There are several other functions where you may find using the LCD touch screen capability advantageous. You can use the LCD touch screen to identify the subject you wish to have tracked when the auto focus mode dial is set to AF Tracking. You can reposition the Histogram and the crosshair guide lines using the touch screen. You can also display the Quick Menu, play back your pictures by sweeping your finger across the screen, or tap to zoom in to better view the picture's detail. As with many things with this camera, experiment. We are sure you'll decide that many touch screen functions are easier to access.

Recommendations for Focusing

When using lenses that are not specifically made for the Micro Four Thirds camera, we rely on focusing manually. Although automatic focus is available on the Four Thirds lenses made by Olympus and Panasonic, it is so slow that you can focus manually faster than the camera can focus automatically. We always focus manually with these lenses. Because virtually any lens can be adapted to the Panasonic G series cameras, we make it a practice to turn both the MF ASSIST and SHOOT W/O LENS commands [ON].

When using the camera on a tripod, we make sure to use the touch screen. With the right software command, we can touch a portion of the screen to identify the point we wish to focus on. The camera then focuses on that point and fires when focus is achieved.

Fine-Tuning White Balance

In chapter 6, we described how to use standard settings for white balance and how to calibrate your camera to a light source using a white sheet of paper. For most of us, this is sufficient. However, the Panasonic GH2 camera provides even greater control by allowing you to fine-tune your color settings by eye. It requires first applying the standard white balance strategies and, if you don't get the desired results, providing additional tinting.

This adjustment is used when the standard white balance presets are inadequate. This can be a result of very unusual lighting conditions, such as when several

different light sources illuminate the subject. For example, an interior scene could have a subject lit by daylight streaming through the window, an incandescent light on the table, and fluorescent lights on the ceiling.

These extreme conditions can fool the white balance calibration—especially when fluorescent lights are involved because they may not emit a full spectrum of light. To compensate for this, Panasonic provides a means of adding tints to the image. These slight additions of hue will be recorded in both JPEG and RAW files. This process is referred to as "Finely Adjusting the White Balance" in Panasonic's Operating Instructions. It is a continuation of using the commands available when you press the right directional arrow button and initiate white balance adjustment (figure 7-6a).

When you first press the WB button and select a white balance preset, you will be prompted to press the down directional arrow button or to touch the screen at the white-bordered ADJUST icon. Either action brings up a screen (figure 7-6b) showing the controls for tinting the color. Press either the vertical directional arrow buttons to control the magenta/green tint or the horizontal directional arrow buttons to control the amber/blue tints. Apply these controls until you neutralize the color cast. The degree of tinting is shown by the displacement of a yellow square within a large white-bordered square. Pressing the up directional arrow button applies a green tint and the yellow square moves up the vertical line (figure 7-7a). To apply magenta, press the down directional arrow button to move the yellow square down the vertical line (figure 7-7b). If you wish to return to the neutral position, press the appropriate directional arrow buttons to return the yellow square to the center of the vertical line. You can also return to the neutral value by pressing the DISPLAY button.

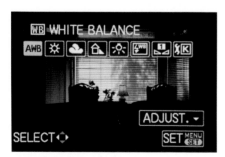

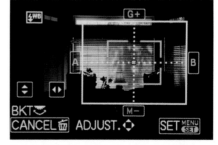

Figure 7-6a: The LCD display screen after pressing the WB button

Figure 7-6b: Fine adjustment controls for tweaking the color balance by eye

If you desire, you can do a white balance bracket and capture three images in which the white balance is varied. This is accomplished by using additional commands in this screen. In figures 7-7a and 7-7b, the letters BKT (bracket) can be seen in the lower-left corner of the display screen next to the rear dial icon. When you

turn the rear dial, two yellow squares that serve as markers appear in the display. They will indicate the range of your bracket from amber to blue (turn the rear dial to the right) or green to magenta (turn the rear dial to the left). Press the MENU/SET button to select the bracket series. Press the shutter-release button to execute the white balance bracket series.

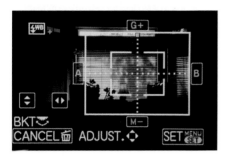

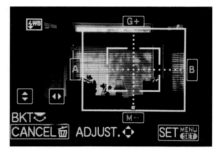

Figure 7-7a: The display when applying a green tint to the image

Figure 7-7b: The display when applying a magenta tint to the image

Intelligent Resolution

Panasonic has a menu command, I.RESOLUTION (Intelligent Resolution), that increases edge definition, enhancing the visibility of fine detail and the reduction of noise in areas lacking fine details. The command provides five options (figure 7-8). We have used I.RESOLUTION and reviewed its effects on JPEG files. It does a good job of applying a sharpening effect and improves the rendition of fine details in these files. We also apply this command to our videos:

MENU/SET>REC>(*pg* 3) I.RESOLUTION>[OFF], [LOW], [STANDARD], [HIGH], [EXTENDED]

Its greatest effect is evident when using [EXTENDED], and the least effect is evident when using [LOW]. The [EXTENDED] option allows you to take natural pictures with higher resolution. The command can also be turned to [OFF]. Note that the [EXTENDED] option does not apply to video recording.

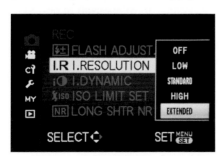

Figure 7-8: I.RESOLUTION command with its five options

Recommendations for Using Focusing, Fine Tuning White Balance, and Intelligent Resolution

Generally, we rely on automatic focusing with all our Micro Four Thirds lenses. Even so, we allow ourselves to refine focusing by making sure that the AF+MF, MF ASSIST, and FOCUS W/O LENS commands are all set to [ON]. Typically, these three commands are turned off at the factory, but since they do not affect automatic operation, we prefer having them available on those occasions when we use a Four Thirds lens. With a Four Thirds lens, we simply switch the focus mode lever to MF.

We do not fine-tune the white balance for still photography. This operation is accomplished with more precision when the image is displayed on the computer monitor and you have leisure time to carefully evaluate the impact of applying color tints. Nor do we use white balance bracketing since we usually get the color we want with just one shot. This is not to say touching up the white balance in the camera is useless, but it is most valuable when shooting movies.

Our view of Intelligent Resolution is similar. We turn it off when taking still photographs, and we may turn it on when taking HD videos.

Getting More Magnification from the Lens

Extra Tele Conversion

Another rationale for using the JPEG file format is to extend the magnification of your lens. According to Panasonic, you can increase the effective focal length of the lens to provide 2× more magnification with no loss of quality. This claim seems too good to be true—and in a way, it is. However, studying the camera specifications and analyzing what is going on reveals the truth in Panasonic's claim.

First, Extra Tele Conversion for still pictures works only if the file is saved as a JPEG and with a picture size of [M] or [S]. We will use the [L] picture size and the 4:3 aspect ratio (4608 × 3456 pixels) for this explanation, but keep in mind that it works with other aspect ratios. Using this as an example, the effective sensor size is 4608 × 3456 pixels, and you save the image with this pixel array when you set the PICTURE SIZE command to [L]. But suppose you decide to save the file as [S]. When you save the image in JPEG with this setting, the image file is only 2336 × 1752 pixels, or basically four megapixels—not the original 16 megapixels. If you look at the LCD screen or the viewfinder, the image will look as if you saved it as an [L] file—in other words, Panasonic engineers have figured out how to take the original 4608 × 3456 pixel image and compress it so it can be displayed with only 2336 × 1752 pixels.

Now what happens when you set the GH2 to Extra Tele Conversion? Well, the camera will show you the center of the 4608 × 3456 pixel sensor. But rather than downsizing the pixel display of the whole sensor, it uses all the original pixels that occupy its center; that is, it crops the image to show and save only the central 2336 × 1752 pixels.

Normally, most photographers would not find this type of zoom to be advantageous for their still photography. You can get the same effect by simply saving the 4608 × 3456 pixels and then cropping it to the central 2336 × 1752 pixels with imaging software, such as Photoshop. But when you do this trick in the camera, you get one benefit: the view on the display screen doubles in size. It's as if your lens is now twice as powerful as it was earlier. Thus, for viewing through the camera, it appears that you have a 2× telephoto. Because you had to downsize the sensor to 2336 × 1752 pixels to get this effect, the resultant extra zoom from this setting does not show any degradation in quality. For still photography, this seems like a minor advantage.

Extra Tele Conversion is incredibly valuable when you shoot video. When you use the video recording mode AVCHD, you are recording only 1920 × 1080 pixels. This situation is analogous to the example in the preceding paragraph. Normally, you would be using the whole sensor, and its output would be adjusted to 1920 × 1080 pixels. But if you select Extra Tele Conversion, the image will be taken with the central 1920 × 1080 pixels of the 4608 × 3456 pixel sensor. This means your lens will gain 2.6× more magnification than you would normally expect. The magnification is slightly higher for the video mode because you are recording in the 16:9 aspect ratio. It provides you with an extended telephoto lens, and when you use the camera in this fashion, the video will look as good as a video recorded without this command.

The command is as follows:

MENU/SET>REC>(*pg* 4) EX. TELE CONV.>[OFF], [ON]

Normally the command is set to [OFF] . To activate it, set the command to [ON]. The EX. TELE CONV. command is not enabled when BURST RATE is [SH], when PICTURE SIZE is [L], or when QUALITY is any of the RAW file formats. If you want to use this command in the video mode and save RAW files on your memory card, you will have to set the mode dial to Creative Motion Picture Mode to set the command:

MENU/SET>MOTION PICTURE>(*pg* 3) EX. TELE CONV.>[ON], [OFF]

The default setting for this command is [OFF], so you will need to turn it [ON] to use it.

Digital Zoom
The DIGITAL ZOOM command differs from EX. TELE CONV. command in that there will be a notable degradation of the image. When describing how the EX. TELE CONV. command works, we pointed out that it works directly with individual pixels of the sensor. That is, there is a one-to-one correspondence between the sensor

pixel and the pixel that was output for the saved file. However, the DIGITAL ZOOM command does not follow this guideline. It takes a single pixel of the sensor and remaps it so that it now occupies the space of four pixels in the final image. In terms of the final image, only one-fourth of the pixels are used to make up the image, versus the one-to-one relationship in the EX. TELE CONV. command. As a result, the image appears blocky—or as Panasonic describes it, there is image deterioration.

You can use the DIGITAL ZOOM command for both still pictures and videos, but not for Burst Groups. The commands are as follows:

MENU/SET>REC>(*pg* 4) DIGITAL ZOOM>[OFF], [2X], [4X]
MENU/SET>MOTION PICTURE>(*pg* 3) DIGITAL ZOOM>[OFF], [2X], [4X]

Normally these commands are set to [OFF]. To activate either one, set the command to either [2X] or [4X]. The [2X] setting doubles the magnification, and [4X] doubles it again. The DIGITAL ZOOM command cannot be used when saving still files in RAW format.

Recommendations for Increased Magnification

We are not fans of digitally increasing the power of the lens, but Panasonic's Extra Tele Conversion command convinced us that it is a worthwhile command while taking videos. In this mode, the command provides an increase in magnification with no degradation in the image. If you have a 10:1 zoom, such as the 14–140 mm lens, you now have a 26:1 zoom whose focal length is increased 2.6 times. We frequently make use of this command when taking videos of animals. However, it is not advantageous for still photography, so we tend to ignore it in this application.

With this much magnification, we make sure the image stabilization is on when handholding the camera. Even so, if you use the Extra Tele Conversion command at the 140 mm zoom setting, this will not be enough; you will need to use a tripod. A tripod is mandatory if you use this command with the Panasonic 100–300 mm lens because you will have the 35mm film equivalent of a 520–1560 mm lens.

Choosing File Formats: JPEG

Some photographers believe that the major criteria in choosing a file format for saving their images is image quality. Essentially, if you want the highest-quality image, you use RAW and work with software outside of the camera to translate the file and generate high-quality images. Instructing the camera to save files in JPEG will reduce image quality and should not be done. Although that is technically correct, you should use a balanced approach in choosing file formats. If the situation warrants it, images should be saved as JPEGs if it improves the camera's capability to fire longer continuous bursts.

Another reason for choosing JPEG over RAW is the need to store images on a memory card. A RAW file can be two to four times the size of an equivalent JPEG, so by saving images as JPEGs you can save store up to four times as many images on a given memory card.

In addition, many image-processing commands are available when you save your files using JPEG. As mentioned earlier, Film Mode has noise reduction controls to reduce the effects of shooting at a high ISO. Also, the various color schemes in Film Mode and My Color Mode will be retained only if you save the files as JPEGs. Using our experience in recording black-and-white images, we can have our cake and eat it, too. When we save RAW and JPEG images, the RAW file still has the color, while the JPEG file appears as monochrome. What makes black-and-white especially convenient is the electronic viewfinder. It provides a preview of the subject as a monochrome image, and this facilitates composition.

Finally, judicious use of JPEG gives you an additional option when shooting videos outside of the Creative Motion Picture Mode. You can use the EX. TELE CONV. command to get some additional reach if you do not have an extreme telephoto lens. This can provide a 2× increase in magnification for still photos, and an increase of 2.6 × to 4.8 × for videos. Moreover, the Film Mode commands can alter contrast, brightness, noise reduction, and sharpness in the JPEG files. These effects are absent in RAW files. Other commands that act primarily on JPEG files are I.RESOLUTION and I.DYNAMIC for optimizing the image. When they are used judiciously, these commands can improve the quality of the saved JPEG file.

Saving images as JPEGs can provide advantages in creating a digital image. You should experiment with the options available when using this file format.

Optical Image Stabilizer (O.I.S.)

The Optical Image Stabilizer (O.I.S.) counteracts the minute tremors and movements that occur when handholding a camera and ensures sharp pictures. Generally, a fast shutter speed helps hide these tiny movements at the time of exposure. But as the shutter speed decreases, meaning the shutter is open longer, the chance of movement occurring while the shutter is open increases, and the image appears smeared. Panasonic's O.I.S. helps prevent image blurring resulting from this jiggling. When you see the Stabilizer icon (table 7-2) on the display screen (figures 7-9a and 7-9b), you know the command is active.

If the shutter speed is so slow that there is a danger of obtaining a blurred image, the Stabilizer icon is transformed into a red Jitter icon. To avoid taking a blurred image, mount the camera on a tripod and make sure it is held rigidly. Or you can increase the ISO and/or ambient light to allow for a faster shutter speed.

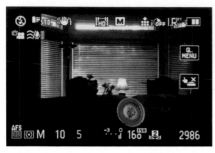

Figure 7-9a: The Stabilizer icon indicates that the exposure has not been evaluated yet

Figure 7-9b: The Jitter icon replaced the Stabilizer icon after the exposure was evaluated; the shutter speed is longer than 1/30 second and requires the use of a tripod

((⌷))	((✋))
Jitter warning Use tripod or faster shutter speed	Stabilizer status May be followed by 1,2, 3, or OFF

Table 7-2: Stabilizer and Jitter icons and descriptions

The STABILIZER command has four settings:

MENU/SET>REC>(*pg* 2) STABILIZER>[OFF], [MODE1], [MODE2], [MODE3]

The available STABILIZER command options are determined by which lens is attached to the camera body. With older Panasonic lenses, there is a Stabilizer On/Off switch, and you can do a direct comparison of the effectiveness of the stabilizer by holding the camera and using this switch. Some of the newer lenses for the Panasonic GH2 camera lack this feature, and the only way to turn off the anti-vibration feature is within the menu. Turning off the O.I.S. is recommended if the camera is mounted on a tripod.

The [OFF] option is available only when a lens without the O.I.S. switch is attached to the camera. Otherwise, the [OFF] option does not display (figure 7-10) and you will use the lens's O.I.S. switch to turn off the stabilization.

When applicable, set the command to [OFF] (or turn off the lens's O.I.S. switch, as appropriate) when the camera is mounted on a tripod. If the STABILIZER command is active when the camera is held absolutely steady, it can generate a blurred image.

Selecting [MODE1] makes the stabilizer function active at all times, so its effects will be visible on the display screen while you are holding the camera. The [MODE2] setting activates stabilization at the moment the shutter-release button is pressed. This is supposed to provide better dampening than [MODE 1]. The [MODE3] setting is used when you pan the camera along a horizontal axis; the stabilizer works in the vertical plane, but it is deactivated on the horizontal plane.

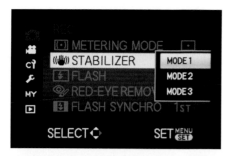

Figure 7-10: STABILIZER command in [MODE1]

O.I.S. Variation among Micro Four Thirds Lenses

The O.I.S. mechanism is located within Panasonic lenses and will not work if you mount the lens on an Olympus Micro Four Thirds camera. Similarly, if you use an Olympus Micro Four Thirds lens on your GH2, you will not have O.I.S. capability. The Olympus antivibration mechanism is built into the Olympus camera bodies. Finally, there are some Panasonic lenses that lack the O.I.S. mechanism and cannot provide stabilization.

Auto Bracketing

Although the AUTO BRACKET command can be used in the predefined scenes modes, we have found it more useful in the P, A, S, and M Modes. This command will automatically take a series of images, each at a different exposure setting. At first glance, one might think this is unnecessary; the camera's built-in meter does an accurate job of indicating exposure, and slight errors in measurement can be corrected by using Exposure Compensation. However, the AUTO BRACKET command value is important in providing a range of exposures for high dynamic range (HDR) photography.

HDR combines several images taken with different exposures to generate a single file with an intensity range greater than that of a single exposure. By combining multiple images of a subject captured at different exposures, a composite file is created and can be viewed with tone mapping software to display different exposure intensities in a single image. This is a technique you can use to overcome some of the limitations of your camera by using image processing.

A single exposure that concentrates on the midtones in a scene may fail to record intensity variations in the highlights and shadows. In this situation to record all of the scene's intensity variations, several different exposures need to be captured. When you bracket exposures, some images will show details in the highlights, and some will reveal details in the shadows. Figures 7-11a-c show three different exposures from a series of seven exposure-bracketed photos. In this example, the

7

exposure is varied by a total of +2 and −2 f-stops, using 1 f-stop intervals (three on each side of the optimum exposure). Individually, the photographs will be unsatisfactory, but by using tone-mapping software, you can merge them into a single image that will have all the information in the highlights, midtones, and shadows (figure 7-11d).

Figure 7-11a: The camera's optimum exposure

Figure 7-11b: Underexposed by 2 f-stops

Figure 7-11c: Overexposed by 2 f-stops

Figure 7-11d: Combined image using HDR software

As a starting point, we would need to tell the camera how many exposures to take and how much variation there needs to be between exposures:

MENU/SET>REC>(*pg* 4) AUTO BRACKET>STEP>[3 1/3], [3 2/3], [3, 1], [5 1/3], [5 2/3], [5 1], [7 1/3], [7 2/3], [7 1]

Each of the options describes the number of shots and their variation, so [3 1/3] means three shots taken at 1/3 f-stop intervals. Or at the other extreme, you can use [7 1], which means taking seven shots at 1 f-stop intervals, where the resulting seven shots will span +3 and −3 f-stops from the optimum exposure.

Then you need to determine the order in which you want take the photographs:

MENU/SET>REC>(*pg* 4) AUTO BRACKET>SEQUENCE>[0/−/+], [−/0/+]

The option [0/−/+] starts the sequence at the exposure recommended by the camera meter and proceeds from underexposure to overexposure. The second option, [−/0/+], starts the exposure on the underexposure side of the range, proceeds to the recommended exposure, and then goes to overexposure. The bar on the bottom of the screen will show how and when the burst will be fired. The final item to select is the AUTO BRACKET icon on the drive mode lever. This will fire all the shots as long as the shutter-release button is depressed. If you fail to hold down the button, you will have to fire each shot individually.

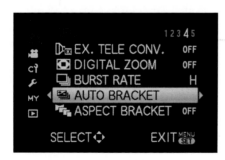

Figure 7-12a: AUTO BRACKET command highlighted

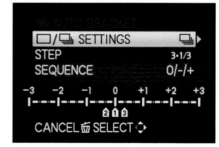

Figure 7-12b: Three options of the AUTO BRACKET command

Executing Auto Bracketing

After the AUTO BRACKET command values have been selected, you are ready to fire your shots. We do not use the AUTO BRACKET command as a shotgun approach to find the best exposure. Rather, we use it to explore HDR photography. We tend to select the maximum of [7 1] for seven shots at 1 f-stops intervals. This way, we have the most data to work with and the best chance of getting a picture we want to keep.

If you are interested in pursuing HDR photography, we have a few more recommendations. First, use the camera in A Mode. This will force the camera to maintain a constant aperture and vary the shutter speed for over- and underexposing the shots. Maintaining a constant depth of field is essential for merging the pictures; otherwise, you will lose definition in those areas that drop out of the depth of field. Second, we recommend mounting the camera on a tripod. Any shift in the camera position will blur the resultant picture when the images are merged. Third, and finally, use a cable release to release the shutter in order to prevent movement prior to exposure.

Do not forget to set the drive mode lever to AUTO BRACKET. Failure to do so will force you to press the shutter-release button for each exposure. This will force you to keep track of when you have completed the series. It is easier to use AUTO BRACKET and have all the images captured with one sustained press of the shutter-release button.

Recommendations for Auto Bracketing

We use the AUTO BRACKET command for taking various exposures of a scene when the range of lighting is sufficiently great that the scene cannot be recorded with a single exposure. Although it is possible to execute this command handheld, we do not recommend it.

If you wish to try this technique, you will need software that can align the images. We use Photomatix. We use a wide-angle lens and set the camera to fire an exposure bracket using five frames per second. Then we set the camera to A Mode and use the AUTO BRACKET command. Keep in mind that you will get better results if you mount the camera on a tripod and fire it with a cable release.

7

The System Approach to Expanding the Camera's Utility

8

Introduction

If you have just bought a Panasonic GH2 camera and the only camera you previously owned was a point-and-shoot compact camera, you will be in for a pleasant surprise. The Panasonic GH2 is a versatile tool. With the availability of accessory lenses and adapters, this camera can take on any photographic assignment. If you already own an interchangeable lens camera, you will be pleased how your older lenses and accessories can integrate with your new Panasonic GH2 camera.

For the neophyte just starting with photography, supplementary lenses can provide a new perspective on recording scenes. You can use a super wide-angle lens to encompass a greater area in an interior shot, or you can employ a telephoto lens for obtaining a close-up portrait of a wary animal. Additionally, you can play with perspective to generate a picture that emphasizes the expanse of a scene or use an extreme telephoto to flatten a scene so that objects appear to be juxtaposed. All of these tricks become possible when you mount different lenses to the camera body.

You may already have an extensive collection of lenses for your single-lens reflex (SLR) body. A Panasonic GH2 camera can be a useful addition because it is smaller and lighter than most of its competitors. It becomes a handy camera to take out on spontaneous trips and informal family gatherings where a larger camera's weight and size can discourage its use. Also, the Panasonic GH2 camera has the unusual and invaluable characteristic of working well with lenses made by virtually all other manufacturers. We have used Nikon lenses with the Panasonic GH2 camera body for our technical work (a mix of close-up photography and photomicrography). For these tasks, the Panasonic's electronic viewfinder and its tilting rear LCD display screen is more usable than the Nikon body's optical viewfinder or its fixed rear LCD screen.

Besides lenses, there are other accessories of interest, such as a tripod for holding the camera. Used judiciously, it ensures you obtain the maximum performance from your optics by holding the camera steady.

8

Optical Accessories: The Micro Four Thirds Lens

The Panasonic GH2 camera is sold as a body only, or as one of two kits. The Panasonic GH2K Kit comes with a basic zoom lens that has a focal length of 14–42 mm. The more expensive Panasonic GH2HK Kit is available with a 14–140 mm focal length zoom lens. Both lenses are capable of handling most photographic assignments. However, you can expand these capabilities by purchasing additional lenses. The most convenient ones to use are those made by Panasonic and Olympus.

The Micro Four Thirds system has a defined set of characteristics for how the lens and camera body communicate, the size of the sensor, and the mechanical connection between the lens and body. Olympus and Panasonic make lenses to this

specification, giving photographers flexibility to use their lenses on the Panasonic G series bodies. This benefits the consumer by providing more choices when buying a lens. Panasonic has an agreement with Leica and sells some accessory lenses with the Leica label—for example, the Leica DG Macro-Elmarit 45 mm f/2.8 ASPH OIS. This macro lens has Mega O.I.S., autofocus, and automatic exposure.

Typically, a camera body and lens are restricted to a single manufacturer—Nikon lenses are used with Nikon camera bodies, and Canon lenses are used with Canon camera bodies. If you buy a lens that is specified for the Micro Four Thirds system, you can be confident that it will work easily with your Panasonic GH2 camera body (table 8-1).

Generally, such a lens guarantees that the following functions will work: automatic exposure, automatic focus, and control of its aperture from the camera body. The only thing you lose when you buy a lens made by Olympus and use it on your Panasonic GH2 camera body is the Optical Image Stabilizer (O.I.S.), a feature for steadying the image and negating the effects of camera movement during exposure. The hardware for this feature resides within Panasonic O.I.S. lenses. In the case of Olympus products, the stabilizer system works on the sensor in the camera body, so Olympus lenses will not have image stabilization when used on a Panasonic body.

Micro Four Thirds Lenses and Four Thirds Lenses

Micro Four Thirds lenses evolved from the Four Thirds system, developed by Olympus. Originally this format was for DSLR cameras, and it was supposed to be more compact than competing products.

However, this advantage was soon lost as other manufacturers made smaller and lighter DSLRs. To regain its advantage in having a small interchangeable lens camera, Olympus designed the Micro Four Thirds system. This reduced the camera size by removing the optical viewfinder and replacing it with an electronic viewfinder. The lens can therefore be placed closer to the sensor, allowing for a reduction in both lens and camera body size.

In comparison to other manufactures, such as Nikon or Canon, Panasonic does not make an extensive range of lenses. Keep in mind that many companies have been manufacturing lenses for decades. Indeed, these companies got their start before there were digital cameras, and consequently their greater number of lenses is a reflection of their longevity. The Micro Four Thirds system is new and has been in production for only a couple of years. In spite of this, it has a good selection of lenses, spanning a focal length range of 7 mm to 300 mm. For users familiar with 35mm film cameras, this translates to focal lengths from 14 mm wide angle to 600 mm telephoto.

Manufacturer	Description	Focal Length	35mm Equivalent	Stabilized?
Panasonic	Wide-angle zoom	7–14 mm f/4	14–28 mm	No
Panasonic	Fisheye fixed focal length	8 mm f/3.5	16 mm	No
Olympus	Wide-angle zoom	9–18 mm f/4.0–f/5.6	18–36 mm	No
Olympus	Wide-angle fixed	12 mm f/2.0	24mm	No
Panasonic	3D fixed	12.5 mm f/12	25 mm	No
Panasonic	Wide-angle fixed	14 mm f/2.5	28 mm	No
Panasonic	Normal zoom	14–42 mm f/3.5–f/5.6	28–84 mm	Yes
Olympus	Normal zoom	14–42 mm f/3.5–f/5.6	28–84 mm	No
Panasonic	Normal zoom	14–45 mm f/3.5–f/5.6	28–90 mm	Yes
Panasonic	Normal zoom	14–140 mm f/4.0–f/5.8	28–280 mm	Yes
Olympus	Normal zoom	14–150 mm f/4.0–f/5.6	28–300 mm	No
Olympus	Wide-angle fixed	17 mm f/2.8	34 mm	No
Panasonic	Normal fixed	20 mm f/1.7	40 mm	No
Cosina	Normal fixed	25 mm f/0.95	50 mm	No
Leica	Normal fixed	25 mm f/1.4	50 mm	No
Olympus	Telephoto zoom	40–150 mm f/4.0–f/5.6	80–300 mm	No
Olympus	Telephoto Zoom	40–150 mm f/4.0–f/5.6	80–300 mm	No
Leica DG	Macro fixed	45 mm f/2.8	90 mm	Yes
Olympus	Telephoto fixed	45 mm f/1.8	90 mm	No
Panasonic	Telephoto zoom	45–175 mm f/4.0–f/5.6	90–350 mm Power Zoom	Yes
Panasonic	Telephoto zoom	45–200 mm f/4.0–f/5.6	90–400 mm	Yes
Olympus	Telephoto zoom	75–300 mm f/4.8–f/6.7	150–600 mm	No
Panasonic	Telephoto zoom	100–300 mm f/4.0–f/5.6	200–600 mm	Yes

Table 8-1: List of Micro Four Thirds lenses compatible with the Panasonic GH2 camera body

Why do we use the lens focal lengths of a 35mm film camera as a reference? Historically, photographic enthusiasts used film cameras and became familiar with how a lens focal length changes the field of view. So a 28 mm lens gives a

wide-angle view of about 75 degrees, a 50 mm lens provides a normal focal length with a 47-degree field of view, and a 100 mm telephoto provides a narrower angle of view of 23.5 degrees.

In time, photographers used the lens focal length to describe its angle of view. By using this as a standard, many photographers didn't realize that in the switch from film to digital, the angle of view also depends on the size of the sensor. Only if the sensor size is constant can the focal length be related to the field of view. This inaccuracy is acceptable if everyone agrees to use 35mm film as a standard. (A 35mm frame of film is 36 mm × 24 mm).

The overall size of digital camera sensors varies. They can range from full-frame sensors (at the same 36 mm × 24 mm dimensions as film) to smaller sensors. The Four Thirds camera sensor dimensions are about half those of a full-frame sensor at 17 mm × 12 mm. This means the relationship between the field of view and the focal length has changed dramatically. If you take a 50 mm lens and mount it on a Four Thirds camera, you will find that the sensor—because it is smaller—sees only half of the field of view of a full-frame sensor. For a full-frame sensor, the field of view is 47 degrees, and a Four Thirds sensor has a 23.5-degree field of view. In other words, the field of view of a 50 mm lens on a Four Thirds camera provides the same field of view as a 100 mm lens on a full-frame camera.

Because of this, digital photographers use the term *crop factor*, or full-frame equivalent. In the case of the Four Thirds system, we started thinking in terms of 2. If you take a normal 50 mm lens from a 35mm film camera and want to see the same field of view on a Four Thirds camera, you would divide 50 by 2 and select a 25 mm focal length lens. By the same token, if you want to replicate the view of a particular lens on a 35mm film camera, you would select a lens that is half the focal length for your Panasonic GH2. For example, if you've used a 35mm film camera and the view through a 300 mm lens is perfect, then you would select a 150 mm lens for your Panasonic GH2.

The Four Thirds System

The Four Thirds system was based on using a sensor with a 4:3 aspect ratio, hence its name. By using a small sensor (half the dimensions of a 35mm negative), its designers manufactured smaller camera bodies and lenses. Included with this design was a new bayonet-type mount with electrical contacts for automatic focusing and exposure. By establishing and defining this standard, it was hoped that other manufacturers would design similar cameras and lenses compatible with the system. At the onset, the Four Thirds standard included digital sensors and associated lenses to have minimal vignetting or light falloff at the corners of images.

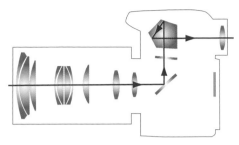
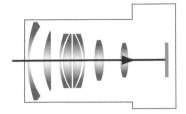

Figure 8-1a: The back focus of a DSLR lens, which is longer than that of a Micro Four Thirds lens

Figure 8-1b: The Micro Four Thirds lens has a short back focus since its viewfinder uses the imaging sensor

The Four Thirds system is used by Olympus E series DSLR cameras (figure 8-1a) and by Panasonic; however, it did not attain widespread popularity. About three years ago, Olympus and Panasonic announced the development of a Micro Four Thirds system. This maintained the same sensor size, but it was designed for a non-DSLR camera body. The chamber containing the mirror and optical viewfinder was eliminated, and an electronic viewfinder was developed (figure 8-1b). The design reduces the distance between the lens flange and digital sensor in the camera body, resulting in a smaller camera body and lens system.

Because the Micro Four Thirds system evolved from the original Four Thirds standard, there is partial compatibility between the Panasonic GH2 camera body and the older lens design. By using an adapter (figure 8-2), these older lenses can be mounted to the camera body, allowing you to control the lens aperture and automatic exposure. Sadly, automatic focus is only partially implemented and is unacceptably slow. We recommend manually focusing the lens. If you are recording video, the sound of the focusing motor will be recorded with your movie.

Figure 8-2: Adapters for fitting other lenses on the Panasonic GH2 body

If you buy Olympus Four Thirds system lenses with the intention of using them on your Panasonic GH2 camera body, keep in mind that you will not have the image stabilizer. Table 8-2 lists the Olympus Four Thirds lenses that can be adapted to the Panasonic GH2 camera body. Many of these lenses are optically excellent, and they

tend to have a larger maximum aperture than the Micro Four Thirds system lenses. For example, the Olympus 90–250 mm zoom lens has an aperture of f/2.8. As such, it makes a useful addition if you are interested in working with limited lighting situations. Some of these lenses, even if used only as manual-focus optics, can be valuable for nature photography. If you wish to use Four Thirds lenses, you need to buy the Panasonic DMW-A1 adapter.

Manufacturer	Description	Focal Length	35mm Equivalent
Olympus	Wide-angle zoom	7–14 mm f/4.0	14–28 mm
Olympus	Fixed focal length	8 mm f/3.5	16 mm
Olympus	Wide-angle zoom	9–18 mm f/4.0–f/5.6	18–36 mm
Olympus	Wide-angle zoom	11–22 mm f/2.8–f/3.5	22–44 mm
Olympus	Normal zoom	12–35 mm f/2.0	24–70 mm
Olympus	Normal zoom	12–60 mm f/2.8–f/4.0	24–120 mm
Olympus	Normal zoom	14–35 mm f/2.0	28–70 mm
Olympus	Normal zoom	14–54 mm f/2.8–f/3.5	28–108 mm
Olympus	Normal zoom	14–42 mm f/3.5–f/5.6	28–84 mm
Olympus	Normal zoom	17.5–45 mm f/3.5–f/5.6	35-90 mm
Olympus	Normal zoom	18–180 mm f/3.5–f/6.3	36–360 mm
Olympus	Fixed focal length	25 mm f/2.8	50 mm
Olympus	Telephoto zoom	35–100 mm f/2.0	70–200 mm
Olympus	Macro fixed	35mm f/3.5	70 mm
Olympus	Telephoto zoom	40–150 mm f/4.0–f/5.6	80–300 mm
Olympus	Macro fixed	50 mm f/2.0	100 mm
Olympus	Telephoto zoom	50–200 mm f/2.8–f/3.5	100–400 mm
Olympus	Telephoto zoom	70–300 mm f/4.0–f/5.6	140–600 mm
Olympus	Telephoto zoom	90–250 mm f/2.8	180–500 mm
Olympus	Fixed focal length	150 mm f/2.0	300 mm
Olympus	Fixed focal length	300 mm f/2.8	600 mm

Table 8-2: List of Four Thirds system lenses that, with an adapter, fit a Panasonic GH2

Focusing a Four Thirds Lens

In the previous chapter, we discussed overriding automatic focus with the Panasonic and Olympus Micro Four Thirds lens-focusing ring. Although this can be done with Four Thirds lenses, we advise against using these models in AF Mode. If you set MENU/SET>CUSTOM>(pg 3) AF+MF to [ON], with the intention of overriding the slow automatic focus by turning the ring and achieving manual focus, you will be in for an unpleasant wait. The lens-focusing ring is disengaged until the camera finds and locks focus. If automatic focusing is slow, you will have to wait for the process to be completed before you can override it manually. As a result, we

use these lenses in M Mode. With this setting, the lens focus responds immediately to a slight turn. If you set MENU/SET>CUSTOM>(*pg* 3) MF ASSIST to [ON], there is an increase in magnification to facilitate focusing. You can see the finest subject details and focus precisely. Pressing the shutter-release button halfway drops the magnification so you can see the whole field of view.

Legacy Lenses, Discontinued Lenses

A glance at an online auction site or a visit to a camera store reveals an abundance of used lenses. Many are orphans, abandoned when their owners replaced their film SLR with a digital camera. These lenses are optically excellent, but they are on sale because they lack automatic focusing or their owners had switched to a camera brand that is incompatible with them. But for you, these lenses are a bargain; they are excellent optical tools for your Panasonic GH2 camera at very reasonable prices. Users of the Micro Four Thirds system cameras fondly refer to these older lenses as legacy lenses.

The Micro Four Thirds mirrorless design, and the replacement of an optical viewfinder with an electronic viewfinder, results in a short distance from the lens flange to the sensor. This means that virtually any lens can be mounted and used on your Panasonic GH2 provided you have an adapter (figure 8-3). Essentially, adapters are short extension tubes designed to allow the attached lens to focus to infinity. Overly long extension tubes will not focus at infinity and are useable only for close-up or macro work. Several manufacturers have built adapters that lengthen the GH2's dimension to accommodate lenses from Nikon, Canon, Pentax, Konica, Minolta, and Leica. In fact, the Panasonic GH2 camera body is unique in that it is one of the few cameras that can mount and use Leica M-mount and R-mount lenses.

8

Figure 8-3: Old manual-focus 20 mm Nikon lens mounted on a Panasonic GH2 camera body with the aid of a Voigtländer adapter

Enhancing the versatility of the Panasonic camera is its compatibility with older discontinued lenses that lack mechanisms for automatic focusing. You focus these lenses by manually turning the lens-focusing ring and stopping when the viewfinder image is sharp. With today's modern DSLRs, this apparently simple operation is surprisingly difficult.

Today's DSLR bodies are dependent on automatic focusing, and their viewfinders are ill suited for judging image sharpness for focus. Fine subject details that are used for judging focus can't be seen because the viewfinder is too small and too dim. The design of these DSLRs has deemphasized the need to have large, bright views of the subject.

The Panasonic GH2 camera measures light intensity directly at the sensor. As you stop down a lens by closing its aperture, the camera compensates by increasing brightness of the viewfinder. In contrast, for DSLRs with an optical viewfinder, the image will get progressively dimmer, ultimately making it impossible to find focus and enhancing display screen imperfections.

This weakness is not present in the Panasonic cameras. Their display screens are very bright and have an automatic gain control that intensifies the display if the subject moves into the shadows or a darkened area. When you close the aperture down, you do not notice any decrease in light, so you never lose sight of your subject. In addition, the display has enough resolution that fine details can readily be seen. In short, the view through this camera is sufficient to judge focus.

Adapters for the Panasonic GH2 Camera Body and Legacy Lenses

Several companies make adapters to attach older lenses to the Panasonic G2 camera body. Table 8-3 lists examples of the various adapters and lenses available for this camera body. The price for the adapters range from a low of $20 for bargain-basement units to $200 or more for units produced by well-known manufacturers.

Legacy Lens to Mount on Panasonic GH2	Panasonic Adapter	Novoflex Adapter	Voigtlander Adapter	Rayqual Adapter
Canon FD				Yes
Contax/Yashica		Yes		Yes
Leica M	Yes	Yes	Yes	
Leica R	Yes	Yes		Yes
M-42 Pentax/Practica		Yes		
Minolta MD		Yes		
Nikon F		Yes	Yes	Yes
Olympus OM		Yes		Yes
Pentax K		Yes	Yes	
Sony Alpha/Minolta AF		Yes		

Table 8-3: Examples of legacy lenses and adapters that can be fitted to the Panasonic GH2 camera body

The more expensive adapters are of higher quality. They are well built, and since we mount our camera on microscopes and telescopes, we accept their cost. However, we have tried some of the inexpensive adapters on several lenses. For casual use they work well, although there are some reports of mechanical problems with the mounts. These complaints are generally minor, such as a lens diaphragm ring facing upside down when mounted on the camera body. Whether you should purchase an economical adapter versus a more expensive one is a matter of personal preference. We have purchased Nikon adapters made by Voigtländer from CameraQuest, a company in California (figure 8-2, figure 8-3).

One reason to spend more money for an adapter is to have a precise distance between the lens and the sensor. If you have an old lens with a focusing ring that stops at the infinity mark, an expensive adapter ensures that the camera will be in focus at infinity when you turn to this setting. Less expensive adapters are a tad shorter, so the lens, when mounted on your Panasonic camera, will focus past the infinity mark. This is not a big deal if you always focus through the viewfinder. Where it is critical is for technical applications where you need absolute precision. We buy the expensive adapters for mounting our Panasonic GH2 on a high-power microscope.

You can find the latest information on currently produced adapters at the following locations: Panasonic (www.panasonic.net); Voigtländer (www.voigtlaender.de/cms/voigtlaender/voigtlaender_cms.nsf/id/pa_home_e.html); Novoflex (http://www.novoflex.com/en/home/); and Rayqual (www.cameraquest.com).[1]

Exposure with Legacy Lenses

Legacy lenses will provide either automatic or manual exposure with the Panasonic GH2 camera body; however, you need to select which mode dial option you wish to use. You have four choices: Manual Exposure (M), Aperture-Priority AE (A), Program AE (P), and Shutter-Priority AE (S) Modes, as covered in chapter 6.

Our favorite method of adjusting the exposure with legacy lenses is to set the mode dial to A. To set the camera's shutter speed, press the shutter-release button halfway. If you wish to over- or underexpose the photograph from the camera's recommended setting, you do so by turning the rear dial to initiate the Exposure Compensation tool. Then you can press the shutter-release button fully to take the picture.

We usually open the lens aperture to the maximum to get the narrowest depth of field. This facilitates focusing by allowing the image to pop in and out of focus with slight changes of the lens-focusing ring. After we find focus, we rotate the lens diaphragm ring to stop down the aperture. As it changes, you will see that the

1 CameraQuest describes and sells Voigtländer products and Rayqual adapters on its website. Rayqual has its own website, www.rayqual.com, but all text on this site is in Japanese.

shutter will remain open longer. When you do this, the view on the display screen stays at a constant intensity, even though you are reducing the light reaching the sensor.

In contrast, you will see the display lighten and darken when you turn the rear dial and change the value for Exposure Compensation. The Exposure Compensation scale indicates how far the exposure is off and when the correct exposure is achieved. In this manner, the viewfinder previews the effects of overexposure and underexposure. As described in earlier chapters, if there is a line of tick marks to either the right or the left of 0, the exposure is not set correctly. If more tick marks appear on the right, you are increasing overexposure and the viewfinder image brightens. If the tick marks appear to the left, they indicate you are decreasing exposure and the viewfinder image darkens. There is no display for showing the changing aperture value—you will see 0.0 for the aperture setting at all times. Fortunately, many, if not most, legacy lenses have clicks that mark full or half aperture steps, so you can tell how many f-stops you have closed or opened the lens by the number of clicks you feel as you turn the diaphragm ring.

If you wish to control the shutter speed directly, set the camera mode dial to M Mode. Rotating the rear dial changes the shutter speed. We seldom use M Mode with our legacy lenses since it is much faster to use A Mode, which gives you automatic exposure.

Useful Non-Panasonic Lenses

We have tested the following non-Panasonic lenses with the Panasonic GH2 camera body with excellent results:

- Nikon Micro-Nikkor 55 mm f/2.8
- Nikon Micro-Nikkor 105 mm f/2.8
- Vivitar Series 1, 90–180 mm f/4.5 macro zoom
- Nikon 180 mm f/2.8 AF
- Nikon 300 mm f/2.8
- Nikon 300 mm f/4 AF
- Nikon 500 mm f/8

Focusing Legacy Lenses

When using legacy lenses, you can enlarge the view from the LCD monitor or the viewfinder by 5×. Simply press the rear dial of the camera. We saw this feature in the Panasonic G2 and are happy to see it in the GH2. This is similar but unrelated to using the MF ASSIST command described in the previous chapter. We did not see this feature described in the Panasonic user manual, and it does not work when using either an Olympus Micro Four Thirds or a Four Thirds lens. It seems to be activated when using a legacy lens. You also have the option to zoom in on a

portion of the image by touching the object on the LCD screen. This will enable you to view parts of the image to help determine focus, which is very useful when the camera is mounted on a telescope, microscope, tripod, or copy stand.

Research Microscopes

We discovered the Panasonic cameras while working in the laboratory and researching the utility of DSLRs on microscopes. At that time, it turned out the Panasonic G1 and GH1 were most suitable for photography through the microscope. This trend continued with the Panasonic GH2, making it our camera of choice for everyday photography, microscope and telescope photography, and recording videos.

This discussion will be limited to describing how the Panasonic can be mounted on a microscope. First, let's look at modern research microscopes. These instruments are very expensive and are usually not available to hobbyists, but if you are a working scientist or student, this section should prove helpful.

Many modern research microscopes have a trinocular head that has two eyepieces for visual work and a third vertically positioned eyepiece for mounting a camera (figure 8-4). Nikon, Leica, Olympus, and Zeiss make the most popular of the professional research microscopes, and in almost all cases their phototubes are not designed to mount cameras equipped with a large sensor. To directly mount a Panasonic GH2 camera body, you would have to go to a third-party manufacturer. A popular source for this hardware is Qioptiq.

Qioptiq makes a high-quality adapter (www.qioptiq.com/optem-large-format-series.html), but the high price usually means it has to be purchased as part of a research grant. Its coupler is designed to mount a camera with a Nikon F bayonet mount. So for a Panasonic GH2 body, you will have to buy a Nikon lens adapter for a Micro Four Thirds body to attach it to a Qioptiq microscope adapter. Go to the company's website and download a PDF brochure describing its mounting system.

An alternative and less-expensive solution is to take advantage of the

Figure 8-4: Nikon microscope with vertical tube for mounting a camera

fittings that are already on the microscope. Many photographic tubes are used with electronic cameras that have a C mount (figure 8-5). This is a threaded male adapter about one inch in diameter that screws onto a camera with a female thread. For about $20, you can purchase an adapter to fit a Micro Four Thirds camera (figure 8-6) and use it to mount the camera on the microscope's C mount. This can prove to be the most inexpensive method of joining your camera to a professional microscope. This strategy won't work with DSLRs because their sensors are larger and will vignette when using such an adapter.

Figure 8-5: C mount from a microscope showing its 25 mm diameter bore

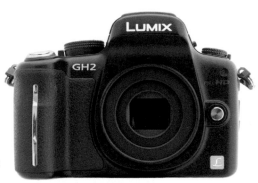

Figure 8-6: A C-mount adapter mounted on a Panasonic GH2 camera

Laboratory, Teaching, and Home Microscopes

Laboratory, teaching, and home microscopes are less expensive, making them more affordable for the hobbyist. Their cost can be reduced even more if they are purchased secondhand, but be careful. Purchasing used microscopes is not for a neophyte who is not able to determine the quality of a microscope lens. Make sure you either have an expert help with the purchase or rely on a quality vendor that supports their products. This is not the time to rely on online auction sites.

Used microscopes should be purchased with a trinocular head. The majority of these will have a narrower photographic port than one found on a modern research microscope. For most microscopes, it is a narrow tube with a 25 mm outside diameter. The microscope adapter is a tube with a clamp on one end that fits outside the microscope tube. The other end has a bayonet mount for many common DSLR cameras. Since you can buy an adapter for virtually any camera lens, as described in table 8-3, you can fit the Panasonic GH2 camera to any microscope.

Figure 8-7: Photograph of a thin slice of granite

For more background on attaching cameras to older microscopes, check the online magazine *Micscape* at www.microscopy-uk.org.uk/mag/indexmag.html.

Use the following steps when using the Panasonic GH2 camera on a microscope:

1. Adjust the microscope with the slide, getting a good sharp image through the eyepiece.
2. Adjust the microscope's light source intensity so the view through the eyepiece is comfortable to your eyes. If the voltage to the microscope illuminator is controlled with a rheostat, set it to the voltage recommended by the microscope manufacturer. If this is too bright, reduce the light intensity with neutral density filters. You do not want to use the rheostat to change the light level because changing the voltage to the bulb will alter its color temperature. Lowering the voltage will give the light a reddish hue while increasing the voltage will give the light a bluish hue.
3. Set the camera focus mode lever to MF.
4. Set the camera ISO to 160. This setting provides the cleanest image with a minimum amount of noise.
5. Turn the camera mode dial to A Mode.
6. Use the following command: MENU/SET>CUSTOM>SHOOT W/O LENS>[ON].
7. Set the camera white balance to incandescent light or set the color temperature scale to 3200 K. If this does not work, you can adjust the color temperature manually to obtain a white balance that will render the background white.
8. Focus the image using the microscope control while viewing it on the LCD screen.
9. Fire the camera with a cable release or, lacking that, set the camera self-timer to a two-second delay.
10. If the image appears to be blurred, increase the duration that the shutter is open by using a shutter speed of one second or longer.

8

With proper equipment and setup, taking pictures through the microscope can be easy and fun (Figure 8-7).

Cable Release

Panasonic sells a cable release for the GH2 (in Panasonic terms, it is a Remote Shutter, part number DMW-RSL1). It is expensive at $50, but for us it is important to be able to take a picture without jarring or moving the camera, especially when we are taking pictures through a telescope or microscope. In addition, if you use the B setting on M Mode, this accessory provides a convenient lock mechanism that will hold the shutter open. Keep in mind that exposures can run for a maximum length of two minutes.

Tripods

You may already own a tripod, but if not, this section is for you. This accessory is often overlooked when you first start taking pictures and videos.

A steady support for picture taking is essential for long exposures, extreme tele-photo work, and obtaining maximally sharp images with the camera. Nonetheless, many photographers object to using one, arguing that it is bulky, that it reduces their mobility, and that it is a detriment for spontaneous photography. These arguments are all true, but consistently using a tripod will improve the quality of your work. In fact, its inconvenience may be its strongest benefit because it forces you to work at a more deliberate pace. Framing the subject can be done leisurely, the depth of field can be carefully evaluated, and time can be spent to ensure that the horizon is not canted in the picture. This deliberate pace trains you to visualize the image before snapping the shutter.

A good tripod can easily cost $300, with more expensive units running over $1,000. Although it is initially expensive, a good tripod will outlast a typical camera and lens setup. One of our tripods is more than 30 years old and still functional.

The more expensive tripods are made with carbon fibers and weigh only a few pounds. However, the less-costly, heavier aluminum tripods are also suitable; their disadvantage is increased weight. This is not a good time to skimp on the cost of equipment. Inexpensive tripods are not only flimsy, they are slow to set up and they do not hold their settings. That is to say, after you mount and position the camera, the tripod may drift slowly out of position or, worse, topple over with your camera attached.

The most expensive units require you to buy two components: the legs for support and the head for aiming the camera. This unit can be surprisingly expensive, especially if the intent is to use telephoto lenses. Any play in the mount or an inability to hold its setting will be aggravating.

There are two types of tripod heads available: pan and tilt heads, and ball heads. The pan and tilt heads are heavier, less-expensive units that allow you to pan (horizontal movement) and tilt (vertical movement) the camera. A ball head is lighter and more expensive. It allows you to move the camera on the tripod any way you want in a smooth motion. We started our photography more than 40 years ago with a Bogen 3047 pan and tilt head, but we replaced it with an Acratech Ballhead. Aiming the camera at a given subject is faster and more convenient with the ballhead.

The tripod legs are equipped with either a 3/8" or 1/4" diameter screw where you can bolt down the head of your choice. If you have a tripod with a 1/4" diameter screw and a tripod head equipped with a 3/8" receptacle, you need not worry. You can buy an adapter to fit the head to the legs.

The prices for these legs range from $300 to more than $600, and the premium models are made of carbon fiber, making them lighter and very durable. Gitzo makes some of the best legs and may cost more than $500. The legs are built in sections, which telescope to shorten their length. Typically the legs are collapsed for convenient transport. We chose the less-expensive legs sold by Manfrotto at about $300 and combined them with an Acratech Ballhead. A complete tripod with a head and legs is less expensive, but if you work with telephoto lenses with a focal length of 200 mm or longer, you will probably upgrade and buy a more expensive unit. Our colleagues have told us that Velbon, Slik, and Hakuba make carbon fiber tripods that cost between $200 and $300, and they have been satisfied with their performance.

Buying Tripods

We have acquired several tripods over the years. Our low-cost favorite is a Tiltall tripod purchased 40 years ago. The basic design of this older tripod is impeccable. Its only fault is its seven-pound weight. You can sometimes find them on online auction sites. Just beware of functional damage and wobbly legs. We typically use this tripod indoors, so we do not have to walk far or set it up quickly. At one time, Leitz sold this high-quality tripod. Now you can buy these Leitz tripods only used, online, for less than $100.

We have carbon fiber tripod legs from Manfrotto and a ball head from Acratech. Their combined weight is only four pounds. For faster setup, the head is equipped with a quick-release mount. Without this accessory, we would have to turn and tighten a screw to fasten the camera onto the tripod. With the aid of the accessory clamp, we can quickly attach and detach the camera.

8

Telescopes

Long-distance photography fascinates many photographers. The thought of photographing wildlife or obtaining a close-up of the moon makes photographers long for a super-telephoto lens. The longest telephoto lens made by Panasonic is a 100–300 mm zoom. This will provide impressive views, but suppose you want something even longer. One way to accomplish this is to attach your camera to a telescope. This can be accomplished easily if you have the right telescope and the right accessories. Mounting is as simple as removing the camera's lens, replacing it with an adapter, and inserting the camera and adapter into the telescope's eyepiece holder. An image of the subject is projected directly onto the camera sensor—a method known as prime focus photography. Exposure is automated and, as with the microscope, it is done with A Mode.

The first step is to find a telescope that can be used with your camera. Today, there are a tremendous number of telescopes to choose from. To keep the telescopes small enough for fieldwork with the camera, we will restrict our discussion to lenses having a front element ranging in diameter from 50 to 100 mm (2 to 4 inches). The performance of telescopes smaller than this is equal to the performance of a telephoto lens. A telescope with an objective lens larger than 100 mm will be difficult to handle for fieldwork. An excellent telescope in the 50 to 100 mm range will be expensive; however, its optical performance will equal the best telephoto lenses.

A Caveat on Telescopes

Telescopes are expensive, and they do provide a far reach; however, although Stellarvue and Tele Vue telescopes are excellent astronomical instruments, the Panasonic GH2 camera is sufficient for the primary target in the skies—the moon. This object is easy to find and is bright enough that you can set the ISO to 160 and shoot. We set our shutter speed at 1/10 second.

However, if you hope to shoot the planets or galaxies, you will have to invest in far more equipment. You will need to get an equatorial mount for planet or galaxy photography, and you will need to take much longer exposures. In this respect, the Panasonic camera is unsuitable for imaging faint objects requiring long exposures (minutes to hours shutter speed). Nonetheless, as a visual experience, telescopes of this size can provide a delightful view of the night skies and can open up a new hobby for the photographic enthusiast. As a terrestrial telescope, it can provide striking close-ups of animals.

Tele Vue, a company known for making some of the best lenses, makes a 76 mm telescope (480 mm f/6.3) that costs $1,500 new. Its optical performance rivals or

exceeds the finest Nikon or Canon telephoto lenses, whose 500 mm optics cost $6,000 to $8,000. This is not to say that this telescope can serve as a replacement for a professional telephoto lens, but keep in mind that there is no lens this long in the Panasonic inventory. Also consider that you have the versatility of having an astronomical grade telescope as well as a superb long-distance lens, and the cost does not seem so formidable. Stellarvue is another company noted for making high-quality telescopes running around $1,000. Stellarvue also sells an 80 mm (lens diameter) telescope (model SV80 ED) for $600.

We have tested the Panasonic GH2 camera extensively on two telescopes: a Tele Vue-85 and a Stellarvue SV 102 ED. Both telescopes have a two-inch eyepiece holder and were easily equipped with a two-inch eyepiece adapter with the appropriate Nikon bayonet mount and a Panasonic Micro Four Thirds adapter for a Nikon mount. The camera was set for Aperture-Priority AE and manual focusing. For photographing the moon, we took advantage of the touch screen for providing an instant close-up of its surface. Focusing on the craters was easily accomplished (figure 8-8).

We use the viewfinder when we use the telescope for terrestrial objects. Ambient daylight obscures the rear LCD screen. Again, higher-magnification aided focusing. This was accomplished by pressing the camera's rear dial. When we needed greater magnification than provided by the base telescope, we found that teleconverters provided 1.4x higher magnification.

8

Figure 8-8: Moon shot taken with Panasonic GH2 camera and a Stellarvue telescope

Recommendations

We found the Panasonic GH2 camera to be remarkably versatile and adaptable to virtually any optical instrument. Using specialized optical equipment, such as telescopes and microscopes, can expand the camera's photographic capabilities. Curiously, as your expertise increases and your desire to explore new areas expands, you may find that the accessories cost more than the camera. Even something as mundane as a tripod may prove to be surprisingly expensive; however, these accessories reveal the camera's full potential.

The Panasonic GH2K camera kit's basic lens is an excellent photographic tool. We recommend that before you buy additional lenses, spend time mastering the included lens. When you're taking pictures and videos, the appearance of the subject changes radically between the 14 mm focal length and the 42 mm focal length. You should also experiment with perspective changes when using the wide-angle setting of this lens.

Fishermen are noted for using a wide-angle lens (14 mm focal length) to magnify the size of their catch. They proudly pose themselves holding the fish in front of them and have the photographer move in close, framing the fish so it appears double to triple its actual size. The results belie the truism that photographs cannot lie. If the photographer uses a 42 mm setting and photographs the fisherman holding the fish out in front, it will appear to have dramatically shrunk. This setting provides a more accurate perspective and shows the fish properly—much to the chagrin of a proud fisherman. Getting to know the strengths and limitations of your lens will enable you to determine if you need any additional lenses.

The 14–140 mm Panasonic lens, part of the Panasonic GH2H Kit, is the preferred lens for shooting video. Its low-noise motor will not be recorded by the camera's microphones, so you can improve the quality of your audio recording. Also, it has a longer reach than the 14–42 mm zoom; for many people, this can be the one lens permanently kept on the camera body. Although other lenses, such as the Olympus Zuiko 14–150 mm, will record the same views, we do not recommend them since you will not have image stabilization, and the noise from the motor will be recorded on the audio track of your video.

If you eventually buy accessory lenses, stick to either the Panasonic or Olympus Micro Four Thirds products, if you can afford them. It should be noted that Panasonic sells some lenses with the Leica label; while they are optically great, they have a very expensive price tag. Panasonic and Olympus have a sufficiently wide range of lenses that can meet most of your photographic needs. They will provide maximum compatibility with your camera body.

If you buy longer zoom lenses, you should buy the Panasonic branded lenses before buying Olympus lenses in order to have image stabilization. This feature gives you the most convenient solution for field photography. However, there is

a paucity of specialized lenses, such as perspective correction, fast lenses (wide maximum aperture), and superlong telephotos. The absence of these lenses can be partially solved by purchasing either Four Thirds lenses or legacy lenses. In both cases, there will be some loss in convenient field operation, and you will have to use manual focus.

Depending on the Four Thirds lens price, it doesn't make sense to buy it unless you are buying the camera body to go with it. Some of these lenses are so expensive that the additional cost for an Olympus camera body is minor. The well-regarded Olympus 90–250 mm lens costs close to $5,000, and the 50–200 mm lens costs close to $1,200. Operationally, you will find these lenses easier to use on an Olympus DSLR. We found focusing to be slow when these lenses are mounted on the Panasonic GH2 with an accessory adapter. In fact, we have to use these lenses on manual focus only.

An economical solution is to buy a legacy lens and the appropriate adapter. We have used our older manual focus Nikon lenses to good effect. If you are interested in close-up work, manual focus macro lenses are excellent. In fact, we prefer using these lenses on our Panasonic GH2 over the Four Thirds Olympus 50 mm f/2.0 macro. Legacy lenses have superior controls for manual focusing. Four Thirds lenses lack this precision, and in a field such as macro photography where you primarily use manual focusing, legacy lenses are more convenient.

Flash Photography

Introduction

As sensitive as the GH2 is to light, there are conditions when more light is needed to photograph a subject. Fortunately, for many subjects the camera's built-in flash will provide additional light. Its output is regulated to provide proper exposure, and it is integrated with the camera's light meter to balance flash lighting with ambient illumination.

Unfortunately, the Panasonic GH2's flash is low powered and cannot illuminate a large area. To accomplish this end, you need to buy an accessory flash unit that has its own battery power source and that slides into a receptacle on the top of the camera. The additional power will give you more light to work with and can illuminate a wider region. Most flash units have a swiveling and tilting flash head that aims light toward the ceiling and reflects it down on the subject. This diffuses the light and eliminates the deep dark shadows caused by aiming the flash directly at the subject. This type of illumination is called bounce flash, since the light is being reflected or bounced off a surface before reaching the subject.

The Built-In Flash

The Panasonic GH2 camera's built-in flash is always under your control and is usable after you manually pop up the flash head by sliding a small button called the flash open lever on the roof of the camera (figure 9-1a). To avoid using the built-in flash in dim conditions, you can fold it down, ensuring the flash will not fire unintentionally. When it is raised, the flash is usable in every mode except those involving video and when recording Burst Groups (figure 9-1b). While in Auto Bracket Mode, only one picture can be captured if the flash is activated.

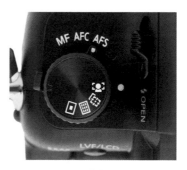

Figure 9-1a: Top of the camera, showing the lever for raising the built-in flash

The Panasonic GH2 camera has multiple flash settings. Table 9-1 lists the available settings and how the flash interacts with various predefined scene modes. This is a useful reference to become familiar with available flash options. Fortunately, you do not need to memorize this chart. After you select a mode, the camera will automatically determine which flash options are allowable. You will find the allowable settings by going to the following command:

MENU/SET>REC>(*pg* 2) FLASH

The FLASH command will be displayed with the complete list of options. Deep black letters and icons indicate the options that are enabled. Light gray letters and icons indicate options that are disabled.

You might wonder how the camera controls flash exposure. First, flash exposure is a two-flash event—a weak preflash followed by a powerful illuminating flash. The preflash is not used for recording the image. It is a reference light that determines the amount of light needed in the second, or illuminating, flash. Think of the preflash as a trial exposure, except the shutter is closed. From this preflash, the camera calculates how long the illuminating flash should last. A longer duration provides more light, and a shorter duration provides less light. Under all conditions, the built-in flash intensity is automatically set.

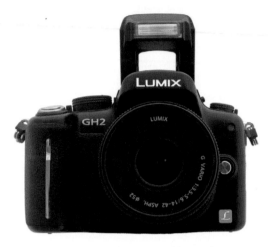

Figure 9-1b: The flash head raised and ready to fire

FLASH Option	FLASH Option Icon	Description
Forced Flash OFF	⊘	Flash will not fire. The built-in flash unit is not raised. To cancel command, raise the flash unit. Note that this is not a command option and is visible only on the display screen.
Forced Flash ON	⚡	Flash will always fire, independent of ambient lighting. Used in daylight as a fill flash.
AUTO	⚡A	Flash may fire when lighting is so low that the shutter speed slows and the Jitter icon appears.
AUTO/Red-Eye Reduction	⚡A◉	Flash may fire if light is low. Tends to prevent red-eye.
Forced Flash ON/ Red-Eye Reduction	⚡◉	Flash will always fire and tends to prevent red-eye.
Forced Flash ON/ Slow Sync.	⚡S	Flash will always fire. Shutter speed is slower in order to lighten a dark background.
Forced Flash ON/ Slow Sync./ Red-Eye Reduction	⚡S◉	Flash will always fire. Shutter speed is slower in order to lighten a dark background. Red-eye reduction is activated.

Table 9-1: FLASH command options, icons, and descriptions

When using the flash, you have to provide guidelines on how it should operate. The first decision is whether to have the flash always fire when the popup flash is raised or to have it fire only when light levels are low. After that is decided, you have to decide if the flash should guard against a phenomenon known as red eye—a condition where the pupils of the eyes glow eerily rather than appear as black circles. The final parameter is whether the flash is fired at the time the shutter opens or just before the shutter closes.

Table 9-1 lists seven icons. Six of the icons represent settings available through the FLASH command to control the type of the flash. The remaining icon, Forced Flash OFF, is not under control of the camera software and is seen only on the display screen when the built-in flash is in the closed position. As you review the available options you will see that several of them are a combination of four components: Forced Flash ON, Auto, Red-Eye Reduction, and Slow Sync.

Forced Flash OFF

When the flash is closed, you will see an icon with a jagged arrow in a circle with a diagonal line on the display screen (table 9-1). This is the Forced Flash OFF icon. Its appearance is controlled by lowering the flash head. When the head is raised, the icon will be replaced with the selected FLASH command option. What FLASH command option you select depends on how and when you want the flash to operate.

Auto

You have the option to have the flash fire only when needed. To do so, select the Auto option (the icon is the letter A). The camera makes the judgment based on its interpretation of sufficient lighting and will fire the flash when it determines there is insufficient light to take a sharp picture.

The command for setting this is as follows:

MENU/SET>REC>(*pg* 2) FLASH>[*Auto*], [*Auto/Red-Eye Reduction*]

Note that Auto function can be combined with the Red-Eye Reduction function, which will be explained later. The key point is that the flash may or may not fire in Auto.

Also remember that Auto does not mean automatic exposure—with the built-in flash unit, you always get automatic exposure. Auto only refers to the flash being under the camera's control. If the lighting is dim enough, the camera will supplement ambient illumination by firing the flash, allowing the camera to capture the image clearly. However, if there is enough light so that the camera can capture the image at a shutter speed that allows handholding the camera, the flash won't fire. Many photographers prefer this setting.

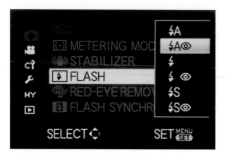

Figure 9-2a: The FLASH command—Auto, Red-Eye Reduction highlighted

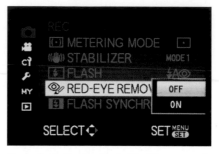

Figure 9-2b: Setting Digital Red Eye removal, an image-processing command

We should also mention Panasonic's Digital Red-Eye Correction process. This is an image processing command that removes any residual red eye left after using the FLASH command's Red-Eye Reduction functionality. As the use of the word "reduction" implies, the complete removal of red eye is not guaranteed with this command. To ensure a complete removal, the camera provides the command RED-EYE REMOVAL (figure 9-2b). This command can be turned on only after you select a Red-Eye Reduction FLASH command option. To activate the Digital Red-Eye Correction software, set the RED-EYE REMOVAL command to [ON]:

MENU/SET>REC>(pg 2) RED-EYE REMOVAL>[OFF], [ON]

Forced Flash ON

The Forced Flash ON option forces the flash to fire regardless of the setting. It will serve as a fill light for a subject in shadows in daylight. That is, if the subject is back illuminated, the flash will provide additional light to ensure that it will not be hidden in its own shadow. If you feel that the flash will detract from the scene, you can cancel it by simply closing the flash head.

The command options for forcing the flash to fire are as follows

MENU/SET>REC>(pg 2) FLASH>[Forced Flash ON], [Forced Flash ON/Red-Eye Reduction], [Forced Flash ON/Slow Sync.], [Forced Flash ON/Slow Sync./Red-Eye Reduction]

Forced Flash ON can be combined with the Red-Eye Reduction and Slow Sync. components, which will be covered later in the chapter.

The Flash Icons on the Display Screen

When you open the flash head and see the selected flash icon, it does more than just show what flash controls are active. It also shows whether the flash is ready to be fired. When you press the shutter-release button halfway, the flash option icon should be red. When the flash is fired, the red icon starts blinking, indicating that the capacitor for the flash is being charged and you cannot fire the camera. When it becomes a steady red light, you can fire the camera and flash.

Additional Controls for Preflash and Internal Shutter

Red-Eye Reduction
Another icon that may appear is a symbol of an eye, representing Red-Eye Reduction (table 9-1). This command needs a bit of background to clarify its function. The camera's flash unit emits light, and if a person or an animal is looking into the lens, the light will enter the eye and be reflected back to the camera. Since the eye

Alternate Ways of Reducing Red Eye

Red eye is a phenomenon caused by light reflecting out of the eye and into the camera lens. It occurs when the subject has dilated pupils and the flash is placed close to and in line with the photographic lens. This makes sense if you think about it. If the pupils are wide open and the flash is close to the lens, the chances of the flash light being reflected back into the camera is enhanced because of the larger opening in the subject's eyes and because the light travels close to the optical axis of the lens.

Although the Panasonic GH2 has a Red-Eye Reduction option, the software is not always 100 percent effective. Use the following strategies to improve your results.

There are three strategies for eliminating red eye. The first is to displace the flash away from the camera lens, reducing the chance that light entering the subject's eyes will be reflected back into the camera lens. This is one reason external flash units are popular—you position the external flash at an angle, thus reducing the chance of light from the flash reflecting back from the subject's eyes directly into the camera lens.

The second strategy is to constrict the subject's pupils by increasing the surrounding light, so do not take portraits of people sitting in a darkened room.

The next strategy is to not have the subject look directly into the camera. Have the subject look at a point to the right or left of the camera, thus reducing the chance that the eyes will reflect light back to the camera lens.

has a rich vascular network, the reflected light will be colored red, resulting in a photograph with the pupils glowing eerily. Animals such as cats have a reflective layer behind the retinas (tapetum lucidum). This causes a cat's eyes to glow yellow rather than red when it looks toward an electronic flash. This is significant for pet photographers in that automated software for red eye removal may fail to take the glow out of the cat's eyes.

Red-Eye Reduction attempts to reduce this effect. According to the Panasonic GH2 manual, the interval between the preflash and the illuminating flash is lengthened. We noticed that this command is not 100 percent effective, so you may wish to use another way to reduce red eye. See "Alternate Ways of Reducing Red Eye," where we list additional strategies that will help in eliminating this phenomenon.

Slow Sync.

The final FLASH command option is represented by an icon of a letter S, representing Slow Sync. Since you will be using the flash when the ambient light is low, there is a tendency for the flash to provide all the light to the subject. Because the flash is a low-power, short-range device, it frequently fails to illuminate the background, rendering it jet black. One way to lighten the background is to increase your exposure. This can be accomplished with a longer (slower) exposure to allow the camera sensor to capture more ambient light. The flash will still expose your subject, but you will have lightened the darker background by using a longer shutter speed.

Recommendation

In the P, A, S, and M Modes, you have the full menu of flash options available to you. We recommend using the Forced Flash ON option. This guarantees that your flash will fire when you open the flash unit, ensuring that the flash will always be available as a fill flash for use in daylight. With the Auto option, you won't know if the flash will fire until you press the shutter-release button fully—and although it is desirable to limit the use of the flash in the interest of conserving battery power, this can be accomplished by simply lowering the flash unit when it is not needed.

In regard to Panasonic's red-eye correction, we are unconvinced that it significantly reduces this phenomenon. But it is something that you might as well leave on, simply because even a slight reduction in red eye can't hurt.

So how do you eliminate red eye if the built-in flash creates it? The simplest way is to avoid having the subject look straight into the camera lens. It is better if the subject glances away toward the left or right of the camera. Second, the idea of constricting the subject's pupils by brightening the room lighting may be another easy way to accomplish this task.

Finally, you may wish to consider getting an external accessory flash unit. This will position the flash tube further from the lens and at an angle, reducing red eye. Also, with the most expensive units you can use bounce flash, which is described at the end of this chapter.

Altering Exposure

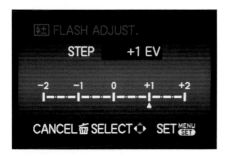

Figure 9-3: The FLASH ADJUST. command set for 1 f-stop overexposure

When using the flash, you may wish to either lighten or darken its effect by adjusting the output. This is easily accomplished with another command:

MENU/SET>REC>*(pg 2)* FLASH ADJUST.>*[a scale of –2 to +2 f-stops in increments of 1/3]*

When you select this command, a scale spanning –2 to +2 f-stops (1 f-stop equates to 1 EV) is displayed (figure 9-3). This allows you to adjust the flash output by either increasing or decreasing it by up to 2 f-stops. Use the rear dial or the left and right directional arrow buttons to move the slider along the scale to select the flash adjustment. When using this command, take some test shots to determine if your selected adjustment is acceptable.

Flash and the Internal Shutter

Figure 9-4a: Setting the flash to fire on the initiation of the shutter-release button

Figure 9-4b: Setting the flash to fire when the shutter closes

Finally, we will discuss how to synchronize the flash to the camera's internal shutter. Although this is something we do not use, it may be of interest to those who want to create special effects. The following command controls the synchronization of the flash with the camera shutter:

MENU/SET>REC>(*pg 2*) FLASH SYNCHRO>[1ST], [2ND]

The movement of the shutter is sometimes referred to as the movement of the shutter curtain since it is essentially the movement of something opening and then closing, much like a curtain. Normally, the flash is fired at the onset of the movement of the shutter curtain (figure 9-4a). However, it can be triggered to fire at the point when the internal shutter ends (figure 9-4b)—the close of the shutter curtain. This is done for special effects, such as when you are writing with light and showing the subject after you complete your script. This is accomplished in the following manner:

1. Pose a person in a blackened room with a lighted flashlight.
2. Open the shutter for a long exposure.
3. During this interval the person moves the lighted flashlight, as though writing with a pen, and generates a trail of light against the black background.
4. Just before the shutter closes, the flash will fire. This will illuminate the subject and allow the camera to capture an image of the writer holding the flashlight at the end of the script. It will appear as if the person wrote glowing letters in midair.

If you close the shutter without firing the flash, you will capture just the glowing script against a black background.

1ST Option
The default option is [1ST]. The flash is timed to fire as the shutter curtain opens. If you photograph a moving car with its headlights on, you will freeze the car in position with its headlights glowing.

2ND Option
Selecting the [2ND] option times the flash to fire just before the shutter curtain closes. This is not used except when you want to provide a special effect, such as writing with light as described earlier. Another example is purposely using a slow shutter speed when photographing a moving car with its headlights on. This blurs the car's body as it moves, and the headlights form an elongated streak. When the flash is fired, just as the shutter closes, the flash will freeze the car in position. The car will appear to have blurred taillights behind it, and the headlights will show up

as an elongated streak. Together, this will give an illusion of motion. Note that this option cannot be used when the flash is set to Red-Eye Reduction.

Figure 9-5a: An external Olympus FL-50 flash set for direct lighting

Figure 9-5b: The flash head tilted to provide bounce flash

External Flash

There are basically two groups of external flashes: one group that is completely separate from the camera and another that attaches to the camera electronic flash hot shoe. We will cover only the external flash units that directly attach to your Panasonic GH2 camera electronic hot shoe (figure 9-5a).

Panasonic sells three external flash units. They all share a common advantage— they generate more light than the camera's small built-in flash. The smallest and least-expensive unit is the DMW-FL220, which takes two AA batteries and directs the flash directly onto the subject. Essentially, this is a more powerful replacement for your built-in flash unit, and it helps preserve your camera battery if you use flash a lot. It is the smallest unit, weighing only 111 gm (about a quarter of a pound).

Although they are heavier and more expensive, the Panasonic DMW-FL360 and the DMW-FL500 models will give you greater control over directing the light output. Both flash units have tilting heads (figure 9-5b) so you can position where the flash will be projected. They both attach to your camera hot shoe so their internal electronics can interpret the camera's optics and settings and use their electric motors to better adjust the light according to your needs.

When you're using a zoom lens, the external flash unit will adjust the flash coverage as you zoom in and out. As you move from wide angle to telephoto, the flash efficiently directs its light to illuminate the area to be photographed. Thus,

when you set your lens to a wide-angle focal length, the flash adjusts its light to fully illuminate the field that the lens sees. Similarly, if you zoom to a telephoto setting, the flash concentrates the beam into a narrower field to better match the view seen by the telephoto lens.

An even more useful feature is that these external flash units have tilting heads that allow their beam to be directed up, away from the subject. This obviates the problems of direct flash (figure 9-6a). You can aim the light up at the ceiling, away from your subject. This technique is described as bounce flash, and it provides flattering light for many subjects. When you use the ceiling as a reflector, light is diffused and redistributed, softening shadows, helping to hide facial wrinkles, and providing softer, more evenly distributed lighting (figure 9-6b). In contrast, direct flash, where the light is cast directly onto the subject, can create harsh shadows, result in squinting, and emphasize wrinkles.

Figure 9-6a: Direct flash provides harsh lighting and causes a blink reflex

Figure 9-6b: Bounce flash provides a softer light; no squinting in this shot

Recommendations

The Panasonic GH2 built-in flash is useful for supplementing dim lighting. However, attaching an external flash unit to your camera hot shoe is better. You can soften the image by not having a direct flash illuminate your subject. Using an external flash unit allows you to create more depth and ambiance, thus strengthening your picture.

Both Panasonic and Olympus sell external flash units. We have used the Olympus FL-50 and FL-36 units interchangeably on the Panasonic GH2. If you already own a compatible Olympus unit (FL-50, FL-50R, FL-36R, or FL-36), there is little need to buy one of the Panasonic units. To see if your Olympus hardware is compatible with the Panasonic GH2 camera, check the following website: http://panasonic.jp/support/global/cs/dsc/connect/gh2.html. You will find that some Olympus flash units are not recommended (FL-40 and FL-20).

9

Videos

Two Roads to Video

The Panasonic GH2 is not only a capable still camera, but also a high-resolution video camera, or in Panasonic's words, a motion picture camera. To understand and exploit this camera's capabilities, you need to understand the organization of its commands and the importance of the mode dial.

It is simple to switch from still to video photography. All that is required is either a press of one button or a turn of the mode dial. In the former situation, you press the red Motion Picture button (figure 10-1) to start your recording. This allows the Panasonic GH2 to be a hybrid camera that can either shoot a photograph or record a video.

The second method is turning the mode dial to the Creative Motion Picture Mode. Its icon is a movie camera. When it is selected, the Panasonic GH2 works as a camcorder, and it will record a video when you press either the shutter-release button or the Motion Picture button. As you gain experience, you will want to explore such effects as slow motion or fast motion. In addition, you may want to vary your shutter speed or your lens aperture to create visual effects, such as isolating the subject from the background.

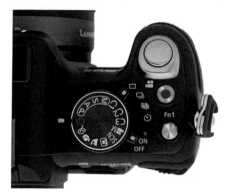

This chapter is divided into two parts. The first part deals with simple video commands, starting with the "General Video Setup" section. These commands are for still photographers who need to switch instantly to a video recording. In fact, a still

Figure 10-1: The shutter-release and Motion Picture buttons

shot can be taken when the video is being recorded. Essentially, the camera has a shutter-release button dedicated for still photographs and a Motion Picture button for taking videos. These buttons provide maximum versatility for choosing your shooting style.

The second part of this chapter is "Advanced Settings: Creative Motion Picture Mode." It requires you to set the mode dial to the icon featuring a motion picture camera (figure 10-1). Turning the mode dial to this setting provides advanced video techniques. The trade-off is that you do not have instant access for still photography. You must turn the mode dial to another icon to take still photographs. In spite of this loss, you will want to explore Creative Motion Picture Mode. You will be able to play with slow motion and fast motion effects. In addition, you can control the shutter speed and aperture of the lens for artistic effects.

10

Since many of the related commands were covered in earlier chapters, there may be some redundancies here. But we will try to keep them to a minimum and give references to subjects covered earlier rather than discussing them again. We urge you to experiment with video. The camera records excellent stereo sound. When you see the quality of your movies on a HD television, you will be amazed at their fidelity and brilliant colors. The videos can also be formatted so you can insert clips on your website or as attachments in your e-mails.

Part 1: General Video Setup

The commands in this section are the foundation of the camera's video capabilities. They give you the flexibility to choose how you will use your recording. You may prefer to show your recordings on an HD television, or you may prefer working with them on your computer. Additionally, you have the convenience of being able to quickly snap a still picture in the middle of recording a video.

Starting and Stopping a Video

When you have your camera set for shooting still photographs, a convenient way to start a video is to use the Motion Picture button. Pressing this button once starts the video, and a second press stops the video. It is a small button with a red dot in the center (figure 10-1), which sits just behind the shutter-release button. Its size, position, and color make it identifiable tactilely and visually. This button starts video recording and will incorporate settings from the predefined scene modes or Intelligent Auto Mode. You can disable the Motion Picture button by setting the following command to [OFF]:

MENU/SET>CUSTOM>(*pg 5*) *Motion Picture* BUTTON>[OFF], [ON]

We don't recommend turning this command to [OFF] because it will limit your ability to switch rapidly between taking a movie and a still photograph. Having this turned [ON] enables you to switch from still photography to video recording by simply pressing the Motion Picture button. If this command it is turned [OFF] and you press the Motion Picture Button you will receive an error message recommending you turn it back [ON].

The main menu includes a MOTION PICTURE menu option that contains commands whose settings are utilized when you are recording a video. The downloadable GH2 Command List (found at http://rockynook.com/panasonicgh2) contains a complete list of MOTION PICTURE commands. These commands will be active when you simply press the red Motion Picture button. In the following sections, you will set the parameters that will be used when you are in every mode *except for* Creative Motion Picture Mode.

Video File Formats

The Panasonic GH2 camera has two video recording types: advanced video coding high definition (AVCHD) and Motion JPEG. AVCHD has three video formats: 1080i, 1080p, and 720p. Use the following command to choose one of three video formats:

MENU/SET>MOTION PICTURE>REC MODE>[AVCHD(1080i)], [AVCHD(720p)], [MOTION JPEG]

Note that 1080p is not seen in the above command. It is available only when you select Creative Motion Picture Mode on the mode dial. We will discuss 1080p later. AVCHD is a sophisticated compression algorithm that saves your videos in a compact digital file (figure 10-2a). The data compression is complicated, and manipulating the images directly requires a powerful, fast computer. Most of us do not have such a machine and as a result we will have to transcode (translate) the recording to another format for editing on our computers. This can be a time-consuming process for a long recording, and Panasonic recommends using this format for playback on high-definition television. If you wish to edit your movies, Panasonic recommends using Motion JPEG (figure 10-2b).

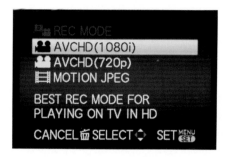
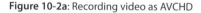

Figure 10-2a: Recording video as AVCHD

Figure 10-2b: Recording video as MOTION JPEG

In spite of Panasonic's recommendation, you can download your video to your computer and edit the motion picture. Indeed, included with the purchase of this camera is the PC software, PHOTOfunSTUDIO 6.0 BD Edition, for working with your AVCHD videos and RAW files. Unfortunately, Panasonic does not provide a program for Apple users. These individuals should get the iMovie program, which can trans-code AVCHD. This software is part of the collection of programs on the iLife disk, which also includes iPhoto for working with your RAW files. The disk costs about $50. We have used PHOTOfunSTUDIO on a Dell laptop running Vista, and we have used iMovie on a MacBook Pro running Snow Leopard. Both programs worked, but if you intend to do a lot of computer work on your recordings, you should save your files as Motion JPEG.

10

When it comes time to download your files to your computer, we recommend connecting your camera to your computer with a USB cable. Start PHOTOfunSTUDIO or iMovie, then attach the USB cable to your camera and computer. Remember, when you attach the cable, your camera will prompt you to select an icon that will direct the camera's output to the computer. The transfer will not begin until you make a selection.

For computer viewing and editing, the simplest and fastest way of working with the video is by saving it as Motion JPEG. This uses a simpler compression algorithm to create the file. Motion JPEG files are larger than AVCHD files, but they have the virtue of being easily edited, and can be read by all computers. A popular program for working with these files is QuickTime. This program is available for free for either Macs or PCs.

Video File Formats

AVCHD is highly compressed and, for computational purposes, requires a powerful computer for editing. The Panasonic GH2 provides three formats. Two are available when you press the Motion Picture button on the top of the camera. The third and highest resolution format, 1080p, is available only when you turn the mode dial to Creative Motion Picture Mode and select either 24P Cinema or Variable Movie Mode. Recording at 1080p will provide the highest image fidelity; however, you will not be able to save your video as a Motion JPEG.

When you record by using the Motion Picture button, you have two AVCHD modes: one at 1280 × 720 pixels (720p) and the other at 1920 × 1080 pixels (1080i) (table 10-1). The 1080i mode will give you higher resolution, but there is a catch. It tends to show a bit of a motion artifact. The output is interlaced scanning, that is, one frame outputs all the odd-numbered rows of pixels, and a second frame outputs all the even-numbered rows of pixels. Together, the two frames will give you full 1080 pixel vertical resolution. The problem is that a subject can move while the camera is recording the two frames. When the frames are combined on your TV screen or other display device, the edges of a moving subject are distorted. A subject that should have a straight line will instead have a line with a ragged appearance. To prevent this artifact, you may want to record at 720p, albeit you will sacrifice some resolution. If you need to retain a resolution of 1080 pixels and want to avoid the motion-induced artifact, you can record it as 1080p; however, to do so requires that you turn the mode dial to the Creative Motion Picture Mode and save the file as a 24P Cinema.

10

REC MODE		REC QUALITY	
Option	**Compression**	**Menu Option**	**Description**
AVCHD 1080i	FSH	FSH	Records at 1920×1080 pixels bit rate 17 Mbps
	FH	FH	Records at 1920×1080 pixels bit rate 13 Mbps
AVCHD 720p	SH	SH	Records at 1280×720 pixels bit rate 17 Mbps
	H	H	Records at 1280×720 pixels bit rate 13 Mbps
Motion JPEG	HD	HD	Records at 1280×720 pixels. Sets ASPECT RATIO value to [16:9].
	WVGA	WVGA	Records at 848×480 pixels. Sets ASPECT RATIO value to [16:9].
	VGA	VGA	Records at 640×480 pixels. Sets ASPECT RATIO value to [4:3].
	QVGA	QVGA	Records at 320×240 pixels. Sets ASPECT RATIO value to [4:3].

Table 10-1: Relationship between REC MODE and REC QUALITY values for video settings

Just as you do with your pictures, you will need to choose a quality level for your videos. This is done with the REC QUALITY command in the MOTION PICTURE menu. For AVCHD we are dealing with how fast data is being recorded to the memory card. For 1080i you choose one of two compressions: FSH or FH. Images stored with FH compression will be of lesser quality, and the compression can result in a loss of fine details in a moving subject. For a given memory card size, you can expect that FH will provide approximately 25 percent more recording time than FSH compression. If you set the REC MODE to AVCHD(1080i), you will set its degree of compression with REC QUALITY:

MENU/SET>MOTION PICTURE>REC QUALITY>[FSH], [FH]

Alternatively, if you have set the REC MODE to AVCHD(720p), you can set its degree of compression to SH or H:

MENU/SET>MOTION PICTURE>REC QUALITY>[SH], [H]

Which should you choose? This is a matter of personal taste, and there is no general guideline. It will depend on the size of the HD television you will use and the degree of motion and amount of fine detail within the scene. We usually use 1080i with FSH compression.

10

If you want to work with AVCHD files on your computer, be prepared for a wait. It will take time to transcode the AVCHD files. If you prefer the immediacy of simply copying a file to your computer hard disk and working with it directly, record it as Motion JPEG. This file format is easy to edit in programs like QuickTime 7 Pro. This program can be downloaded, and there are versions that work on both Windows and Apple computers. After you set REC MODE to MOTION JPEG, you can go to REC QUALITY (figure 10-3).

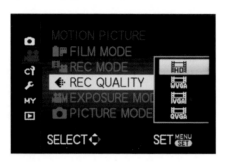

Figure 10-3: REC QUALITY of Motion JPEG set to HD

When you adjust the quality of a Motion JPEG file, you are not controlling its compression. Instead, you are setting the pixel array (table 10-1). The largest Motion JPEG pixel array is HD (1280 × 720 pixels), followed by WVGA (848 × 480 pixels), followed by VGA (640 × 480 pixels), and finally QVGA (320 × 240 pixels). Be advised that the convenience of using a computer-friendly file is obtained at the cost of a larger file size. Motion JPEG HD files are twice as large as AVCHD(720p) files, and this translates to half of the available recordable video time.

For Motion JPEG video, the command for REC QUALITY is as follows:

MENU/SET>MOTION PICTURE>REC QUALITY>[HD], [WVGA], [VGA], [QVGA]

Recommendation for Using Video Formats

Our goal when capturing our video images is to use the highest quality, so invariably we set the recording as follows:

 MENU/SET>MOTION PICTURE>REC MODE>[AVCHD(1080i)]
 MENU/SET>MOTION PICTURE>REC QUALITY>[FSH]

The quality of our setup is for FSH in the AVCHD mode. Sometimes, when we know we will be working with the file solely on the computer, we will use Motion JPEG and set the REC QUALITY to HD. Keep in mind that you can improve the video quality further by setting the mode dial to Creative Motion Picture Mode and working with 24P Cinema or Variable Movie Mode. We will discuss these topics later in this chapter.

Focusing Videos

The MOTION PICTURE menu has its own CONTINUOUS AF command that differs slightly from the command used for still photographs (table 10-2). When you turn this command off, the camera will set focus at the beginning of the video recording and fix focus at this initial point. There will be no focus correction if your subject moves toward or away from the camera. This takes place even if the camera's focus mode lever is set to AFS or AFC. Turning on CONTINUOUS AF allows the camera to continuously change focus in order to render a moving subject sharply. To set camera focus at a defined plane, set the camera to MF and focus manually.

In summary, when CONTINOUS AF is turned on in the MOTION PICTURE menu, it will override any setting on the focus mode lever when recording a video.

Focus Mode	CONTINUOUS AF	Focus Results	
		Shutter Pressed Halfway	Video Recording Initiated
AFS/AFC	ON	Sets initial focus	Will focus continuously as video is recorded
	OFF	Sets initial focus	Will use initial focus throughout the recording
MF	ON	Requires manual focusing	
	OFF		

Table 10-2: Relationship between the MOTION PICTURE menu's continuous automatic focus and the camera's focus mode lever

Audio Setup

The Panasonic GH2 camera uses a built-in stereo microphone to record sound. It is very sensitive and will record the sound of the lens focus motor on most of the Micro Four Thirds lens. This is the reason Panasonic sells the 14–140 mm zoom lens as a superior video lens. It is designed for video recording and has a silent focus motor. Because of this feature and its 10× zoom range, it is the ideal normal lens for this camera. Its disadvantages are its high price and increased weight. To set audio, you use the following command:

MENU/SET>MOTION PICTURE>(*pg* 3) MIC LEVEL ADJ.>[LEVEL 1], [LEVEL 2], [LEVEL 3], [LEVEL 4]

When you first access this command you will see LEVEL 1, 2, 3, or 4 (figure 10-4a); however, when you use the right directional arrow button to change the level, you will see a live view and a pair of audiometers that display the sound level (figure 10-4b). When the volume increases, the bars extend to the right. Too loud of a sound will overwhelm the microphones and their fidelity becomes distorted. As a warning, the audio bars will flash a red signal. These bars continually change

10

Figure 10-4a: Setting the audio level for the microphone

Figure 10-4b: Audiometer displayed in the viewfinder

with the sound volume. You can display a miniature set of audiometer bars in the viewfinder and see the audio level while you are recording a video. To do so, use the following command:

MENU/SET>MOTION PICTURE>(*pg* 2) MIC LEVEL DISP.>[OFF], [ON]

A problem when working outdoors is the wind. Depending on its speed and direction, it can generate a distracting noise in your recording. Fortunately, Panasonic has provided a gradable audio filter for minimizing this distraction. To remove this interference you can use the WIND CUT command (figure 10-5).

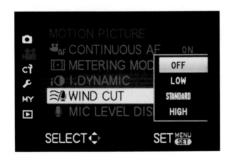

Figure 10-5: MOTION PICTURE menu display for altering the degree of wind noise to cut

The command for WIND CUT is as follows:

MENU/SET>MOTION PICTURE>(*pg* 2) WIND CUT>[OFF], [LOW], [STANDARD], [HIGH]

Taking Still Pictures While Recording Video

As mentioned earlier, you can use the Motion Picture button for recording your videos and the shutter-release button for taking still photographs. The camera is so versatile that you can actually take a still picture while recording the video.

Panasonic gives you two choices when you set up your camera for this dual operation.

The first choice is to put a priority on video recording with minimal interruptions. This is called Motion Picture Priorities, and it will record the still photo as a JPEG in a small size. This provides minimal disruption of the video recording process, but the camera overrides your settings for file formats. If you had set your camera to record RAW files, it will instead save the file as a small JPEG when you press the shutter-release button while you're recording a video.

The second option is called Still Picture Priorities. This allows you to save your photograph in a larger file format. It will use the values you had previously set in the REC menu; if you had set the camera to save your images as RAW files, that is what you will get. But the catch is the disruption of your video recording. You may notice the viewing screen going dark when the still photograph is being recorded. There will also be an interruption in the audio recording at this time.

You can select Motion Picture Priorities or Still Picture Priorities with the following command:

MENU/SET>MOTION PICTURE>PICTURE MODE>[*Motion Picture Priorities*], [*Still Picture Priorities*]

Recommendation

We are addicted to high-quality video clips and save our video recordings in REC MODE [AVCHD(1080i)] with REC QUALITY [FSH] selected. Even though we display and work with our images and recordings on computers, we find it worthwhile to invest the extra time and effort to work with these files. We use either an Apple computer with iMovie '11 or a Windows computer using PHOTOfunSTUDIO 6.0 BD Edition. If you adopt our strategy, restrict the length of your recording. A long continuous video can be difficult to edit, and you will find it advantageous to make short recordings and splice them together to make a longer-running video clip.

If you do not want to work with PHOTOfunSTUDIO 6.0 BD Edition or iMovie '11, you should record your files as Motion JPEG and use QuickTime 7 Pro. Again, we use the highest quality setting of [HD]. Remember that in this mode you have a seven-minute limit for one recording. You can resume recording by stopping and restarting your camera. But when you are recording an interview, keep an eye on the clock and strategically time your breaks so you can stop recording before the seven-minute mark.

The REC HIGHLIGHT command shows you the overexposed regions of the movie. This is similar to the HIGHLIGHT command used during playback. The main difference is this command is executed while you are recording the video, and it provides a preview of what will be overexposed. We set this command to [ON]. The black-and-white blinking in the regions that are being overexposed is not recorded

10

in the video. Finally, we set the I.DYNAMIC command to [STANDARD] or [HIGH]. We find the I.DYNAMIC command to be helpful in bringing out shadow details when a bright illuminant is in the scene.

LCD Screen versus Viewfinder

You can use the LCD screen or the viewfinder to frame your subject and control the recording of your video. Each has its advantages and disadvantages.

Using the LCD screen to frame relatively stationary subjects while recording a video is easiest when you use a tripod. Having a stable mount prevents involuntary camera movement. Moreover, you can create a more professional-looking video. For example, a pan/tilt head allows you to smoothly shift your viewpoint as you sweep the scene. Using your lens to zoom in or out is much easier when the camera is stably mounted because it prevents a shift in view as you turn the zoom ring. Remember, your camera does not have a motorized zoom lens, so smoothly changing your magnification while holding the camera steady is difficult. Recently, Panasonic has announced the future release of lenses with a motorized zoom control. This is advantageous for video work because it will provide a smooth increase or decrease in the field of view while recording the clip.

With the LCD screen, your view broadens, enabling you to see what is going on around you. It helps you record what you want and avoid what you don't want. You can see people about to walk into your video before they get there, giving you time to prevent the disruption. You will need to evaluate each situation to determine whether to use the LCD screen or viewfinder to keep track of your subject during video recording. Just remember that the audio is always running while you are recording.

For those times when you need to handhold the camera to record a video, use the viewfinder. By pressing the camera body against your face, the camera is stabilized and provides a steadier view than holding the camera away from your body and using the LCD screen.

Assigning Categories

Videos can be assigned categories just like still pictures. If you have selected a predefined scene mode, your videos will be assigned the selected mode's category. When you turn the mode dial to iA, you will find this mode has categories that can be used for videos. When Intelligent Auto Mode has determined the video's category, the associated icon will be displayed in the lower-left corner on the display screen, and the category will be saved with the video (table 10-3). These categories are used for filing and finding the videos during playback.

10

i-Portrait	i-Scenery	i-Macro	i-Low Light	General
![i-Portrait icon]	![i-Scenery icon]	![i-Macro icon]	![i-Low Light icon]	![General icon]

Table 10-3: Intelligent Auto Mode's available video categories and displayed icons

Exposure Compensation

As with pictures, you have the option to adjust the video's exposure using Exposure Compensation. It works the same way as with pictures. Press the rear dial to activate Exposure Compensation. If the Exposure Compensation scale is glowing yellow, turn the rear dial right or left to increase or decrease the exposure. However, if you do this during a recording, a clicking sound from the rear dial will be recorded and will disrupt your audio recording.

Remaining Recording Time

Your camera is set at the factory to show the number of shots that can be taken based on the available space on your memory card. It incrementally counts down this number as you record a photograph, thereby showing you the putative shots remaining. An analogous counter is available for the videographer that shows the time remaining for a recording to the memory card, but it is not routinely displayed. To see the time remaining for recording, set the following command:

MENU/SET>CUSTOM>(pg 6) REMAINING DISP.>[Remaining Shots], [Remaining Time]

Memory Card Recording Capacity Name	Display Style Option
Remaining Shots	⌾:🗇
Remaining Time	🎥 : ⊕

Table 10-4: Icons for indicating Remaining Shots and Remaining Time

This is an invaluable command when you are recording long video clips. Seeing the remaining time gives you an indication as to whether you need to change cards to record a long sequence.

If you use the Creative Motion Picture Mode, the camera routinely shows the time remaining for a recording on your memory card, making the command unnecessary.

10

Part 2: Advanced Settings: Creative Motion Picture Mode

Using the GH2 as a Video-Only Camera

When you turn the mode dial to the Creative Motion Picture icon, you cannot use the shutter-release button for taking still photographs. By sacrificing this capability, you gain additional control and settings as a video camera. For example, you can now change the shutter speed and aperture of your camera. This enables you to control the depth of field and, in some cases, eliminate the flickering arising from fluorescent lamps. Also, you can use a higher quality mode for saving your recordings. This part of the chapter describes the more advanced video capabilities of the Panasonic GH2 camera. The majority of the commands we described in the first part of the chapter are applicable in this mode. The exception is that in some recordings, you cannot record your files in AVCHD interlaced format nor as Motion JPEG files.

Figure 10-6(a-c): Creative Motion Picture Mode—selecting Manual Movie Mode, 24P Cinema, and Variable Movie Mode

When you activate Creative Motion Picture Mode, three icons display on the LCD screen. You can highlight each icon by using the right and left directional arrow buttons. As each icon is highlighted, one of the following names is displayed: MANUAL MOVIE MODE (figure 10-6a), 24P CINEMA (figure 10-6b), and VARIABLE MOVIE MODE (figure 10-6c).

Manual Movie Mode is an extension of the commands described earlier, and as its name implies, you can adjust the shutter speed or the aperture of your camera.

It allows you to record a video in either AVCHD or Motion JPEG format. To select Manual Movie Mode, use the following command:

MENU/SET>CREATIVE MOVIE>[MANUAL MOVIE MODE]

The two other options, 24P Cinema and Variable Movie Mode, are used by professional videographers. They can be accessed as follows:

MENU/SET>CREATIVE MOVIE>[24P CINEMA], [VARIABLE MOVIE MODE]

The reason 24P Cinema and Variable Movie Mode are separate commands is to provide a new format for saving videos. This format provides the highest quality, but at a cost. You will see that the REC MODE command is grayed out, so you lose the ability to save your files in all of the formats described earlier. The most significant cost is the loss of Motion JPEG. When you turn the mode dial to Creative Motion Picture Mode and select 24P Cinema or Variable Movie Mode, you can record only in 1080p (1080 progressive). This type of recording has the highest fidelity. The only control you have is how much compression you want to apply to the files. The compression is set with the REC QUALITY command. The least compression (or highest quality) is [24H], and an increased compression (lower quality) is [24L] (figure 10-7):

MENU/SET>MOTION PICTURE>REC QUALITY>[24H], [24L]

Video File Formats Revisited

Earlier we mentioned interlaced versus progressive output for your AVCHD video files. When you are using your Panasonic GH2 primarily as a still camera and you use the Motion Picture button for recording video, the highest-quality recordings are in 1080i format, or 1080 rows of pixels sent out in an interlaced format. Remember that interlacing required sending out two frames—one for all the odd-numbered rows of pixels, and another for all the even-numbered rows of pixels—and this can result in some degradation in the appearance of moving subjects. A superior method is to use progressive format, where all 1080 rows of pixels are sent out as a single frame. In Creative Motion Picture Mode, you can use progressive format with 24P Cinema and Variable Movie Modes. This creates a superior file for editing and viewing. However, you will lose the ability to create a Motion JPEG video file. This loss of a convenient file format for editing will be felt most by users who have older computers and find it difficult to work with AVCHD images. While in Creative Motion Picture Mode, you must use the Manual Movie Mode option to create Motion JPEG recordings.

10

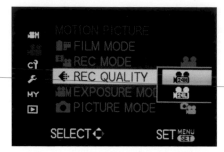

Figure 10-7: REC QUALITY command with [24H] selected

Controlling Aperture and Shutter Speed

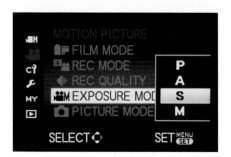

Figure 10-8: The menu for selecting P, A, S, or M in EXPOSURE MODE

To enter the following command for EXPOSURE MODE command, you must first turn the mode dial to Creative Motion Picture Mode. Keep in mind that using EXPOSURE MODE is not restricted to Manual Movie Mode. It is also used in 24P Cinema and Variable Movie Mode:

MENU/SET>MOTION PICTURE>EXPOSURE MODE>[P], [A], [S], [M]

You may recognize the letters in the command. They are found on the mode dial for setting semiautomatic and manual modes for taking still photographs (figure 10-8). The [A] indicates that you set the aperture, the [S] indicates that you set the camera's shutter speed, and the [M] indicates that you set both. The [P] is the odd one of the group, where you cannot set either. It is an automatic exposure mode where the camera is in control of both the aperture and the shutter speed.

The [A] command controls the aperture for depth of field (figure 10-9). In most consumer camcorders, the sensor and lens are optically constrained and generate images with only great depths of field. However, the larger sensor of the Panasonic GH2 camera allows you to reduce the depth of field, and you can direct the viewer's attention to the subject by blurring out the background. This is a unique feature and is limited, usually, to professional video equipment. You can minimize the depth of field by using the largest lens opening (minimum f-stop value). In part, the

enthusiasm for the larger aperture lens for the Panasonic GH2 camera expresses a desire to minimize the depth of field so the audience's attention will be drawn to the subject by blurring the background and foreground.

Figure 10-9: Aperture setting of f/7.1

For other scenes, you may wish to expand the depth of field. This can be a useful strategy when you need to turn off automatic focusing. Earlier we described how lenses from Nikon, Canon, and other manufacturers can be fitted to the Panasonic GH2. Such optics require manual focusing.

The [S] command is useful when you are working under fluorescent, mercury vapor, or neon lights. Unlike an incandescent lamp, these bulbs generate light intermittently and flicker at a rate of 50 or 60 cycles per second. This is not noticed by the naked eye, but it can be seen as unexpected darkening and brightening in a video. The remedy for this defect is to increase the shutter speed. By using the [S] command and setting a shutter speed at 1/100 second or 1/125 second, it may be possible to find the sweet spot that reduces or eliminates this annoyance (figure 10-10).

Figure 10-10: Shutter speed of 1/125 second

To set the aperture or the shutter speed, use the Q.MENU button. While you are previewing your scene on the LCD screen, press the Q.MENU button and use the directional arrow buttons to highlight the aperture setting (it will change from white to yellow). When it is highlighted, press the MENU/SET button, and you will see a list of apertures (figure 10-9). Use the up and down directional arrow buttons to highlight the one you want. Press the MENU/SET button to make your selection. You can use this same process to set the shutter speed.

10

Notice the letter A in the bottom-left corner of figure 10-9. Select it and press the MENU/SET button. You will then see the letters P, A, M, and S. You simply select S and press the MENU/SET button again to replace A with S (figure 10-10). You can now select the shutter speed number. Press the MENU/SET button to see a list of available shutter speeds. From there, you can highlight the one you want and press the MENU/SET button again.

24P Cinema and Variable Movie Mode

The majority of professional videographers use 24P Cinema or Variable Movie Mode. When it is set, you can create your file only in 1080p (1080 progressive); you cannot create your file in either an interlaced AVCHD (1080i) format, the non-interlaced 720p format, or in Motion JPEG format. As a result, when you look at the MOTION PICTURE menu you will see REC MODE grayed out, indicating it is unavailable (figure 10-11).

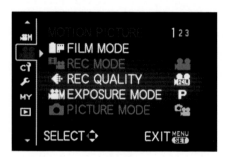

Figure 10-11: Menu showing REC MODE command is unavailable

To increase your available recording time, albeit with some sacrifice in quality, you can use the REC QUALITY menu to decrease the file size, thereby increasing the length of your potential recording time. The command for altering the quality is as follows:

MENU/SET>MOTION PICTURE>REC QUALITY>[24H], [24L]

The lower-quality, higher-compression mode is [24L] (figure 10-12), which increases your potential recording time by about 30 percent.

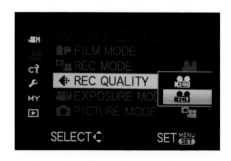

Figure 10-12: REC QUALITY command with [24L] selected

Playing with Time

After recording in 24P Cinema, the playback shows the subject moving in real time. But you have the option of altering the speed by using Variable Movie Mode during the recording. With this mode, the subject's motion is accelerated or decelerated during playback. Acceleration is equivalent to time-lapse photography, and deceleration allows you to better study the movement of a fast moving subject. To access these capabilities, you do the following:

MENU/SET>CREATIVE MOTION PICTURE>[VARIABLE MOVIE MODE]

When you select [VARIABLE MOVIE MODE] by pressing the MENU/SET button, you will see FRAME RATE on the screen (figure 10-13). By pressing the MENU/SET button again, the following options are displayed: [300%], [200%], [160%], and [80%] (figure 10-14). These values reflect your video's recording speed. Essentially, you will see your video accelerated by 3× (300%), 2× (200%), and 1.6× (160%). If you photograph a clock's second hand for one minute, when you play it back the full rotation is seen in 20 seconds (300%), 30 seconds (200%), or 37.5 seconds (160%). If you select [80%] to record the video, it will take 72 seconds to play back the video. In essence, you have a slow-motion view of the subject.

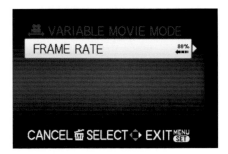

Figure 10-13: Variable Movie Mode is selected

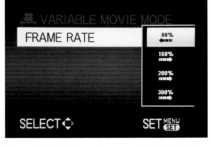

Figure 10-14: Recording speeds in Variable Movie Mode

Recommendations

We enjoy shooting videos. In some cases, they are well planned and meticulously executed with the camera mounted on a tripod. In other cases, it is an impromptu reaction to record a family event and we rapidly switch from recording photographs to recording videos while handholding the camera. The Panasonic GH2 lends itself to either application.

When we have time to plan, we use Creative Motion Picture Mode. This allows us to explore artistic effects, such as adjusting the depth of field or altering the speed with which the subject will be viewed. By using a shorter than normal shutter

speed we can eliminate the flicker arising from fluorescent lights. For impromptu work, we usually use the Motion Picture button, which minimally disrupts our still photography session. Experiment with your camera's video capabilities. Test all of the possible color schemes and predefined scene modes. See what works for you and when.

For the most satisfying and professional-appearing videos, you should mount your camera on a tripod. This is not to say you cannot create a pleasing video without this accessory, but failing to use a tripod results in the subject randomly moving within the borders of the frame. This can be distracting and looks unprofessional, especially if you intend to do an interview.

Do not be afraid to work with AVCHD. If you take short video recordings, you can edit these files on your computer. In the case of Apple computers, you will have to buy additional software; however, the cost is nominal. The iLife series costs about $50, and it provides you with several programs. You will find two to be helpful for photography: iPhoto and iMovie. You can use iPhoto to work with RAW files, and iMovie will allow you to work with AVCHD files or Motion JPEG files. If you own a PC, be sure to load Panasonic's PHOTOfunSTUDIO 6.0 BD Edition. It comes with the camera, and it will enable you to work with AVCHD and RAW files. Start working with short video clips that do not run longer than a couple of minutes. This will enable you to estimate the time it takes to work with longer video streams.

Do not hesitate to work with Creative Motion Picture Mode. In this mode you will have manual control of your camera's aperture and shutter speed while shooting a video. Although it is unclear in the GH2 user manual, you will have access to [P], [A], [S], or [M] in 24P Cinema and Variable Movie Mode. If you do not wish to play with these functions, you can set the camera to [P] to make it as convenient as a point-and-shoot camera. Take advantage of your Q.MENU button to rapidly change your settings. The main handicap of Creative Motion Picture is its inability to capture a still photograph while recording a video.

We found the EX. TELE CONV. command to be extremely valuable, but its utility is limited by how rapidly we can access it. Using the menu commands is far too laborious. As a result, we assigned this command to the Fn1 button so we can turn it on quickly.

10

10

Playing Back Your Pictures and Videos

Introduction

The previous chapters concentrated on describing how to record and review pictures and videos. This chapter has two parts. The first part covers how the Panasonic GH2 camera processes and presents the images stored on your memory card. The second part covers downloading your saved images to your computer and using image-processing software outside of the camera. This approach will give you more flexibility to process your images and build your own movie loops and slide shows.

The image-processing commands are relatively simple, and the presentation commands to play back groups of videos and still pictures using prerecorded music and presentation styles are more complex. Although these functions mimic what can be done on your computer, they lack the power to organize and process your images like a PC or Apple program can.

So is this something you will want to use? Maybe not. It depends on how comfortable you are doing image processing and building still picture and video presentations with your computer.

In this respect, PC owners are lucky. They can do this immediately and with no extra cost by using the Panasonic-supplied program PHOTOfunSTUDIO 6.0 BD Edition. Users of Apple computers will probably use the programs supplied in the iLife series. Frequently these programs are preloaded on a new Apple computer, but if it is not, you can purchase iLife for a nominal fee ($50).

We have utilized the PLAYBACK menu features extensively to learn how to process and present pictures and videos in the Panasonic GH2, and although we can clearly see its value and have enjoyed the results, we do not use it. Instead, we regularly download our pictures and videos to our computers to free up space on our camera's memory card. We use our computers to process our pictures and videos, and we write them to DVDs for viewing and safekeeping. So if you are comfortable with working with your pictures and videos on your computer, you may wish to bypass much of this chapter.

With that said, we have found some of the PLAYBACK menu commands to be useful when we are traveling and want to view our recently captured memories as a group. If you utilize the automatic camera modes—Intelligent Auto Mode and predefined scene modes—you might want to use the PLAYBACK menu commands for a specific category.

It is possible you will not find the camera's PLAYBACK menu commands all that valuable and may want to skip to the end of this chapter and read the section on downloading your pictures and videos to the computer.

11

Playback Terminology

Panasonic uses the term *Playback* several different ways: PLAYBACK menu, PLAYBACK MODE command, and Playback button. It can be rather confusing as to which one is being discussed. Although they all center around playing back saved images from the memory card, they have distinct differences.

The PLAYBACK menu is the last menu option within the camera's main menu. It has two main commands, SLIDE SHOW and PLAYBACK MODE, each with a series of submenu commands for organizing, building, and playing back selected pictures and videos as a presentation. In addition, the PLAYBACK menu has a set of image-processing commands to help you improve your saved pictures and videos.

The PLAYBACK MODE command is one of the two presentation structure commands within the PLAYBACK menu (with the SLIDE SHOW command being the other presentation structure). It enables you to identify a group of saved images, such as by category, and play back the group of images one at a time.

The Playback button was discussed earlier in the book. This green arrow button on the upper-right of the back of the camera gives you the ability to review (play back) all of your saved images one at a time. Depending on your selected data display format, it allows you to see the camera settings that were used when the image was recorded.

Where the PLAYBACK MODE command allows you to play back a subset of the total saved images, it does not allow you to see the camera settings used to record the image. That is available only with the Playback button.

PLAYBACK Menu

Overview

The PLAYBACK menu has a vast menu structure consisting of three distinct groups of commands:

- SLIDE SHOW command for showing a continuous display of images to an audience
- PLAYBACK MODE command for viewing a group of images one at a time
- Image-processing commands to assign print information or improve your images

A note of caution before you read further: although the PLAYBACK menu is straightforward, we have found it can have a steep learning curve, especially for users who are not very experienced in menu structures or image processing. There are multiple menu levels that need to be navigated and managed. The image-processing function has limitations and, in some cases, the results are not as exacting as they would be if you conducted the image processing via your computer.

11

SLIDE SHOW Command

The SLIDE SHOW command is an elaborate structure of submenu commands and values that result in automatic playback of a specific group of saved images, with a chosen image presentation and transition style to create a desired mood and ambience.

Determine Presentation Content

The PLAYBACK menu's SLIDE SHOW command has several options for how to play back your saved pictures and videos. For example, you can create a slide show consisting of only still pictures or only videos, or you can select a specific category, such as Portraits, which includes pictures and videos assigned the Portrait category. Finally, you can limit the show to only your favorite images.

In addition, there are multiple slide show presentation styles. You can vary the presentation style and the time interval between each picture or video, and you can choose if you will use the camera's prerecorded music, only the recorded audio, or no sound at all. After you have determined your slide show content and style, you can start the slide show presentation and watch it on your camera display screen or on your TV.

The first decision you make is the type of pictures and/or videos the slide show presentation will contain. Select the value from the following command:

MENU/SET>PLAYBACK>SLIDE SHOW>[ALL], [PICTURE ONLY], [VIDEO ONLY], [3D], [CATEGORY SELECTION], [FAVORITE]

Table 11-1 describes the different SLIDE SHOW command options you have to choose from.

SLIDE SHOW Option	Types of Files Included in Slide Show
ALL	All pictures, Burst Groups, and videos
PICTURE ONLY	All pictures and Burst Groups only
VIDEO ONLY	All videos only
3D	All 3D pictures
CATEGORY SELECTION	Only pictures, Burst Groups, and videos in a specific category
FAVORITE	All pictures, Burst Groups, and videos marked as favorites Option displayed when you have selected MENU/SET>SETUP>(pg 3) FAVORITE FUNC.>[ON] and at least one picture or video is marked as a favorite.

Table 11-1: SLIDE SHOW command options

11

CATEGORY SELECTION: *Categories*

Both the PLAYBACK menu's SLIDE SHOW and PLAYBACK MODE commands take advantage of your stored image categories, described in chapter 4 (figure 11-1).

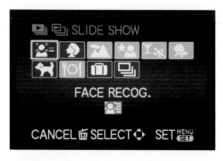

Figure 11-1: SLIDE SHOW available categories

Playback Category	Recorded Categories
FACE RECOG. icon	FACE RECOG.
Portrait icon	All PORTRAIT predefined scene modes, i-PORTRAIT, NIGHT PORTRAIT i-NIGHT PORTRAIT, BABY1/BABY2, i-BABY
Scenery icon	All SCENERY predefined scene modes, i-SCENERY, NIGHT SCENARY, i-NIGHT SCENERY, SUNSET, i-SUNSET
Night portrait icon	NIGHT PORTRAIT, i-NIGHT PORTRAIT, NIGHT SCENERY, i-NIGHT SCENERY
Sports/party icon	SPORTS, PARTY
Baby icon	BABY1/BABY2, i-BABY
Pet icon	PET
Food icon	FOOD
Travel icon	TRAVEL DATE
Movie icon	AVCHD, Motion JPEG
Burst icon	Burst Groups only

Table 11-2: Recorded categories mapped into available SLIDE SHOW and PLAYBACK categories

11

Not all of the predefined scene modes will fall into a playback category. For example, Close-up's FLOWER predefined scene mode images do not fall into any of the playback categories. When selecting the specific playback category, use

table 11-2 to determine which recording category will fall into which SLIDE SHOW and PLAYBACK MODE category. When selecting FACE RECOG., you will be asked to select a specific registered face for playback purposes.

As an added feature, the camera highlights the icons for categories that have images stored on the memory card. After a short delay, the total count of images found within the selected category is displayed on the screen. Therefore, if a category icon is not highlighted, there is nothing stored on the memory card in that category (figure 11-2).

Figure 11-2: Highlighted categories indicate that images exist; disabled categories indicate that no images exist

When you select your slide show content, you will need to select the presentation style, which consists of the transition from one picture or video to the next, the picture display style, and the music.

Presentation Style Commands

How you build your presentation is really a personal preference. We recommend that you try each of the different presentation styles and listen to the prerecorded music to determine what you like.

When you have selected the SLIDE SHOW presentation content, you will be presented with a standard presentation style submenu asking you to specify how you want the selected pictures, Burst Groups, and videos to be presented (figure 11-3). One exception is the CATEGORY SELECTION command option. You will first be presented with a list of categories to select from. After you have selected a category, you will be presented with the standard presentation style submenu.

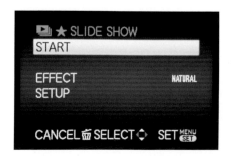

Figure 11-3: Standard SLIDE SHOW presentation style submenu

11

Because of the uniqueness of the SLIDE SHOW command's menu structure, we will vary our menu path nomenclature to include [*selected option*] as a placeholder for the selected SLIDE SHOW command option and selected category when [CATEGORY SELECTION] has been selected.

There are a few places within the SLIDE SHOW menu structure where the available presentation styles have minor differences. For example, there is no transition style for [VIDEO ONLY] slide shows. Rather than cover all of the exceptions here and potentially complicate the flow of the discussion, you can look for the specific option in the SLIDE SHOW portion of the downloadable GH2 Command List (found at http://rockynook.com/panasonicgh2).

EFFECT Command

This command allows you to set the slide show presentation style, which includes how a picture is displayed, the transition style for switching from one image to the next, and the type of music that is played when playing back your pictures and Burst Groups. The EFFECT command is disabled for [VIDEO ONLY] slide shows since audio is recorded while taking videos. Set the slide show's effect style with the following command:

MENU/SET>PLAYBACK>SLIDE SHOW>[*selected option*]>
EFFECT>[AUTO], [NATURAL], [SLOW], [SWING], [URBAN], [OFF]

Each EFFECT command option has its own transition style and music. You will see that selecting [URBAN] will cause some of the pictures to be played in black and white, and [AUTO] is available only when a CATEGORY SELECTION option is selected. When [OFF] is selected, the only sound you will hear is the recorded audio of your video.

If you wish to override the recorded audio, make sure the EFFECT command is not set to [OFF], and set the following command:

MENU/SET>PLAYBACK>SLIDE SHOW>[*selected option*]>SETUP> SOUND>[MUSIC]

SETUP Command

The SETUP command has three submenu commands that allow you to set how the slide show presentation will operate. Assign the slide show's setup values using the following command:

MENU/SET>PLAYBACK>SLIDE SHOW>[*selected option*]>SETUP> [DURATION], [REPEAT], [SOUND]

11

DURATION command: Use the following command to control the length of time each picture is displayed:

MENU/SET>PLAYBACK>SLIDE SHOW>[*selected option*]>
SETUP>DURATION>[1 SEC.], [2 SEC.], [3 SEC.], [5 SEC.]

This command is automatically set to two seconds ([2 SEC.]) unless EFFECT is set to [OFF], in which case you can select your own duration from the allowable options.

REPEAT command: Use the following command to continuously loop through the selected images or play through them only once:

MENU/SET>PLAYBACK>SLIDE SHOW>[*selected option*]>SETUP>REPEAT>[OFF],
[ON]

SOUND command: This command will establish how to handle the slide show's accompanied sound, such as recorded audio in your videos:

MENU/SET>PLAYBACK>SLIDE SHOW>[*selected option*]>SETUP>SOUND>[OFF],
[AUTO], [MUSIC], [AUDIO]

where:
OFF: No sound will play, including recorded audio.
AUTO: Music will play when there is no recorded audio.
MUSIC: Music will play instead of recorded audio.
AUDIO: Only recorded audio will play.

START Command
There are no options within the START command. Selecting START initiates your slide show presentation, which will be dictated by what you selected in the other SLIDE SHOW commands. The presentation will play the selected pictures and/or videos in order of recorded date and time.

Execute the START command as follows:

MENU/SET>PLAYBACK>SLIDE SHOW>[*selected option*]>START

SLIDE SHOW Operational Controls
When you start a slide show presentation or start playing back a group of images, you may want to pause the playback, jump ahead, or replay an image. Table 11-3 lists operational controls to help you navigate during a SLIDE SHOW playback. The operations allow you to pause or stop a slide show anywhere while it is playing, but

11

you can only skip forward or backwards between individual pictures, Burst Groups, and videos. This means you cannot skip within a video or a Burst Group; you can only skip to the next or previous video or Burst Group.

SLIDE SHOW Playback Operation	Operational Directions
Play/pause slide show	Press the up directional arrow button.
Stop slide show	Press the down directional arrow button.
Back to previous picture, Burst Group, or video	Press the up directional arrow button (pause), then the left directional arrow button.
Skip ahead to the next picture, Burst Group, or video	Press the up directional arrow button (pause), then the right directional arrow button.
Reduce volume level	Turn the rear dial to the left.
Increase volume level	Turn the rear dial to the right.

Table 11-3: Slide show playback operational controls

Recommendations

Although there are some drawbacks, playing a slide show is a fun way to view your pictures and videos if you are unable to immediately download them to a computer for processing. To get the best results, make sure you have your pictures and videos categorized correctly and delete the images you no longer want. In addition, remember that this playback feature can use only the images and videos on the inserted memory card. If you use multiple memory cards, you cannot combine them into one presentation in your camera.

We recommend you use the slide show feature as a novelty. You will get far better results when you download your pictures and videos to your computer and use third-party software to process them and organize them into a permanent slide show.

PLAYBACK MODE Command

Overview

Where the SLIDE SHOW command automatically plays a selected group of images, the PLAYBACK MODE command (figure 11-4a) lets you manually play a selected group of pictures, Burst Groups, and videos from the memory card one at a time. For Burst Groups you will use the right and left directional arrow buttons to manually move through the individual frames within a Burst Group.

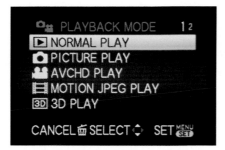

Figure 11-4a: PLAYBACK MODE command menu page 1

Figure 11-4b: PLAYBACK MODE command menu page 2

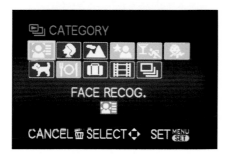

Figure 11-4c: PLAYBACK MODE>CATEGORY menu

Use the following command to select images you want to view:

MENU/SET>PLAYBACK>PLAYBACK MODE>[NORMAL PLAY], [PICTURE PLAY], [AVCHD PLAY], [MOTION JPEG PLAY], [3D PLAY], [CATEGORY PLAY], [FAVORITE PLAY]

Table 11-4 contains the PLAYBACK MODE command options along with a description of what group of pictures and videos will be selected for each option. Select an option and press the MENU/SET button. For all but the [CATEGORY PLAY] option (figure 11-4b), the camera will group all of your images for the selected option and present the first one on the display screen for your viewing.

The [CATEGORY PLAY] option has an additional step and presents you with a menu to select the category you wish to play back (figure 11-4c). Select a category and press the MENU/SET button. The camera will identify all of the images in the selected category and will display the first one for your viewing.

11

PLAYBACK MODE Option	Description
NORMAL PLAY	Play back all pictures, Burst Groups, and videos.
PICTURE PLAY	Play back pictures and Burst Groups only.
AVCHD PLAY	Play back all videos recorded using AVCHD.
MOTION JPEG PLAY	Play back all videos recorded using Motion JPEG.
3D	Play back all 3D pictures only.
CATEGORY PLAY	Play back all pictures, Burst Groups, and videos in the specific category.
FAVORITE PLAY	Play back pictures, Burst Groups, and videos that are identified as favorites. Option enabled when you have selected MENU/SET>SETUP>FAVORITE FUNC.>[ON] and at least one picture or video is marked as a favorite.

Table 11-4: PLAYBACK MODE command options

PLAYBACK MODE Operational Controls

The operational controls listed in table 11-3 for navigating through slide shows also work in the PLAYBACK MODE. Use them to navigate through the playing back of pictures, Burst Groups, and videos. In addition, a touch screen navigation bar is displayed at the bottom of the display when playing back a Burst Group (figure 11-5). Use this bar to reverse, play/pause, fast forward, or stop the playback. There is a similar touch screen navigation bar displayed when playing back videos, but it also includes a vertical volume control bar.

Figure 11-5: Burst Group playback touch screen navigation bar

Recommendations

We recommend using the PLAYBACK MODE command as a quick and easy way to view a group of pictures and videos that would otherwise be dispersed throughout your current memory card.

Image-Processing Commands

Overview

Table 11-5 contains a list of the 12 PLAYBACK menu image-processing commands available to help you modify, document, and print your images. Additional quick-reference information containing each of the commands, plus their submenu commands, values, and high-level descriptions, can be found in the PLAYBACK section in the downloadable GH2 Command List (found at http://rockynook.com/panasonicgh2).

We recommend you review table 11-5 before proceeding with this section. You may already be using image-processing software that covers these commands. If that is the case, feel free to skip to the section "Working outside of the Camera" near the end of this chapter. You can always come back to this section if you change your mind.

PLAYBACK Command	Description
TITLE EDIT	Add a title to a picture to be displayed during playback. Title will also be available in TEXT STAMP command.
TEXT STAMP	Collect a set of data to be printed on the picture.
VIDEO DIVIDE	Divide a video into two separate videos.
RESIZE	Reduce a picture's size for email or website use.
CROPPING	Identify a portion of a picture and save it as a new picture.
ASPECT CONV.	Convert a picture with an aspect ratio setting of [16:9] to one of the following three settings: [3:2], [4:3], or [1:1].
ROTATE	Rotate a picture clockwise or counterclockwise in 90-degree increments.
ROTATE DISP.	Display portrait oriented pictures vertically on the display screen.
FAVORITE	Identify pictures and videos as favorites so they can be played back as a group.
PRINT SET	Identify pictures to print and print criteria.
PROTECT	Set a protection key to prevent a picture or video from being deleted by mistake.
FACE REC EDIT	Delete or replace Face Recognition information in selected pictures.

Table 11-5: PLAYBACK menu image-processing commands

We have structured this section to allow you to zero in on a specific command and learn how to use it along with any concerns and limitations you will need to know. But before we go through each of the commands, there are several common steps that are used for many of the commands. We will cover these common steps here rather than repeat them for each command.

Common PLAYBACK Menu Command Steps

Several of the commands use the same options. The [SINGLE] and [SINGLE IN BURST GROUP] options apply the command to single saved images. The [MULTI] and [MULTI IN BURST GROUP] options apply the command to as many as 100 save images at a time. In addition, the [CANCEL] option removes the previously applied command action from saved images.

When [SINGLE] is selected, you will scroll through each saved image one at a time using the right and left directional arrow buttons. Use the MENU/SET button to select a single image for which to apply the command.

When [MULTI] is selected, you are presented with up to six saved images on the display screen at one time. You can scroll through the images and select up to a maximum of 100. Use the DISPLAY button to mark an image for processing. When you have marked all the images you want to process, press the MENU/SET button for the command to process.

When the [SINGLE IN BURST GROUP] or [MULTI IN BURST GROUP] options have been selected, only Burst Groups are displayed. These two options allow you to select frames within a single Burst Group or frames within multiple Burst Groups. You will be presented with up to six saved Burst Groups on the display screen at one time. Use the MENU/SET button to select a Burst Group.

For the [SINGLE IN BURST GROUP] option, scroll through the group's frames and use the MENU/SET button to select one. For the [MULTI IN BURST GROUP] option, use the DISPLAY button (MENU/SET button for PRINT SET and PROTECT) to select one or more frames, and then press the MENU/SET button to continue with processing the command. Use the directional arrow buttons to navigate through both the Burst Groups and their frames.

In the above cases we will refer to these actions as "scroll through" and "select."

Figure 11-6: Entered text with SET highlighted

Several of the commands involve entering text. In this case, you will be presented with a text entry screen. This is the same text entry screen used to enter name information for BABY1, BABY2, PET, and FACE RECOG. The screen is simple and straightforward. Pressing the DISPLAY button will cycle through capitalized alphabet, lowercase alphabet, and number/symbol keyboard pads. Use the directional arrow

buttons to navigate through the keyboard, and press the MENU/SET button to enter a highlighted letter. Highlight SET on the top-left portion of the screen, and press the MENU/SET button to accept your entered information (figure 11-6). When applicable, we will refer to this process as "enter via the text entry screen".

Several of the processing commands display an associated icon in the top-left corner of the screen while the command is operational. When the command is applied to an image, the icon is also displayed on the image during command execution and later when viewing the image using the PLAYBACK button.

TITLE EDIT

This command gives you the option to assign title information (maximum of 30 characters) to one or more pictures at one time. The title information will be carried over and available for printing with the pictures when using PHOTOfunSTUDIO 6.0 BD Edition software.

What you should know:
- The TITLE EDIT command is not available for the following types of images:
 - Videos
 - Protected pictures
 - Pictures taken in RAW only or RAW/JPEG formats
 - Pictures recorded with other equipment
- The entered title information will display when you view individual pictures with the DISPLAY button (figure 11-7). Only the title information entered on the first frame in a Burst Group will display.

Figure 11-7: Title information displayed on a saved image

To use the TITLE EDIT command, follow these steps:
1. Select MENU/SET>PLAYBACK>TITLE EDIT>[SINGLE], [MULTI], [SINGLE IN BURST GROUP], [MULTI IN BURST GROUP]. Press the MENU/SET button.
 a) Scroll through the saved image(s). Press the MENU/SET button when you find the picture(s) or frames within a Burst Group to which you wish to add title information.

11

b) Enter the title information in the text entry screen, and press the MENU/SET button to store the title with the selected image(s).

2. Press the Trash Can button to exit the command.

TEXT STAMP

Use the TEXT STAMP command to stamp the recording date and time, name, travel location, travel day, and/or title (entered from the TITLE EDIT command) onto a new copy of a recorded picture for printing purposes. Figure 11-8 displays the TEXT STAMP command menu for entering the data. Table 11-6 shows the descriptions of each data field.

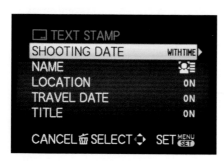

Figure 11-8: TEXT STAMP command menu options

TEXT STAMP Command	Option	Description
SHOOTING DATE	OFF	Do not include recorded date and time.
	W/O TIME	Include recorded year, month, and day.
	WITH TIME	Include recorded year, month, day, hour, and minute.
NAME	OFF	Do not include saved registered name information.
	(face icon)	Include Face Recognition name. When asked to include age, if [YES] is selected, age information will be added.
	(baby/pet icon)	Include registered name settings of BABY1, BABY2, or PET. When asked to include age, if [YES] is selected, age information will be added.
LOCATION	OFF	Do not include MENU/SET>SETUP>TRAVEL DESTINATION>[LOCATION] information.
	ON	Include MENU/SET>SETUP>TRAVEL DESTINATION>[LOCATION] information.
TRAVEL DATE	OFF	Do not include calculated number of days elapsed since travel departure date.
	ON	Include calculated number of days elapsed since travel departure date (ex. "5" for Day 5).
TITLE	OFF	Do not include saved title for picture(s) from MENU/SETUP>PLAYBACK>TITLE EDIT.
	ON	Include saved title for picture(s) from MENU/SETUP>PLAYBACK>TITLE EDIT.

Table 11-6: TEXT STAMP command options with descriptions

11

What you should know:

- Pictures made from original pictures that are size [L] or [M] will be sized to [S].
- Pictures must be printed using compatible software and on a compatible printer. Some software cannot read the pictures' associated text, and some printers will cut off characters. The supplied PHOTOfunSTUDIO 6.0 BD Edition software can read this information from the downloaded pictures.
- There is no guarantee that the text will be printed or positioned correctly. If you specify to have the picture's recorded date printed, it will overlay the stamped text. Check with your print shop before having your pictures printed to determine if they will be able to print your pictures with the added text.
- Adding text may cause the picture's printed quality to deteriorate.
- The TEXT STAMP command will not work for the following types of pictures:
 - Videos
 - Pictures taken in RAW only or RAW/JPEG formats
 - Pictures recorded without setting the clock first
- The entered text stamp information will display when you view individual pictures with the DISPLAY button. Only the title information entered on the first frame in a Burst Group will display.

To set the text stamp information for your picture(s), follow these steps:

1. Select MENU/SET>PLAYBACK>TEXT STAMP>[SINGLE], [MULTI], [SINGLE IN BURST GROUP], [MULTI IN BURST GROUP]. Press the MENU/SET button.
 a) oll through the saved image(s). Press the MENU/SET button when you find the picture(s) or Burst Group to which you wish to add text stamp information.
 b) er the text stamp information, using table 11-6 as your guide.
2. The following questions are asked, depending on the selected pictures and Burst Groups:
 a) If you have selected a picture with Face Recognition in the Baby or Pet category, and/or either the [*Face Recognition*] or [*Baby/Pet*] option was selected for the NAME command, you will be asked the following question:

 DO YOU NEED AGE STAMP? [YES] [NO]

 Select [YES] to include the age with the text stamp information; select [NO] to exclude it.
 b) You will be asked if you want to save the new picture(s) with the text stamp information. Which question you are asked depends on the size of the original picture(s):
 If the PICTURE SIZE is [L] or [M], the following question will be asked:

 IT WILL BE STAMPED ON THE PICTURE RESIZED TO S. SAVE NEW PICTURES? [YES] [NO]

11

If the PICTURE SIZE is [S], the following question will be asked:

SAVE NEW PICTURES? [YES] [NO]

Select [YES] to save the new picture(s); select [NO] to stop the process.

3. The following informational message is displayed while a new Burst Group is being saved:

NEW FILE IS SAVED TO OUTSIDE OF THE BURST GROUP.

4. Press the Trash Can button to exit the command.

Each new picture will have a white Text Stamp icon in the upper-left corner of the display screen (just below the green Playback Mode arrow), and the saved text stamp information will be displayed in red in the lower-right corner of the display screen (figure 11-9a). The text information is small and easy to miss, but when you realize what you are looking for, you should have no trouble finding it (figure 11-9b)

Figure 11-9a: Red TEXT STAMP command information in lower-right corner

Figure 11-9b: Enlarged lower-right corner showing the TEXT STAMP information

VIDEO DIVIDE

This option allows you to divide a saved video into two parts and save both parts as individual files. For example, if you have a 50-second video and you divide it into two parts at the 40-second mark, you will end up with two video files, one with a length of 40 seconds and the other with a length of 10 seconds. The audio portion of the file will also be divided.

After you have divided a video, you cannot put them back together with the camera software. The accuracy for setting the division is one second. If you need greater precision, you need to download the video to a computer and use movie editing software.

11

What you should know:
- You cannot divide the following kinds of videos:
 - Videos set as a favorite

- · Protected videos
- · Videos with a total recording time of about two seconds or less
- · You cannot divide a video if one of the resulting videos will be about one second or less.
- · Dividing [MOTION JPEG] videos reorders the file numbers. For example, suppose there are 105 files on your memory card. You divide video file 100 into two smaller files. The original file 100 is deleted, and all of the subsequent file numbers are decreased by one. The videos resulting from the division will be files 105 and 106, with file 105 being the video up to the point of division and file 106 being the video containing the portion after the division.
- · Dividing [AVCHD] videos does not reorder the file numbers. For example, suppose there are 200 files on your memory card. You divide video file 160. The resulting videos will be files 160 and 201, with file 160 being the original video up to the point of division and file 201 being the new video containing the portion after the division.

To execute a VIDEO DIVIDE, follow these steps:

1. Select MENU/SET>PLAYBACK>VIDEO DIVIDE.
2. Select the video you wish to divide.
3. Press the MENU/SET button to play the video.
4. Press the up directional arrow button at the location in the video where you wish to make the divide. The video will pause.
5. Press the down directional arrow button to execute the divide.
6. You will receive the following message:

DIVIDE THIS MOVIE FILE? [YES] [NO]
DO NOT REMOVE THE BATTERY/MEMORY CARD WHILE PROCEEDING.

Select [YES] to complete the divide; select [NO] to stop the divide.
7. Press the Trash Can button to exit the command.

It will be easier to first play back the video to find the point where you want to make the division. When you have decided where to divide it, initiate the VIDEO DIVIDE command.

RESIZE

The RESIZE command will create a copy of a picture with a reduced picture size (number of pixels). This makes the new picture easier to post to websites or attach to e-mails. For example, if you have 100 files saved on your memory card and you execute the RESIZE command for file 80, you will end up with 101 files on your memory card; file 101 will be the resized version of file 80.

11

What you should know:
- You can resize pictures only from a larger size to a smaller size.
- You cannot resize the following types of files:
 - Video files
 - Pictures taken in RAW only or RAW/JPEG formats
 - Pictures stamped with text stamp information

To resize your picture(s), follow these steps:
1. Select MENU/SET>PLAYBACK>(*pg* 2) RESIZE>[SINGLE], [MULTI]. Press the MENU/SET button.

[SINGLE]

 a) Scroll through the saved image(s). Press the MENU/SET button when you find the picture you wish to resize.
 b) If the selected picture is size [S], the following error message will display:

 THIS PICTURE CANNOT BE RESIZED

 c) If the selected picture is size [L] or [M], a screen is displayed with the selected picture's current size and an arrow pointing down to a possible resize choice. If there is more than one resize choice, you will see a yellow arrow pointing to the left or right. Use the corresponding directional arrow button to access the other resize option:
 - A picture size of [M] can be copied to size [S]
 - A picture size of [L] can be copied to size [M] or [S] (figure 11-10).
 Use the left or right directional arrow buttons to select a resize value and press the MENU/SET button.

Figure 11-10: Original picture with picture size of [L] set to be resized to [S]

[MULTI]

 a) A screen appears listing both [M] and [S] picture sizes with all of the possible aspect ratio values and related sizes. Use the up and down directional arrow buttons to select [M] or [S] and press the MENU/SET button.

11

b) Scroll through and use the DISPLAY button select the pictures you wish to resize. If you have selected a picture that cannot be resized to the selected new size, the following message will be displayed:

THIS PICTURE CANNOT BE RESIZED

c) When you have found all the pictures you want to resize, press the MENU/ SET button.

2. You will be asked if you want to save new picture(s) with the new size:

SAVE NEW PICTURES? [YES] [NO]

Select [YES] to save the new picture(s); select [NO] to stop the process and return to scroll though the pictures.

3. Press the Trash Can button to exit the command.

CROPPING

Cropping creates a new picture containing only a portion of the original picture. The CROPPING command requires you to enlarge a picture, determine the center of the picture, and then create a new picture containing what you see in the display screen. This is not an exact science. You can enlarge the picture only by set increments, plus the resulting picture size will have to fit within the set of available picture sizes.

What you should know:
- The picture quality of cropped pictures will deteriorate due to excessive enlargement.
- Face Recognition information will not be copied from the original picture to the new cropped image.
- You cannot crop the following:
 - Videos
 - Pictures stamped with Text Stamp information
 - Pictures taken in RAW only or RAW/JPEG formats

To crop your picture, follow these steps:
1. Select MENU/SET>PLAYBACK>(*pg* 2) CROPPING>[SINGLE], [SINGLE IN BURST GROUP].
 a) Scroll through the saved image(s). Press the MENU/SET button when you find the picture or frame within a Burst Group frame you wish to crop.
 b) Turn the rear dial to the right to enlarge the picture. Use the directional arrow buttons to position the picture.

11

2. Press the MENU/SET button. The following message displays:

SAVE NEW PICTURES? [YES] [NO]

Select [YES] to complete the cropping; select [NO] to stop the process.

3. Press the Trash Can button to exit the command.

The original picture or Burst Group will be unaffected, and a new file will be saved on the memory card containing the cropped image (figures 11-11(a-c)).

Figure 11-11a: Original picture prior to being cropped

Figure 11-11b: Cropped picture prior to being saved

Figure 11-11c: The cropped picture with a new file number

ASPECT CONV.

An aspect ratio of 16:9 does not completely fit on some computer monitors or on older-style TVs. If you plan to create a presentation for your TV or computer and you have pictures with an aspect ratio of 16:9, you may want to convert them to a different aspect ratio. This command allows you to take a picture with a current aspect ratio of 16:9 and create a new picture with an aspect ratio of 3:2, 4:3, or 1:1.

What you should know:
- Face Recognition information will not be copied from the original picture to the new picture.
- This command does not work on the following files:
 - Videos

11

- Pictures stamped with Text Stamp information
- Pictures taken in RAW only or RAW/JPEG formats
- Pictures with an aspect ratio other than 16:9

To convert your picture's 16:9 aspect ratio to a different aspect ratio, follow these steps:

1. Select MENU/SET>PLAYBACK>(*pg* 2) ASPECT CONV.>[SINGLE], [SINGLE IN BURST GROUP]>[3:2], [4:3], [1:1] and press MENU/SET button. Figure 11-12a contains the available aspect ratio options.
2. Scroll through the saved image(s). Press the MENU/SET button when you find the picture(s) or frame(s) within a Burst Group for which you want to change the aspect ratio (figure 11-12b).
3. If the selected picture or Burst Group is not eligible for conversion, the following error message displays:

 CANNOT BE SET ON THIS PICTURE

4. After it is selected, the picture or Burst Group frame will have a yellow target box representing the new aspect ratio size, with arrows indicating the direction the target box can be moved using the directional arrow buttons (figure 11-12c). Position the target box where you want it and press the MENU/SET button. The new picture will be cropped to the new aspect ratio. The following message will display:

 SAVE NEW PICTURE(S)? [YES] [NO]

5. Select [YES] to complete the aspect ratio conversion; select [NO] to stop the process.
6. Press the Trash Can button to exit the command.

A new picture with the selected aspect ratio will be saved (figure 11-12d).

Figure 11-12a: Select new aspect ratio value

Figure 11-12b: Original picture with an aspect ratio of 16:9

11

Figure 11-12c: New aspect ratio super-imposed on picture

Figure 11-12d: New picture with aspect ratio of 3:2

ROTATE

Although most pictures are taken holding the camera horizontally, there will be times when you will want to hold the camera vertically to snap a portrait or that perfect picture. Vertical pictures can be displayed on the display screen horizontally using the ROTATE DISP. command, but when you print un-rotated vertical pictures, you will find there will be two black lines, or borders, one on each side of the picture. This might not be to your liking. Rotating the vertical pictures for print purposes will eliminate the black borders on the printed version of the picture. The ROTATE command is enabled only when the ROTATE DISP. command is set to [ON].

What you should know:
- You cannot rotate the following:
 - Videos
 - Protected pictures

To use the ROTATE command, follow these steps:
1. Select MENU/SET>PLAYBACK>*(pg* 2) ROTATE.
2. Select the picture you want to rotate 90 degrees and press the MENU/SET button. The following error message displays if the selected picture is not eligible for rotation:

 CANNOT BE SET ON THIS PICTURE

3. Using the up and down directional arrow buttons, select the direction you want to rotate the picture and press the MENU/SET button.
4. Press the Trash Can button to exit the command.

ROTATE DISP.

This command controls how you will view vertical pictures during playback:
1. Select MENU/SET>PLAYBACK>*(pg* 2) ROTATE DISP>[OFF], [ON].

2. Select [ON] to automatically display pictures vertically; select [OFF] to display vertical pictures horizontally during playback. Press the MENU/SET button to accept the highlighted value.

Note: Displaying a vertical picture vertically during playback will cause the picture to be displayed smaller in order to fit on the screen.

FAVORITE

Assigning a picture, video, or Burst Group to Favorite status gives you quick access to these pictures. You can group all identified Favorite files for playback purposes through the SLIDE SHOW or PLAYBACK MODE commands. In addition, when you delete pictures and videos, the [ALL DELETE EXCEPT *favorite*] option will exclude deleting any files identified as a favorite. Note that MENU/SET>PLAYBACK>(*pg* 3) FAVORITE is enabled only if MENU/SET>SETUP>(*pg* 3) FAVORITE FUNC.>[ON].

When the FAVORITE FUNC. command is set to [OFF], no new pictures, videos, or Burst Groups can be marked with the Favorite status. Previously marked saved images will retain their Favorite status behind the scenes, but it is not recognized by the camera's software until the FAVORITE FUNC. command is set to [ON].

When the command is set to [ON], the FAVORITE command is enabled. A white star along with a yellow down arrow is displayed in the lower-right corner of the LCD screen, indicating that pressing the down directional arrow button will set or unset favorite status for the displayed image (figure 11-13). In addition, previously marked saved images will have a white star displayed in the upper-left corner when reviewed. You can remove all of the favorite statuses by setting the FAVORITE command value to [CANCEL].

Figure 11-13: Favorite set/unset icon displayed

What you should know:
- You can set a total of 999 pictures, Burst Groups, and videos as favorites.
- Pictures taken in RAW only or RAW/JPEG format cannot be set as favorites.
- The [CANCEL] option will be disabled if there are no pictures, Burst Groups, or videos currently identified as a Favorite.

To initiate the FAVORITE functionality, follow these steps:
1. Select MENU/SET>SETUP>(*pg* 3) FAVORITE FUNC.>[ON].
2. Select MENU/SET>PLAYBACK>(*pg* 3) FAVORITE>[SINGLE], [MULTI], [SINGLE IN BURST GROUP], [MULTI IN BURST GROUP], [CANCEL].
 a) Scroll through the saved image(s). Press the MENU/SET button when you find the picture(s) or frame(s) within a Burst Group you wish to make favorites.

To cancel saved images' assigned FAVORITE status:
1. Select [CANCEL]. You will receive the following message:

 CANCEL ALL FAVORITE SETTINGS? [YES] [NO]

2. Select [YES] to cancel the favorite status for all images, and press the MENU/SET button; select [NO] to stop the process.
3. Press the Trash Can button to exit the command.

PRINT SET

This command allows you to set information that will ultimately print on your still pictures when using the digital print order format (DPOF) system utilized by many photo printers and photo printing services. You select the pictures, how many prints you want of each, and whether to include recorded date/time stamp information.

What you should know:
* The print indicator and information are not automatically deleted when you have printed the pictures. You will have to go back and execute the PRINT SET command [CANCEL] option to erase the information when you are done printing the pictures.
* You cannot set print information for the following types of files:
 * Video files
 * Pictures taken in RAW

To initiate the PRINT SET command, follow these steps:
1. Select MENU/SET>PLAYBACK>(*pg* 3) PRINT SET>[SINGLE], [MULTI], [SINGLE IN BURST GROUP], [MULTI IN BURST GROUP], [CANCEL].
 a) Scroll through the saved image(s). Press the MENU/SET button when you find the picture(s) or frame(s) within a Burst Group to which you wish to add print set information.
 b) The COUNT field and DATE button will appear. Enter the number of prints you want in the COUNT field (figure 11-14a). Press the DISPLAY button to include the date/time stamp information. The Print Set information consists of the Print Set icon, number of prints, and, if selected, the Date icon will display on the screen.

11

Figure 11-14a: Enter the number of prints you want for the selected picture

Figure 11-14b: Print Set information displayed with the Playback button

To cancel assigned print settings:

2. Select [CANCEL]. The following message will be displayed:

 CANCEL ALL PRINT SETTINGS? [YES] [NO]

3. Select [YES] to cancel all print settings; select [NO] to stop the cancellation process (figure 11-14b). Press the MENU/SET button.
4. Press the Trash Can button to exit the command.

The Print Set information and icon will display on the screen when the picture is displayed with the Playback button.

PROTECT

Did you ever intend to save something and you inadvertently deleted it? It's pretty upsetting when that happens. The PROTECT command allows you to set an indicator in the shape of a key (figure 11-15a) on a picture, frame within a Burst Group, or video, which will prevent you from deleting it accidentally. The Protect icon will also display in the top line of data when the picture is displayed with the Playback button (figure 11-15b).

Figure 11-15a: Protect icon displayed on a protected picture

Figure 11-15b: Playback of the same picture with the Protect icon

11

What you should know:
- The [CANCEL] option will be enabled only if at least one picture or video is already protected.
- Protected images are deleted when the FORMAT command is executed.
- A second press of the MENU/SET button will unprotect an image. The protection indicator acts as a toggle.

To initiate the PROTECT functionality, follow these steps:
1. Select MENU/SET>PLAYBACK>(pg 3) PROTECT>[SINGLE], [MULTI], [SINGLE IN BURST GROUP], [MULTI IN BURST GROUP], [CANCEL] and press the MENU/SET button.
 a) Scroll through the saved image(s). Press the MENU/SET button when you find the picture(s) or frame(s) within a Burst Group you wish to protect.

To cancel assigned protection status:
1. Select [CANCEL]. The following message will be displayed:

CANCEL ALL PROTECT? [YES] [NO]

2. Select [YES] to remove all current protection statuses from pictures and videos; select [NO] to stop the process. Press the MENU/SET button.
 If you wish to protect one or all of them again, you will have to execute the PROTECT command again for each one you wish to protect.
3. Press the Trash Can button to exit the command.

FACE REC EDIT
This command has two functionalities. One allows you to delete existing face recognition information associated with a selected picture. The second allows you to replace an existing picture's face recognition information with information associated with another registered face.

What you should know:
- You can replace a picture's existing face recognition information only with existing information from the face recognition registry.

To initiate the FACE REC EDIT command, follow these steps:
1. Select MENU/SET>PLAYBACK>(pg 3) FACE REC EDIT>[REPLACE], [DELETE].

 [REPLACE]

 a) Scroll through the pictures. Locate the picture for which you wish to change the face recognition information. Press the MENU/SET button. If the selected

11

picture does not contain face recognition information, the following error message will display:

NO FACE RECOG. INFORMATION FEATURED

b) If the selected picture has face recognition information, the following message will display:

WHO TO REPLACE?

Press the MENU/SET button. The Face Recognition screen appears and displays the six registered people.

c) Select the registered face that has the face recognition information you want to copy to the selected face in step a. Press the MENU/SET button.

d) The following message will display:

REPLACE FACE RECOG. DATA? [YES] [NO]

Select [YES] to replace the data. Press the MENU/SET button. The face recognition information associated with the picture selected in step a will be replaced with the face recognition information associated with the picture selected in step c. Select [NO] to end the process and return to the Face Recognition screen containing the six registered people.

[DELETE]

a) Locate the picture from which you wish to delete the face recognition information, and press the MENU/SET button.

b) The following message will display:

WHO TO DELETE?

c) Press the MENU/SET button. The following message will display:

DELETE FACE RECOG. DATA? [YES] [NO]

To delete the picture's face recognition information, select [YES] and press the MENU/SET button; select [NO] to stop the process.

2. Press the Trash Can button to exit the command.

Working outside of the Camera

Overview

There is a lot of variety in how you can view and manage your pictures and videos outside of your camera. You can play them on your computer or TV, print the pictures, e-mail them, and add them to your personal website. As technology

evolves and new inventions are developed, most likely you will want to move your pictures and videos into those new arenas.

You have some current options that we will briefly discuss. What you use will depend on your available equipment and software and your level of knowledge to use both. Rather than go into details on how to use different technology, we recommend that you consult both your camera manual and your other equipment and software manuals, along with their corresponding websites, for specific information on how to accomplish your goals.

Downloading and Playing Pictures and Videos on Your Computer

Since the slide shows you created on the camera are based on images saved to your memory card, our suggestion is to download your pictures and videos to your computer and build slide shows there, using either PHOTOfunSTUDIO 6.0 BD Edition software or other third-party software, such as iLife '11.

There are two ways to download your picture and video files to your computer. The first is to use the supplied cable that can be inserted into the mini-USB port of the camera and the USB port of your computer. Typically, if you have installed PHOTOfunSTUDIO 6.0 BD Edition, you will see a prompt for copying the camera files to your computer. This is a straightforward process, but it uses the camera's battery to move the files from the memory card to the computer, so you may wish to use a card reader rather than use your camera. If you deplete your battery while downloading your files, you may corrupt and lose them. If you decide to use your camera and the USB cable, make sure you have a fully charged battery.

The second method is to download the files directly from the memory card. You can remove the card from your camera, and then download the files to your computer using a card reader connected to your computer's USB port. Card readers are devices that have a slot for one or more types of memory card. A card reader may not even be necessary—many laptop computers have an SD card reader built into the chassis. You simply insert the card into your computer and then start your download. Again, if you have a PC with PHOTOfunSTUDIO 6.0 BD Edition software, you will see prompts to save your files onto your computer. It is a straightforward process, and after the files are downloaded, you can organize them, edit them, and display them. If you wish to edit your RAW files, be sure to load SILKYPIX Developer Studio. This will provide you with the capability to alter contrast, sharpness, and color balance.

If you want to process your files and want more advanced controls than those provided by the Panasonic software, you can download free software. Two choices for either Windows or Apple computers are Picasa (www.picasa.google.com) and GIMP (www.gimp.org).

11

Playing Pictures and Videos on Your TV Screen

Directly linking your camera to your TV will yield more viewing options than linking your camera to your computer. The Panasonic GH2 camera can be connected to your TV directly with either the AV cable (supplied with your camera) for non-HDTVs or an HDMI cable (not supplied) for HDTVs. In addition, how you link the camera to the TV is dependent on the age, brand, and type of TV you have, so we recommend that you consult both the camera manual and TV manual, as well as the manufacturers' websites, to get up-to-date information.

After the camera is connected, you can play your slide shows on your TV. One advantage is if you have a wide-screen HDTV, you will be able to appreciate the definition, color, and contrast of both your pictures and your videos. The HDTV serves as the screen for your slide shows and provides an ideal venue for displaying pictures to a small audience.

Printing Your Pictures

As we have discussed with the PLAYBACK menu commands, the Panasonic GH2 camera has the capability of allowing you to set up commands to print your pictures. You can add text to your pictures using the TEXT STAMP and TITLE EDIT commands. You can specify which pictures you want to print and then use the DPOF print system to have them printed. There are some limitations because the print information is always conveyed through your camera and only deals with what is saved on your memory card. You also have the option of downloading your pictures to your computer, determining what you want to print, and then either printing them on your personal printer or sending them to an outside printing service on the Internet or in local stores.

Recommendations

We recommend that you download your pictures and videos to your computer, build the slide shows you want using either the PHOTOfunSTUDIO 6.0 BD Edition software or other third-party software, and then store the results on a DVD so you can play back your saved memories over and over again on your computer or TV. An added benefit is that you can also copy your DVDs and send them off to friends and family to share your memories. We also recommend that you consider doing post-processing on your computer instead of in the camera.

11

Appendix A—Common Error Messages and Resolutions

The Panasonic GH2 camera displays error messages throughout the utilization of the camera's functions. The following chart contains the most common error and informational messages in alphabetical order for easy lookup.

Message	Description
A FOLDER CANNOT BE CREATED	You have reached the maximum number of allowable folders. The default starting number is 100, and the number can go up to 999.
CANNOT BE SET ON THIS PICTURE	The requested change cannot be executed for the selected picture or video. For example, an error message displays when a non-eligible picture or video is selected for such commands as ASPECT CONV., ROTATE, TITLE EDIT, TEXT STAMP, and PRINT SET.
CANNOT RECORD DUE TO INCOMPATIBLE FORMAT (NTSC/PAL) DATA ON THIS CARD	The memory card format is incompatible with the Panasonic GH2 camera.
EDITING OPERATION CANNOT PROCEED AS INFORMATION PROCESSING IS ONGOING	This message is displayed when a command has been initiated to read or play back files from the memory card while the camera is engaged in processing other information from the memory card.
INSERT SD CARD AGAIN	An error occurred when you tried to access the memory card.
LENS NOT FOUND, OR *CUSTOM Menu's* SHOOT W/O LENS IS SET OFF	The lens is not attached or seated correctly on the camera body, or a non-Panasonic GH2 lens is being used and the MENU/SET>CUSTOM>*(pg 7)* SHOOT W/O LENS command is set to [OFF].
MEMORY CARD ERROR FORMAT THIS CARD?	The memory card has an unsupported format.
MEMORY CARD PARAMETER ERROR	The memory card is not compatible with the Panasonic GH2 camera.

Resolution
Do one of two things: – Download the files you wish to retain to your computer and delete any folders you no longer need. After you have freed up available folder numbers, you can create new folders. – Select MENU/SET>SETUP>(pg 5) FORMAT to reformat the memory card. This will delete everything on the card. Select MENU/SET>SETUP>(pg 4) NO.RESET to reset the file and folder numbers.
Stop the execution of the command on the selected picture or video. Review the command's restrictions and determine if you should be executing another command, or make a change to the selected file.
Use a different memory card or reformat the current memory card. If the memory card contains data you wish to save, download the data to your computer prior to reformatting.
Wait for the camera to complete its processing before initiating a command that will read or process image files from the memory card. If you turn the camera off while it is rebuilding information on a modified memory card, the camera will restart the information retrieval from the point it left off.
Take out the memory card and reinsert it. Ensure that it is properly inserted (correct direction) and there is no dirt on the connections. If the error continues to occur, try a different compatible memory card.
Detach the lens and realign the red dots (one on the lens and one on the camera body). Gently seat the lens onto the camera body. Ensure that the lens is at a 90-degree angle to the camera body. Turn the lens in the direction away from the shutter-release button. You should hear a click when the lens is seated properly. If you are using a non-Panasonic GH2 lens, ensure that the MENU/SET>CUSTOM>(pg 7) SHOOT W/O LENS command is set to [ON].
If you wish to continue to use the memory card for your Panasonic GH2 camera, download any saved pictures and videos from the memory card to your computer, and reformat the card using the MENU/SET>SETUP>(pg 5) FORMAT command. This will format the card for use in the Panasonic GH2 camera.
Replace the memory card with one that is compatible with the Panasonic GH2 camera: – SD memory card (8 MB to 2 GB) – SDHC memory card (4 GB to 32 GB) – SDXC memory card (48 GB to 64 GB)

Message	Description
MOTION RECORDING WAS CANCELLED DUE TO THE LIMITATION OF THE WRITING SPEED OF THE CARD	The memory card is insufficient to record the videos at the required speed and file format.
NO ADDITIONAL SELECTIONS CAN BE MADE	An attempt has been made to select more than the maximum number of pictures and/or videos that can be selected at one time. This occurs when the [MULTI] option has been selected during the following commands: DELETE MULTI, FAVORITE, TITLE EDIT, TEXT STAMP, or RESIZE.
NO BATTERY POWER REMAINS	The battery charge is insufficient.
NO FACE RECOG. INFORMATION FEATURED	When you are executing [REPLACE] or [DELETE] in the MENU/SET>PLAYBACK>(pg 3) FACE REC. EDIT command, the selected picture does not have face recognition information associated with it.
NO PICTURE TO PLAY IN CATEGORY	When you are executing the CATEGORY SELECTION option in the PLAYBACK MODE command or SLIDE SHOW command, no pictures or videos were found on the memory card for the selected category.
NO VALID PICTURE TO PLAY	The Playback button was pushed, and the memory card is empty.
PICTURE IS DISPLAYED FOR 4:3 TV	Informational Message: When the AV cable is connected to the camera and the TV, this message informs you that the MENU/SET>SETUP>(pg 3) TV ASPECT value 4:3 was selected. This message also occurs when a USB cable is connected only to the camera. In this case, connect the other end of the cable to a computer or printer.
PICTURE IS DISPLAYED FOR 16:9 TV	Informational Message: When the AV cable is connected to the camera and the TV, this message informs you that the MENU/SET>SETUP>(pg 3) TV ASPECT value 16:9 was selected. This message also occurs when a USB cable is connected only to the camera. In this case, connect the other end of the cable to a computer or printer.
PLEASE CHECK THAT THE LENS IS ATTACHED CORRECTLY	The lens is not registering as being seated correctly on the camera body. Or if the lens is attached properly and it is not a Panasonic GH2 compatible lens, the SHOOT W/O LENS command has been set to [OFF].
PLEASE CHECK THE CARD	The camera is unable to read from or write to the memory card.
PLEASE CLOSE THE FLASH	The flash unit is still open when it should be closed.

Resolution

Use an SD Class 4 or higher memory card for AVCHD recording, and use an SD Class 6 or higher memory card for Motion JPEG recording. If the problem persists, try reformatting the memory card.

If the recording continues to be cancelled, the data writing speed has deteriorated. Make a backup and then reformat the card.

Reduce the number of pictures being selected and execute the operation again.

Turn the camera off and charge the battery. If you have multiple Panasonic-approved batteries available, insert an alternate battery while charging the low battery. This way you will always be ready to take pictures.

Select another picture that has face recognition information tied to it.

This can be resolved only for future pictures. A picture's scene category is set at the time the picture is taken, based on either the Intelligent Auto (iA) Mode scene category or the predefined scene mode you manually selected when the picture was taken. If no category was assigned to the picture, or if the category is not an available Playback category, the picture will not be included in any of the selected Playback categories.

The Playback function will work only when there are pictures and/or videos stored on the memory card for playback.

Click the MENU/SET button to delete the message. If this isn't the TV ASPECT value you want, change the assigned value using MENU/SET>SETUP>(pg 3) TV ASPECT.

Click the MENU/SET button to delete the message. If this isn't the TV ASPECT value you want, change the assigned value using MENU/SET>SETUP>(pg 3) TV ASPECT.

Ensure that the lens is turned sufficiently in the direction away from the shutter-release button so it is properly secured to the camera body. You should have heard a click when it seated properly. If necessary, detach the lens and realign the red dots (one on the lens and one on the camera body). Gently seat the lens onto the camera body. Ensure that the lens is at a 90-degree angle to the camera body. If the lens is attached properly and it is not a Panasonic GH2 compatible lens, set the SHOOT W/O LENS command to [ON]

Most likely, the memory card is not functioning. Try a different memory card. If this does not fix the problem, ensure that there is no dirt in the memory card chamber. If the error message persists, contact Panasonic technical support for additional information.

The camera will not turn off until the flash unit has been closed. Close the flash unit, and the camera will turn off.

Message	Description
PLEASE MAKE SURE TO TURN ON THE POWER OF EXTERNAL MICROPHONE	Informational Message: This message reminds you to ensure that the external microphone is turned on when it is attached.
PLEASE OPEN THE FLASH	Informational Message: This message informs you that the camera needs the flash opened because there is insufficient lighting to take the picture.
READ ERROR/WRITE ERROR	The camera is unable to read from or write to the memory card.
REGISTRATION FAILED	When you are executing MENU/SET>REC>FACE RECOG.>AUTO REGISTRATION>[MEMORY SET], the camera is unable to identify the image as a face and is therefore unable to register the image.
SOME PICTURES CANNOT BE DELETED	Some pictures were not created with the current standard for digital camera files (DCF), and therefore they cannot be deleted with the Delete function.
THE LENS IS NOT ATTACHED PROPERLY. DO NOT PUSH LENS RELEASE BUTTON WHILE LENS IS ATTACHED.	The lens is not seated completely on the camera body. Pushing the lens release button would potentially cause more damage.
THIS BATTERY CANNOT BE USED	The battery is not Panasonic approved.
THIS CARD IS NOT FORMATTED WITH THIS CAMERA, AND NOT SUITABLE FOR MOVIE RECORDING	The memory card was formatted in another camera or a computer, and it has a lower than required recording speed.
THIS MEMORY CARD CANNOT BE USED	The memory card being used is not compatible with the Panasonic GH2 camera.
THIS MEMORY CARD IS WRITE-PROTECTED	The memory card's write-protected switch is in locked position to prevent anything from being written to or deleted from the memory card and to prevent it from being formatted.
THIS PICTURE CANNOT BE DELETED	The picture was not created with the current standard for digital camera files (DCF) and therefore cannot be deleted with the DELETE function.
THIS PICTURE CANNOT BE RESIZED	The selected file is not eligible for resizing. Videos, pictures saved as RAW files, pictures with a Text Stamp, and pictures that are already size [S] cannot be resized.
THIS PICTURE IS PROTECTED	The picture or video is protected, and the action (for example, attempts to delete a protected picture or video) cannot be completed.

| **Resolution** |
| This message displays when an external microphone is attached. Ensure that the microphone is turned on and its battery is charged sufficiently for use. |
| Open the flash unit or add more light to the image. |
| Take out the memory card and reinsert it. Ensure that it is properly inserted (correct direction) and there is no dirt on the connections. If the error message still displays when reading or writing to the memory card, turn off the camera, take out the memory card, turn the camera back on, and reinsert the memory card. Sometimes having the camera recycle through its start routines reinitializes the commands, and this can occasionally resolve a camera problem. Another option is to try a different memory card. If the error message persists, contact Panasonic technical support for additional information. |
| Ensure that the image includes a complete human face directly facing the camera with both eyes clearly visible and open. |
| To delete these pictures, copy the files you wish to save to a computer, then format the memory card. |
| Turn the lens in the direction toward the shutter-release button to unseat it. Line up the lens again and turn it in the opposite direction, away from the shutter-release button to reseat it. Make sure the camera body and lens are aligned perpendicularly when you are seating the lens. |
| Use only Panasonic-approved batteries. Check your Panasonic GH2 user manual for a list of approved batteries. |
| Reformat the memory card in the camera. If the memory card contains data you wish to save, download the data to your computer prior to reformatting it. |
| Replace the memory card with one that is compatible with the Panasonic GH2 camera:
 − SD memory card (8 MB to 2 GB)
 − SDHC memory card (4 GB to 32 GB)
 − SDXC memory card (48 GB to 64 GB) |
| Move the memory card lock switch to the unlocked position. |
| To delete this picture, copy the files you wish to save to a computer, then format the memory card. |
| Do not select the picture or video. Reinitiate or continue the MENU/SET>PLAYBACK>(pg 2) RESIZE command without the ineligible file. |
| Unprotect the picture or video and retry the action. |

Message	Description
TO MOVE IMAGE, SCROLL TO LEFT OR RIGHT	Informational Message: This message is displayed when you first press the Playback button after turning on the camera or awakening it from sleep mode. It reminds you to scroll left or right to move through the saved images for playback. Scrolling can be done by either touching the LCD screen or using the directional arrow buttons.
TOUCH SCREEN TO ENLARGE IMAGE	Informational Message: This message is displayed when you first press the Playback button after turning on the camera or awakening it from sleep mode. It informs you of the option to enlarge the image on the LCD screen by using the touch screen feature.
TRY ANOTHER CARD	An error has occurred when trying to access the inserted memory card.

Resolution
This informational message disappears within a couple of seconds or when another action is taken.
This informational message disappears within a couple of seconds or when another action is taken.
Take out the memory card and reinsert it. Ensure that it is properly inserted (correct direction) and there is no dirt on the connections. If the error continues to occur, try a different compatible memory card.

Appendix B—Intelligent Auto Mode Menu Options

The following chart contains the active high-level menu options available when Intelligent Auto Mode is enabled. For additional submenu information, see the downloadable GH2 Command List (found at http://rockynook.com/panasonicgh2), which is an overall menu option chart.

Main Menu	Option	Menu Page	Description
INTELLIGENT AUTO	ASPECT RATIO	1	Aspect ratio defines the ratio of width to height of the resulting picture for printing and playback. The 4:3 aspect ratio means 4 units of width to 3 units of height. The resulting picture will be wider than it is tall by 1 unit.
	PICTURE SIZE	1	Sets the number of pixels for the image. The more pixels, the finer the picture's detail will appear when the picture is enlarged. The picture's resulting file size is directly proportional to the number of pixels. The more pixels, the larger the picture's file size.
	QUALITY	1	Sets the compression rate of pictures. Options include JPEG and RAW. JPEG format processes the data post-capture so it is a subset of the picture data. RAW format saves all of the picture data and will allow you more flexibility when conducting your own post-processing steps.
	FACE RECOG.	1	Activates the camera's face recognition software.
	STABILIZER	1	Reduces the effects of camera jitters during picture recording. This command is locked during video recording to [MODE1]. Note: Stabilization can be ineffective if there is excessive camera movement during high-zoom magnification, when using digital zoom, when taking pictures of moving subjects, or in indoor or low-light environments (slow shutter speed).

Main Menu	Option	Menu Page	Description
INTELLIGENT AUTO *Motion Picture*	REC MODE	1	Establishes the recorded data format for videos.
	REC QUALITY	1	Establishes the recorded data quality for videos. The list of available options is controlled by the selected REC MODE value.
	CONTINU-OUS AF	1	Allows the camera to be set in continuous auto focus. Note: The sound of the camera continuously setting the aperture and focus action can sometimes be captured on the audio portion of a video. If this is a problem, set the option to [OFF].
	WIND CUT	1	Reduces wind noise during video recording. Note: This option changes the audio results.

Main Menu	Option	Menu Page	Description
CUSTOM	CUST.SET MEM.	1	Allows you to store up to three sets of command options and enable them through the mode dial's CUSTOM Mode option.
	GUIDE LINE	1	Displays a guide line pattern to help you align the image properly according to personal taste. The selected option is displayed when framing pictures and videos.
	LCD INFO. DISP.	1	Sets a color scheme to be used on the LCD screen's data display information screens. This option is not applicable to the data display screens in the viewfinder.
	REMAINING DISP.	1	Displays the remaining number of pictures that can be recorded or the remaining video recording time, based on the current type of recording. The number is shown on the display screen and is updated with each picture or second of video that is recorded. This metric refers to remaining space on the memory card, not remaining charge on the battery.

Main Menu	Option	Menu Page	Description
SETUP	CLOCK SET	1	Set the camera's date and time information when you first get the camera. The current date and time stamp will be stored with each picture and video.
	WORLD TIME	1	Use this option to set your home and travel destination's time zone. The option includes a daylight saving time indicator for both your home and destination time zones. If you are moving from one time zone to another, you can use the new time zone's date and time information for your pictures without affecting the camera's clock. You will be prompted for your travel start and end dates plus your destination's time zone. This way you will have the correct date and time stamp associated with each picture and video.
	BEEP	1	Sets the volume of the audible beep that signals focus confirmation, self-timer, alarm, and Burst Group recording. Note that the beep will occur only when the conditions are enabled.
	LCD MODE	1	Adjusts the brightness of the LCD screen. You may need to increase the LCD screen's brightness when the surrounding light is bright to be able to view the data on the LCD screen. Changing the LCD screen's brightness does not affect the resulting pictures or videos, but does affect remaining battery charge. Note: Regardless of the setting, in bright environments the LCD screen may be too dim to adequately view the data and image. In these cases, either shield the LCD screen with your hand or use the viewfinder.
	LANGUAGE	1	All of the displayed messages and option titles will be displayed in the selected language. The picture titles you supply will be written in whatever language you choose, and additional symbols for the selected language will be available.

Main Menu	Option	Menu Page	Description
PLAYBACK	SLIDE SHOW	1	Select a group of still pictures and play them back on the LCD screen or a TV (with the AVCHD cable adapter), or download them to a computer. You can accompany the slide show with music and set the playback speed.
	PLAYBACK MODE	1	Initiates a selected PLAYBACK MODE option for your pictures and videos, which can be viewed on the LCD screen, a standard TV with the included AV cable, or an HDTV with an HDMI cable.
	TITLE EDIT	1	Add a title (maximum of 30 characters) to a picture to be displayed during playback. Only alphabetic characters (upper- and lowercase), numbers, spaces, and symbols can be added. Note: The DISPLAY button pages through the available keyboards, and the directional arrows navigate through the displayed keyboard and settings. The MENUWSET button selects a keyboard value.
	TEXT STAMP	1	Collects a set of data about each selected picture and stores it with the picture. The data will be printed on the picture. Data that can be used includes the following: — SHOOTING DATE: Recorded date and time — NAME: The name information from Face Recognition, BABY1, BABY2, or PET — LOCATION: The travel destination, according to the current date and time from the TRAVEL DATE command's LOCATION option — TRAVEL DATE: The travel date from the TRAVEL DATE command's TRAVEL SETUP option — TITLE: The title information from the MENU/SET>PLAYBACK>TITLE EDIT command Note: This option works only for pictures saved as JPEG files. It does not work for videos, pictures recorded without the clock and title set, or pictures that already have a TEXT STAMP. Pictures with a size of [L] or [M] will be changed to [S].
	VIDEO DIVIDE	1	Allows you to divide a video into two separate videos. Note: You cannot divide a video too close to its beginning or end.

Main Menu	Option	Menu Page	Description
PLAYBACK	RESIZE	2	Allows you to reduce the picture size. This will make a smaller file so you can e-mail the file or post it to a website more easily.
	CROPPING	2	Allows you to identify a portion of the picture to be copied to a new file. Use the directional arrows or the rear dial to identify the borders of the picture you wish to keep as a separate file. The original file is not affected.
			Note: Only JPEG pictures without a text stamp can be cropped. The quality of the resulting picture may deteriorate.
	ASPECT CONV.	2	Allows you to convert a picture with an aspect ratio of 16:9 to 4:3, 3:2, or 1:1.
			Note: Only JPEG pictures without a text stamp can be converted to a different aspect ratio.
	TEXT STAMP	1	Collects a set of data about each selected picture and stores it with the picture. The data will be printed on the picture. Data that can be used includes the following:
			– SHOOTING DATE: Recorded date and time
			– NAME: The name information from Face Recognition, BABY1, BABY2, or PET
			– LOCATION: The travel destination, according to the current date and time from the TRAVEL DATE command's LOCATION option
			– TRAVEL DATE: The travel date from the TRAVEL DATE command's TRAVEL SETUP option
			– TITLE: The title information from the MENU/SET>PLAYBACK>TITLE EDIT command
			Note: This option works only for pictures saved as JPEG files. It does not work for videos, pictures recorded without the clock and title set, or pictures that already have a TEXT STAMP. Pictures with a size of [L] or [M] will be changed to [S].
	VIDEO DIVIDE	1	Allows you to divide a video into two separate videos.
			Note: You cannot divide a video too close to its beginning or end.
	RESIZE	2	Allows you to reduce the picture size. This will make a smaller file so you can e-mail the file or post it to a website more easily.

B

Main Menu	Option	Menu Page	Description
PLAYBACK	CROPPING	2	Allows you to identify a portion of the picture to be copied to a new file. Use the directional arrows or the rear dial to identify the borders of the picture you wish to keep as a separate file. The original file is not affected. Note: Only JPEG pictures without a text stamp can be cropped. The quality of the resulting picture may deteriorate.
	ASPECT CONV.	2	Allows you to convert a picture with an aspect ratio of 16:9 to 4:3, 3:2, or 1:1. Note: Only JPEG pictures without a text stamp can be converted to a different aspect ratio.
	ROTATE	2	Rotates a picture in 90-degree increments clockwise or counterclockwise. Note: You cannot rotate videos or protected pictures. The ROTATE DISP. option must be [ON].
	ROTATE DISP.	2	Allows displayed pictures to be automatically rotated.
	FAVORITE	3	Select up to 999 pictures as Favorite and play them back as a group. Note: Only JPEG pictures can be marked as favorites. Requires that FAVORITE FUNC. command be set to [ON].
	PRINT SET	3	Use the digital print order format (DPOF) system to select one or a group of pictures for printing. You can specify the number of prints to make and whether each print should include the picture's date and time stamp on the resulting print. The resulting file can be sent to a DPOF-compatible photo printer or photo printing service. Note: This option works only for JPEG pictures.
	PROTECT	3	Set a protection key to prevent one or more pictures from being deleted by mistake. Note: Reformatting the memory card will delete protected files.
	FACE REC EDIT	3	Delete and replace face recognition information in selected pictures. Note: Deleting face recognition information also deletes the picture's Face Recognition category. You cannot edit face recognition information on protected pictures.

Acknowledgments

The Rocky Nook Team has been invaluable in helping us put together this book. We have appreciated the input and support from Gerhard Rossbach (Publisher, CEO), Matthias Rossmanith (Project Manager), and Joan Dixon (Managing Editor). A special thanks to Jocelyn Howell (Editorial Assistant) for fielding a countless number of book publishing questions and helping us smooth the project's rough edges. Her quick response and upbeat attitude was always appreciated. In addition we were fortunate to have the help of Jeanne Hansen (Copyeditor), James Johnson (Technical Proofreader), and Petra Strauch (Layout).

All writers know that a book starts with a blank page. Filling, in this case, nearly 300 pages with text and photographs takes days, weeks, and months of research, discussion, writing, and rewriting. And although it might seem one is working alone, in reality there are many people who help the writer produce the book. We have appreciated the Rocky Nook team not only for their help, but also for their kindness and professionalism in support of our goal. One of the benefits of producing this book is developing new friends and working together on a project.

In addition, a special thanks to our families for being patient and understanding when our time with them was limited and our conversations were sometimes single-minded about the Panasonic GH2 camera.

Brian Matsumoto
Carol Roullard

www.VistaFocus.net

Index

Get in the Picture!

c't Digital Photography gives you exclusive access to the techniques of the pros.

Keep on top of the latest trends and get your own regular dose of inside knowledge from our specialist authors. Every issue includes tips and tricks from experienced pro photographers as well as independent hardware and software tests. There are also regular high-end image processing and image management workshops to help you create your own perfect portfolio.

Each issue includes a free DVD with full and c't special version software, practical photo tools, eBooks, and comprehensive video tutorials.

Don't miss out – place your order now!